FANTASY NUDES
Digital Techniques in Photography

Jim Zuckerman

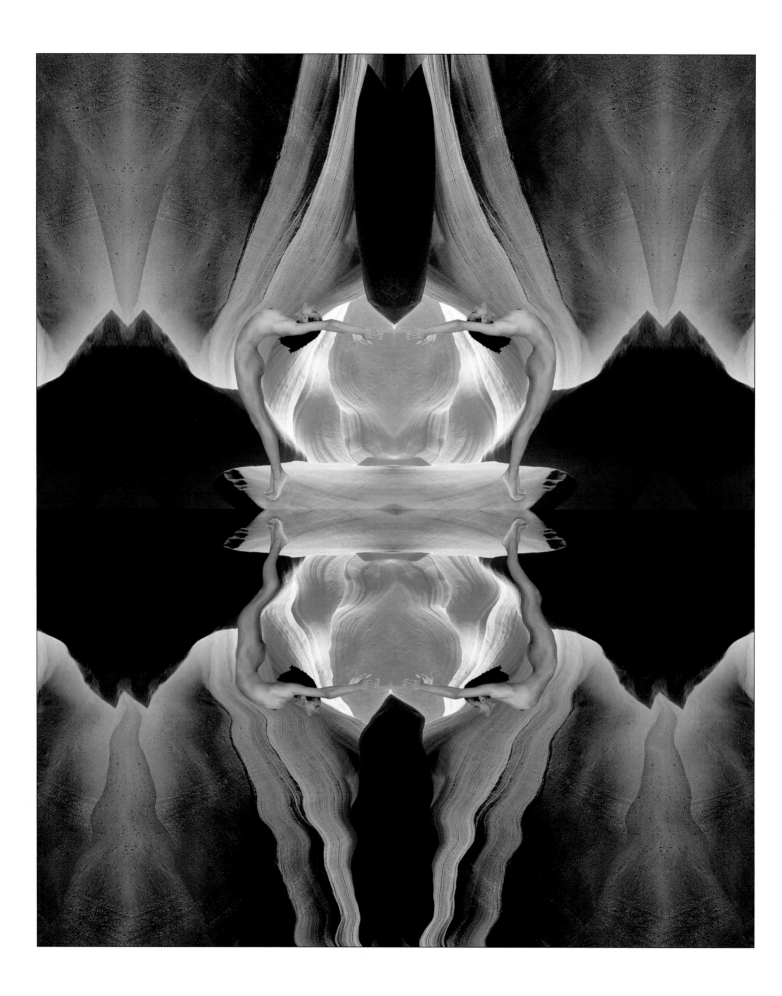

FANTASY NUDES

DIGITAL TECHNIQUES IN PHOTOGRAPHY

Jim Zuckerman

SILVER
PIXEL
PRESS

Rochester, NY

FANTASY NUDES
Digital Techniques in Photography
Written by Jim Zuckerman

Published in the United States of America by
Silver Pixel Press®
A Tiffen® Company
21 Jet View Drive
Rochester, NY 14624
Fax: (716) 328-5078

Printed in Belgium by Die Keure n.v.

The author and publisher acknowledge all trademarks and registered trademarks of products featured in this book as belonging to their respective owners.

Library of Congress Cataloging-in-Publication Data
Zuckerman, Jim.
 Fantasy nudes : digital techniques in photography / Jim
Zuckerman.
 p. cm.
 ISBN 1-883403-48-0
 1. Photography--Digital techniques. 2. Female nude in art.
3. Adobe Photoshop. I. Title.
TR267.Z83 1988
778.3--dc21 98-8196
 CIP

Acknowledgements
I would like to express my appreciation to Paul Klingenstein, chairman of Mamiya America, Inc., for introducing me to Silver Pixel Press. I also must thank my best friend, Scott Stulberg, for introducing me to new techniques within several computer programs, particularly MetaCreations Painter. Scott's remarkable ability to intuitively elicit the inner workings of complex programs is amazing, and he generously shares this knowledge with me. Many of the photographs reproduced in the following pages have been produced as a direct result of our friendship.

Dedication

This book is dedicated to Dennis Prager, the man I most respect and admire. Dennis' brilliant insights into the great issues of life have profoundly enriched my life. I would like to commend to you, the reader, two of his books: *Think a Second Time* and *Happiness is a Serious Problem*.

About the Author

Fantasy Nudes: Digital Techniques in Photography is Jim Zuckerman's sixth photography book. He is also a contributing editor to *Petersen's Photographic Magazine* and his images, articles, and photo features have been published in scores of books and magazines.

Jim's photographic specialities include digital effects; photo and electron microscopy; and wildlife, nature, and travel photography. He has led photo tours to destinations around the world and has taught creative photography at universities and private schools, including UCLA and Kent State University in Ohio.

His work has appeared on posters, greeting cards, calendars, and corporate publications, as well as packaging and advertising. Westlight, a division of Corbis, represents his stock photography.

Contents

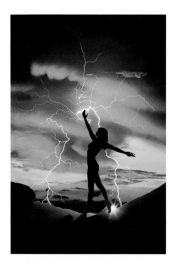

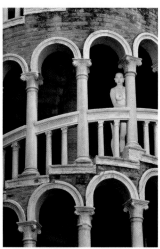

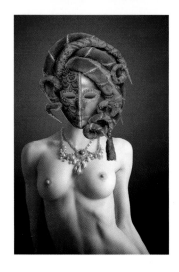

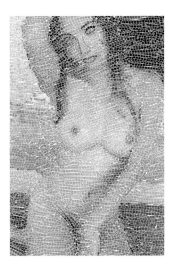

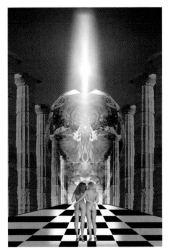

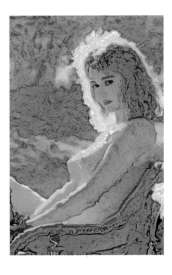

Introduction

I have been manipulating photographs on a computer for seven years now, and even though I have worked on hundreds of images, I am still in awe of the creative possibilities offered by this new technology. Any type of effect I can imagine can now be accomplished in brilliant color right before my eyes, in real time, on a computer monitor. It's an exciting time to be a photographer.

This book explores the art of digital manipulation using the female form as the primary subject. I will demonstrate different styles and techniques, using several computer programs, but this is really only the beginning for you. The creative potential in the digital world is so enormous that any book can only offer you an introduction to the possibilities. It is up to you to apply this knowledge to your own images in unique and exciting ways.

Please understand that digital technology is not an excuse for mediocre photography. You should not assume a bad photo can be greatly improved by changing the colors or abstracting the original. An unattractive pose or expression, bad lighting, or an unflattering camera angle will not produce a beautiful image even with extensive digital manipulation. "Garbage in, garbage out" is a good adage to remember.

The ease with which photographers can now alter photographs is not celebrated by everyone. Some people feel this new technology is cheating. They feel it somehow denigrates the photographic process, that it degrades the inherent artistry of the medium. These people forget, of course, that when photography was first invented about 160 years ago, artists at the time scoffed at the idea of picture taking as an art form. Photography merely captures what we can see, they would say. An artist, on the other hand, interprets the world around us with a brush and oils.

More to the point, though, is that from the beginning of photography, photographers have manipulated their images using whatever means worked. Often, reality was not the objective. Black-and-white film itself alters our reality of color. When you look at the work of Ansel Adams or John Sexton, do you think to yourself that they were cheating? Do you respect them less for rendering color in shades of gray?

Consider the distortion of reality with photographic lenses. Wide-angle lenses exaggerate perspective, making foreground elements seem disproportionately large compared to the background. Telephoto lenses compress elements in a scene. If you focus on a subject close to the camera with a long lens, the background is rendered out of focus. This is not what our eyes see.

Do you use filters? Virtually every filter on the market changes the way a photo looks. When Ansel Adams darkened the skies above his famous landscapes by using yellow, orange, or red filters, was he cheating? When a polarizing filter eliminates glare or helps to cut through atmospheric haze or smog, is this unfair?

No one ever said that photography must capture what we see with our eyes. Photographers who disdain any type of manipulation are playing by whose rules? Not mine. And probably not yours. Computers are just another tool for photographers to use as a creative outlet.

They allow us to alter images for artistic satisfaction. I feel very strongly that it's the final result that counts. The method by which we achieve our inner vision—be it a brush, a lens, or a computer—is simply a means to an end. It is the tool we use for self-expression.

Let's get to know this amazing new tool and put it to creative use.

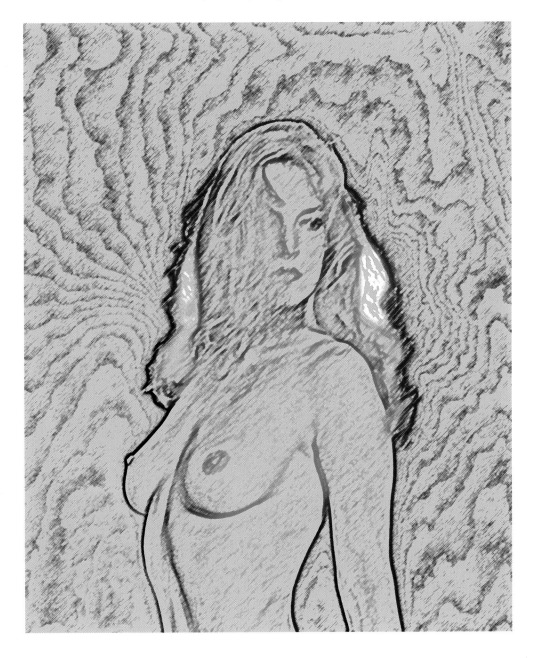

Applying the filter Colored Pencil *is one of the techniques I often use in Photoshop when I want to transform a photograph into a painting. Sometimes I like the effect, and sometimes I don't. It's not really possible to predict how the filter will affect a photo. This portrait illustrates an instance when the filter worked exceedingly well.*

1 Getting Your Feet Wet

Before I discuss the actual techniques used to manipulate photographs, it is necessary that I begin at the beginning. I will assume you know nothing about computers. Every aspect of the entire process will be introduced and explained in detail to give you a full understanding of what is involved in digitally altering photos. If you feel you are totally ignorant about computers, keep in mind that when I bought my first Macintosh six years ago, I didn't know the difference between a hard drive and overdrive! I knew nothing about the digital world. So I appreciate where you might be coming from, and I will make your introduction to this unfamiliar area of technology as painless and interesting as possible.

Digital Manipulation vs. the Darkroom

Since the inception of photography, photographers have altered images in the darkroom. Controlling exposure, contrast, and color balance are basic procedures in darkroom work. Other traditional techniques include burning and dodging, sepia toning, bas-relief,

Classic darkroom techniques include multiple exposure and sandwiching film. A multiple exposure occurs when two or more photos are exposed at different times onto raw stock (undeveloped film). A sandwich is the physical contacting of two slides or negatives and then exposing them together onto raw stock in one exposure. This photo would have been done in the darkroom by double-exposing the lightning and the sunset, and then sandwiching the result with the nude silhouette. With the software program Adobe Photoshop, you can execute this technique and watch it happen in real time on your computer's monitor. Only when you are satisfied with the results is it output to film or paper.

The model had been photographed outdoors in the afternoon. I cut her out of the background by creating a clipping path around her using the Pen *tool (this means laying down and then connecting a series of dots around the periphery of the figure). I then copied the selected figure to the clipboard and pasted it into the sunset background. With* Image: adjust: brightness/contrast, *the exposure on the figure was decreased until the model appeared to be a silhouette. The lightning photo was then pasted into the sky, and I used the* Darken *mode in the* Layers *palette to blend the two background elements.*

Finally, I applied Filter: sharpen: unsharp mask *to the entire composite photo. This filter sharpens the photograph for output to film. The parameters in the dialog box I use most often are: amount—80 percent, radius—1.5 pixels, threshold—zero. I applied* Unsharp Mask *to every photograph in this book before the digital file was translated to film or before it was used to make the color separations that produced the images on these pages.*

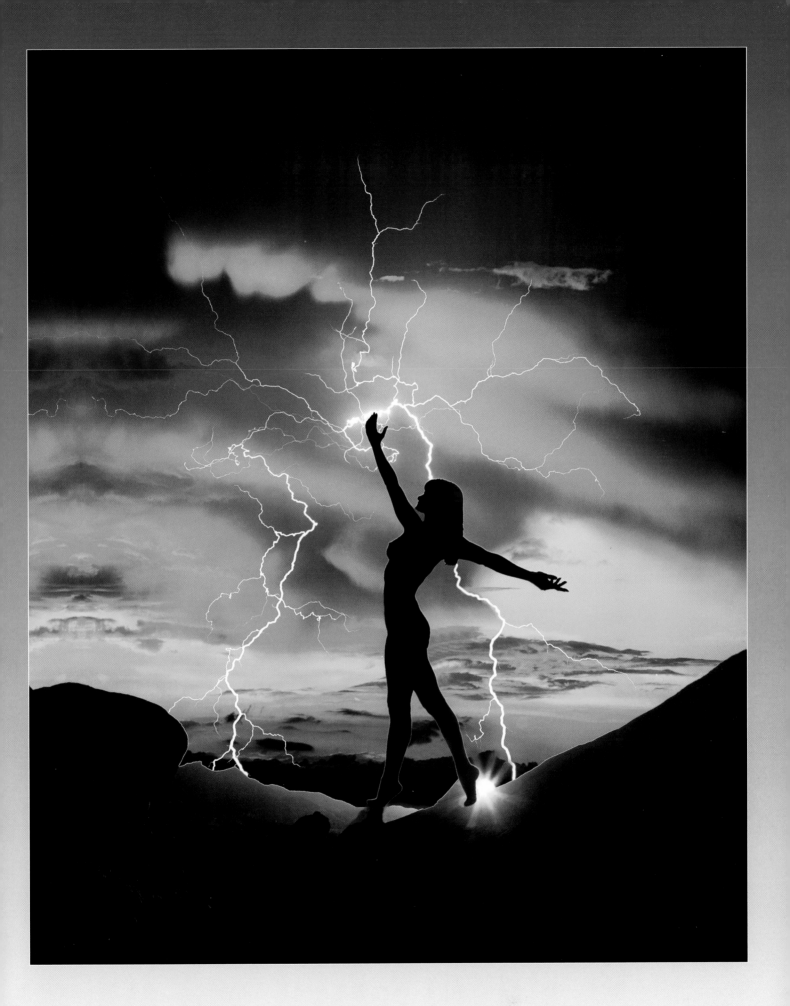

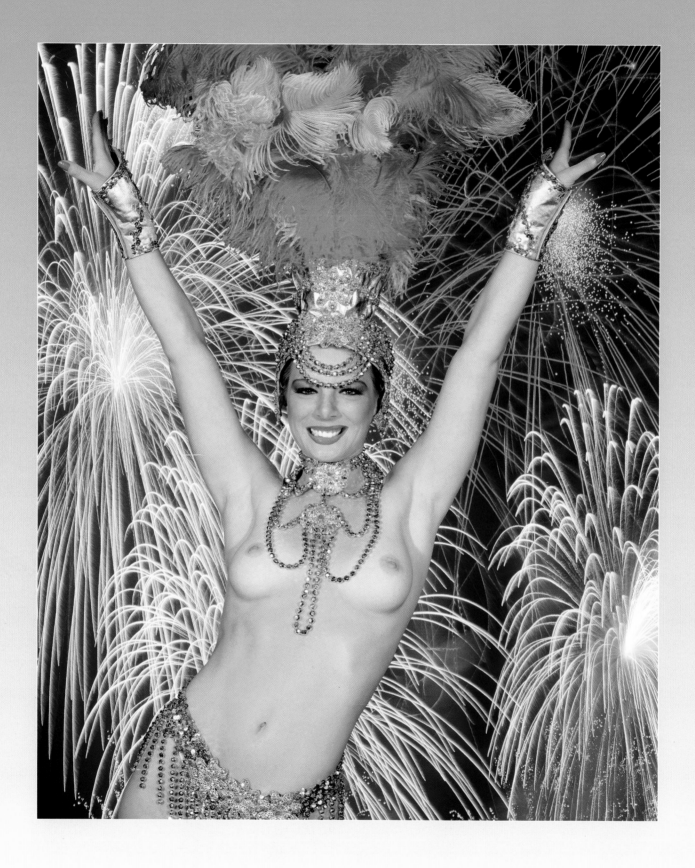

solarization, posterization, litho masking for compositing more than one image, and many more.

All of these techniques can now be done with a computer, in real time, and you don't have to develop film or paper to see the results. It happens right before your eyes on the monitor. If you don't like what you did, simply "undo" it and try again. You don't have to go through a box of 8x10-inch paper before you produce a perfect image. When you like what you see, it can be output to a slide, a negative, a print, or color separation film to make plates for a printed piece.

That's the good news.

Even better news is that the capabilities of the computer go so far beyond darkroom work that you simply won't believe it until you experience it firsthand. Nothing will prepare you for the myriad of effects you can achieve on any photograph in your files. The most difficult aspect of digital manipulation is deciding which technique to use, because there are so many!

Hardware and Software

Both hardware and software are needed to manipulate photography. "Hardware" refers to all of the electronic components: the computer itself, the monitor, internal and external hard drives, the printer, a CD-ROM drive, and any other equipment you use.

"Software" is the generic term for the programs, or set of instructions, that tell your computer what to do when you hit certain keys on the keyboard or click the mouse. There are software programs for almost any task you want your computer to perform. For example, if you want to look at photography Web sites, you would need to use Web-browser software, such as Netscape Navigator. The most popular program on the market for manipulating photos is Adobe Photoshop. Plug-ins, programs that operate within other programs, can be added to expand the capabilities of Photoshop. Kai's Power Tools and Terrazzo are just a few of the plug-ins available. If you want to turn your photos into paintings using brush strokes simulating the style of, among others, Monet

Another familiar technique that photographers employ in the darkroom is masking. A high-contrast black-and-white mask is created from one photograph (in this case from the model and her headdress), and a second photograph is double-exposed behind the subject where the two images are not superimposed over each other. They only meet at the edges. Photoshop accomplishes this procedure easily and with total control. Instead of working in the dark with critical tolerances and where you can't determine if the composite image looks realistic, Photoshop allows you to make the final photograph perfect before it is output to a slide or print.

The model had been photographed against a black background. I used the Magic Wand tool to select the black, and then pasted the fireworks into the selection.

or Van Gogh, MetaCreations Painter is a program you should look into. For sophisticated three-dimensional design and animation, you may want to use Strata Studio Pro, Detailer, or Infini-D.

There are many software programs you will eventually want to learn. Some of them can be mastered quickly, while others, like Adobe Photoshop, will take many weeks, or even months, before you understand their depths. But don't let that intimidate you. After all, learning to produce great photographic images is a lifelong pursuit, so what's a few months?

Choosing a Platform

Before you buy a computer, a decision must be made regarding which platform to use. Adobe Photoshop is made for both IBM clones (also called PCs) and Macintosh. Mac is the traditional tool for the graphics industry, but in the last couple of years, the PC has undergone significant changes to make it more "user-friendly" in ways that imitate Macintosh. Both systems have advantages and disadvantages.

Money is a major consideration, of course, and if you're on a tight budget, you will probably favor the IBM platform. It is less expensive than a Mac, and PCs can be every bit as fast and powerful as Macintosh. If you do select the IBM platform, make sure that the service bureau you work with is capable of handling digital files from a PC. A service bureau is the company that turns your slides or negatives into digital files by scanning them. After you manipulate the photos, they will output them back to film.

Macintosh is, in my opinion, much easier to work with than PCs. It costs more to buy, but the way in which Mac operates makes it easier

to learn. If computers intimidate you, a Mac will make your immersion into the digital world a less painful one. Most art directors, graphic designers, illustrators, and photographers who manipulate photographs work with Macintosh. Virtually all of the service bureaus cater to Mac users as well. However, both platforms enable you to have full creative control over your images.

An interesting way to assess which system is appreciated for its ease of operation is to listen to PC users when they analyze a new hardware or software product. They often are excited to find out that it is now "more like a Macintosh." Mac users, on the other hand, almost always disdain the way PCs handle certain operations.

Wherever you purchase your new computer, it is absolutely essential that you feel confident that technical support will be available. This is extremely important. You will need someone on the other end of the phone who is kind, generous with their time, patient, and very knowledgeable. If you buy the equipment from a discount mail-order company, this may not be the case. Trust me. You will need help when you first get started. There are so many unforeseen factors that can cause problems, you will be eternally grateful for the safety net.

The company I buy my equipment from was still patiently helping me with questions and problems a year after my initial large purchase. One good thing to know about computer equipment retailers is that prices continually come down over time on most items. Unlike photographic equipment, which gets more expensive every year, computer hardware gets more powerful for less money. At some point you have to jump in, though, and start making incredible pictures.

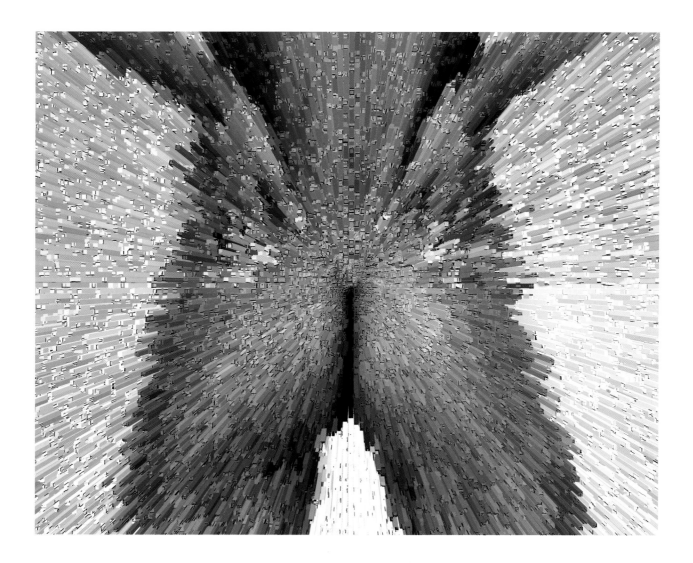

The computer's ability to manipulate photos goes far beyond what is possible in the darkroom. This particular effect is called Extrude, and it is a Photoshop filter. There is no possible way it could have been created in the darkroom. Throughout this book, as you study the text and captions, I hope to impress upon you just what an amazing tool the computer is.

The Monitor

Just like in photography, compromises may need to be made with respect to price versus features. One of these important decisions is the size of the monitor. A large working area is a great convenience in manipulating photography. I use a 20-inch Radius Intellicolor Display/20e, which allows me to have several large images on the screen as well as to examine a magnified portion of a single image with amazing clarity.

Some people prefer using two 20-inch monitors linked together, where the tools and menus of a program are displayed on one monitor, leaving the second monitor uncluttered as a workspace. Graphic designers who lay out pages for magazines can also use this arrangement for double page spreads, allowing them to devote each monitor to a single page, thereby enjoying a larger view of their work.

The next best choice, and one that can save you from $600 to $1000, is a 17-inch color monitor. A friend of mine uses one of these, and he is able to do everything that I can do. It's just that his digital images appear somewhat smaller as he works on them. A 15-inch monitor is, in my opinion, too close in price to the 17-inch to be considered seriously. I think if you are going to invest in computer equipment for photographic manipulation, you would be disappointed in a 15-inch monitor. And anything smaller shouldn't even be considered for serious work.

Two other monitor considerations are resolution and bit depth. Resolution refers to the number of pixels a monitor can display. (The term pixel stands for picture element, and it is the smallest unit in a scanned photograph. Each pixel on a color monitor is composed of three colors—red, green, and blue.) Bit depth determines how much memory is assigned to each pixel, and therefore, how many colors the system can display. For color photo manipulation, the recommendation is 24-bit, which displays 16.7 million colors.

Archival storage is important because you will eventually create too many photos to keep on a hard drive. You will need an inexpensive means of storing scanned and manipulated photographs. In addition, some of your original slides or negatives will be so good that you'll want to work on them to produce many variations. These four versions of a nude portrait hardly scratch the surface of the myriad of possibilities.

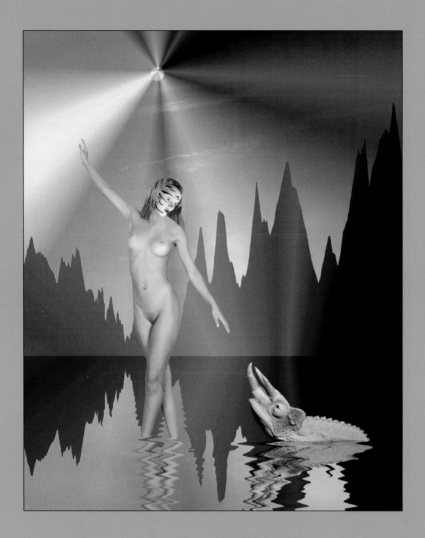

The advantages of owning a large monitor will be obvious when you have several photos open at one time. The desktop gets very crowded, and with a small monitor—15 inches or less—the size of each photo must by necessity be diminutive. Monitors that are 17 to 20 inches are much more conducive to working on complex composites in Photoshop.

This image consists of six photos. While deciding how to assemble them, I displayed them on my monitor along with other images that didn't make it into the final version. My 20-inch monitor made the process much easier because its large size facilitated my conceptualization. I began by using Layer: transform: scale to squeeze and stretch the range of mountains. Then I filled the mountains with a gradient abstract created using Kai's Power Tools. The sky is a combination of a sunset and another gradient design created using Kai's Power Tools. The reflection was made the same way as the one on page 21. The model was pasted into the scene, and then I used the Clone tool to "cover" her feet with the reflected image, suggesting she was actually standing in water. The mask was then cut out and pasted over her face. The original photo of the mask included the glass eyes. Next, I selected only the upper portion of the chameleon and inserted it into the frame. The reflection of the reptile was created for the final touch.

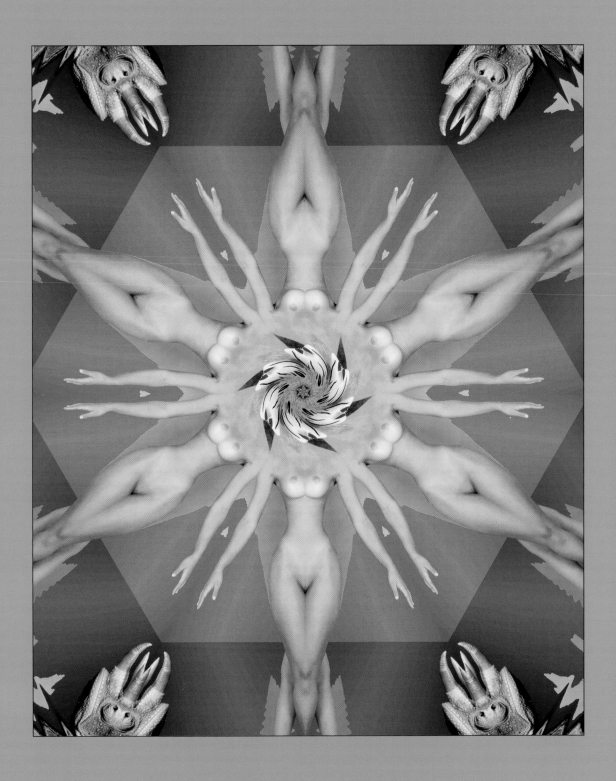

Terrazzo *is an inexpensive software program made by Xaos Tools, Inc. It is a Photoshop plug-in and works like a filter.* Terrazzo *can turn any photograph, or any portion of a photo, into a kaleidoscopic image. As with most filters, you have many options within the dialog box. The kaleidoscopic patterns from which to choose are varied and fascinating, and some of my favorite abstract designs were derived using* Terrazzo. *This example originated from the image on page 18.*

The Computer

When you bought your first camera, you probably thought that the camera body would define the kind of pictures you could take. It didn't take long to realize that it is really the speed of the lenses and their focal length that allow you to take the images you want.

Similarly, the computer is only the starting point. The elements that go inside the computer define how fast you can manipulate images, how much memory it has, and how many peripheral pieces of hardware can be connected to the system. The computer you buy should be expandable. In other words, like cameras that allow interchangeable lenses, your computer should allow you to upgrade its capabilities.

In the Macintosh platform, I would currently recommend either the PowerPC 7300, the 8600, or the 9600. The chip that runs these computers and enables them to process information at very high speed is, at this writing, the 604e. Chips are measured in megahertz, which defines how fast they process information. The most current chip available, the lightning-fast G3, is capable of running two to four times faster than the 604e. Only a few years ago, the processing speeds of these chips would have been inconceivable.

It is very important to have enough RAM in your computer. Think of this item as "computing power." I suggest a minimum of 64 MB, but 96 MB or above is better. RAM increases the overall performance of Photoshop when the program is asked to handle many high-resolution photos at a time. You can actually allocate more of the computer's RAM to Photoshop (or any other program) by clicking once on the program's icon (when the program is closed) and then choosing Command "I." In the dialog box that appears, type the amount of RAM you want allocated to the program in the box Preferred Size. *Never give any one program all the RAM you have, because the operating system requires a minimum amount to operate. I give Photoshop 70 percent of the RAM in my computer.*

This composite is comprised of seven photos. To work on so many photos at one time, a large amount of RAM will enable you to paste the images together without long delays between your command and the computer's execution.

This composite photo began with the background image, the Alaskan mountain range. The reflection was created by copying the upper part of the landscape to the clipboard, then pasting it into the entire frame, flipping it vertically, moving it into position, and then using the Wave *filter to simulate water. I cut and pasted each component into the scene, including the image of the earth obtained free of charge from the Johnson Space Center in Houston (it is in the public domain). I implied movement of the wings of the scarlet ibis by using the* Clone *tool on 60 percent opacity.*

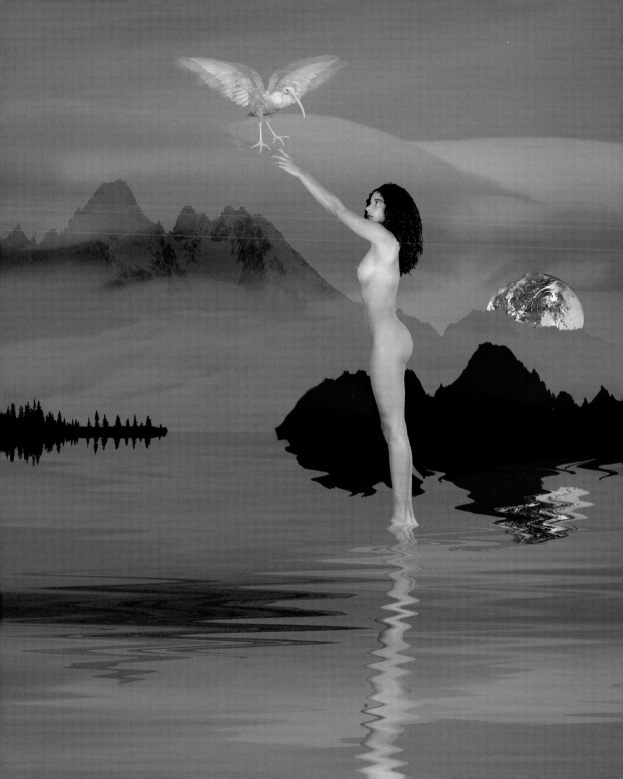

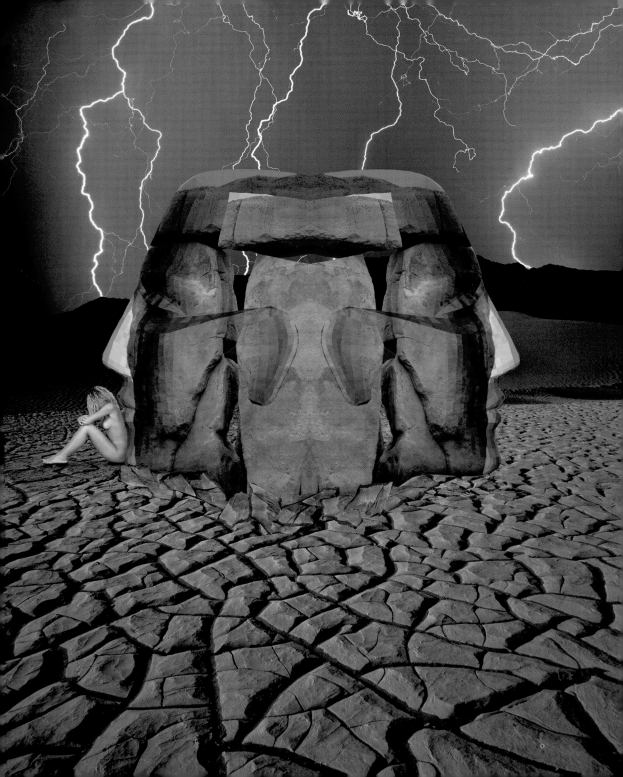

Three-dimensional rendering is possible using a program specifically designed for this purpose. My favorite 3-D software package is MetaCreations Detailer. A two-dimensional photograph can be "texture-mapped" onto a 3-D surface, such as a cube, cone, cylinder, or sphere. Then that image can be combined with other elements to create a very unique composite. When working in three dimensions, your visual thought process is challenged, because an object can be viewed from any orientation—top, bottom, back, and so on.

In this example, a mannequin head was texture-mapped with rocks from Stonehenge using the program Detailer. Then it was imported into Photoshop and cloned to form a mirror image. To create the double, I merely selected the head, copied it to the clipboard, pasted it into the frame, and flipped it horizontally. Moving the second head to align with the original completed the mirror. It was then composited with the model, the lightning, and the desert in Photoshop.

In the IBM world, I recommend any computer using the Pentium II with MMX chip. The IBM clones running on the Pentium are almost as fast as Macintosh computers. Just remember that you will want to add hardware as time goes on. Your computer should have enough SCSI ports (pronounced "skuzzy"), or plug receptacles, in the back to accept new additions to the system.

If you are still vacillating between Macintosh and a PC, keep in mind that most service bureaus that will be doing your scanning and film output are oriented to Mac. Also, it is much more difficult to color-calibrate an IBM monitor (due to the copyrighted ColorSync software used in Apple computers). This means that you must make sure that the colors of the original photograph that you see on the monitor will be the same colors on the digital output transparency or print at the service bureau. Any discrepancy in color (or density) between the scan and the original shot (as you view it on the monitor) can be corrected once you're in Photoshop. However, it is imperative that once you select the color balance on the monitor, the service bureau's film recorder or printer must produce the same results. Having said that, it's important to understand that color matching is not an exact science and sometimes a perfect match is difficult to achieve.

The Hard Drive

Computers store information in the form of positive and negative electrical charges on hard drives. The hard drive's capacity for storage is measured in bytes. Each byte equals one alphabetical letter, one space between words, or one

grammatical mark. In a Photoshop file, three bytes of memory are assigned to each pixel in an image.

When you buy a computer, you have a choice of an internal or external hard drive (will it be contained within the computer itself or will it sit on your desk next to the computer), and you can choose the storage capacity as well. Hard drives are defined in terms of millions (megabytes or MB) or billions (gigabytes or GB) of bytes. I have two internal hard drives and one external one. The typical hard drive storage capacity of most home computers used to be from about 40 to 200 MB. Since the price of hardware has decreased so much in recent years, 1, 2, and even 4 GB drives are now standard equipment. Since one high-resolution 35mm slide consumes 32 MB of storage capacity (and 6 x 7cm high-resolution images equal about 40 MB), it is obvious that if you are serious about working on hi-res pictures (high resolution means that the end product will be as sharp as current technology allows), you will need a larger hard drive. Buy as much storage capacity as you can afford. My hard drives' storage equals 15 GB, although this is overkill even for most professional photographers. The absolute minimum I would recommend is a hard drive with a storage capacity of 1 GB. These are now relatively inexpensive and you will definitely use the space. If you plan on diving into the digital field with a vengeance, I suggest you upgrade to a 4 GB drive. Remember, the hard drive not only stores digitized photographs, but it also holds all of your software programs (like Adobe Photoshop), as well as many other things required to run the computer.

Desktop color printers have come a long way in the last few years. They can now reproduce digital files with remarkable accuracy. The depth of color, the brilliant contrast, and the sharp detail in the prints would have been unthinkable until recently. Now, most original photographs and digitally manipulated images can be rendered close to their appearance on the monitor.

However, a high-end computer can display 16.7 million colors. There are many brilliant as well as subtle hues that elude even the best desktop printers. I used exceptionally intense colors of magenta and yellow in this nude torso, and when I made a print of it, the inks couldn't accurately output the richness of color I saw on the monitor. I would guess that the colors contained in this photo are even a challenge for a commercial printing press. Interestingly, the transparency that was output from the digital file is a very close color match to what I saw on the monitor. The transparent color dyes in slide film are more capable of color depth and intensity than the opaque dyes used on paper.

This photograph, which was manipulated to look like a painting, was created in Fractal Design Painter using first the Mouse/ Impressionist brush and then the New Paint Tools/Palette brush.

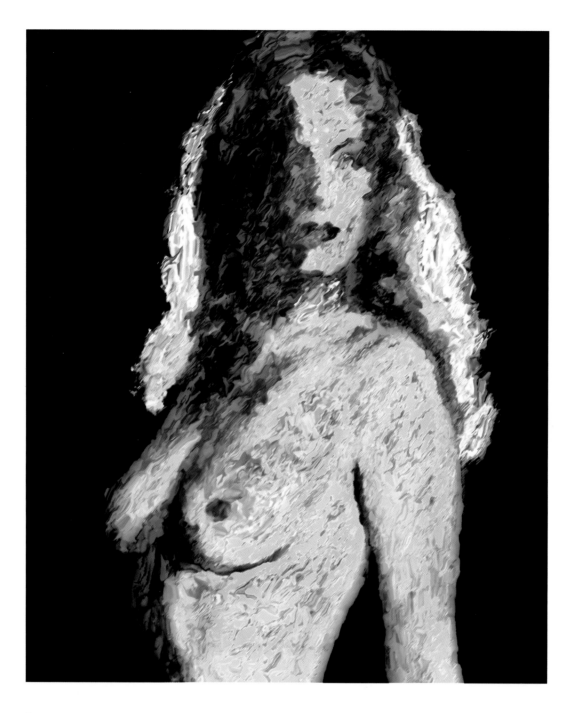

Fractal Design Painter is a unique program that enables photographers to give photographs the look of paintings. A wide variety of "brushes" are available to smear and streak the original color image in an endless number of ways. This portrait was taken against a wall in my studio using two strobes and two soft boxes for shadowless front lighting. Looking at the finished portrait, it is hard to imagine that this started out as a traditional photograph. I used the Smeary Mover Cloner brush to create this portrait and then adjusted the color using Image: adjust: hue/saturation within Photoshop.

RAM

RAM stands for Random Access Memory, and it is measured in megabytes. This is a component that you buy for the computer to enable it to process information. The more RAM you have, the faster it will accomplish the task you instruct it to do. All computers come with a minimum of RAM, and it is up to you to purchase more. The Macintosh 9600, for example, comes with 32 MB of RAM. The minimum amount of RAM that I feel is required to work on photographs is 36 MB. I worked on high-resolution photos for two years with only 36 MB of RAM, and I was able to accomplish everything I needed to do. The processing time was slow, but it got the job done. Compared to the amount of time the same effects would take in a darkroom, a computer running on a minimum of RAM appears lightning fast.

If you can afford to buy more RAM, it will be the single best investment you can make to speed up your computer. 64 MB of RAM will significantly decrease processing time, and 96 MB and above will make your machine really fly. For optimum performance of Photoshop, Adobe recommends that you have three to five times the RAM as the file size you typically work on. For example, if you work on 30 MB photos, the RAM in your computer should be from 90 to 150 MB. But this does not mean you can not manipulate high-resolution photos with less RAM. It just means that the processing time will be longer for each operation.

Virtual Memory

One of the often overlooked secrets in making your computer run efficiently is to turn off Virtual Memory. This is a command that you can find in Control Panels under Memory. Select the "off" mode, and any time your computer runs unusually slow, first check to see if it has inadvertently reverted back to "on."

Portable Media

You will need some means of bringing your completed photo manipulations to your service bureau and taking scanned original photographs home to transfer to the hard drive in your computer. There are several choices. Just make sure the service bureau you will be using can accept the portable medium you intend to purchase.

One of my preferences is a Jaz drive made by Iomega. A small cartridge that holds 1 or 2 GB of information is inserted into the drive, and then digital photos can be copied onto it from your hard drive and taken to your service bureau. This data is then copied onto their hard drive and sent to the film recorder (see chapter two for more about this) to make a slide, or to a printer to make a print. No loss of quality occurs in this transfer from your hard drive to the service bureau's drive.

Zip drives, by Iomega, are another favorite of mine. Each Zip disc holds 100 MB, which is one-tenth the storage capacity of a Jaz cartridge, but Zip discs are significantly cheaper. Zip drives have a reputation for being very reliable. The discs are very thin, which makes sending them through the mail to clients or service bureaus easy.

SyJet by SyQuest is yet another portable medium option. These cartridges are similar to the Jaz system, and they can be purchased in various storage capacities.

CD technology is another good choice as a portable medium. You can not only record

images (and audio tracks) on them, but you can also rerecord over the photos, just like an audio or videotape. CD rerecordable drives are more expensive than Zip drives, but discs are cheaper, and each disc holds about six and a half times more data.

Another choice is a DAT (digital audio tape) drive. DAT tapes are similar to small cassette tapes, and each one holds 4 or more gigabytes of storage. This is an inexpensive medium to transfer and store information. DAT drives are considerably slower than Jaz and Zip drives, and they require you to learn a software program called Retrospect to operate them.

Archival Storage

The last crucial part of your system is a means of long-term storage. Because the hard drive in your computer eventually gets filled up, you will want to have another means of storing all of the scans and manipulated images you accumulate for future use.

DAT tapes are a good method. They not only act as a portable medium for transferring information to the service bureau, but because each tape holds many gigabytes, they can also act as an economical archival storage system. Once in a while a DAT tape can crash, which means it malfunctions and data will most likely be lost. For this reason, it's a good idea to make two identical backup tapes.

The CD format is another alternative. CDs are considered a very stable way to store information for the long term. You will need a CD Recorder to permanently imprint the digital information on a CD-R disc. Alternately, using a CD ReWriter, data can be recorded on a CD-RW disc, and you can write over it at will. At present, each disc holds 650 MB.

I categorize my CDs into three groups: (1) master scans, (2) film outputs, and (3) components. Master scans include original photographs that have been scanned but not yet manipulated. These include sunsets, mountain ranges, wildlife, models, travel locations, and so on. Film outputs are the images that I've already turned into slides. I store them because in the future I may want to make additional transparencies from the digital files or possibly use the image in conjunction with other photos. Components are pieces of pictures, abstracts, and images that I've cut out of their original backgrounds. Seventeen to 20 high-resolution photos of approximately 40 MB each can fit on one CD.

Each CD in my collection has a printed index page in a loose-leaf binder that corresponds to all the photos on the disc. In this way, I can quickly browse through all of my digital images when I'm compositing images or looking for a conceptual shot for a client. In creating the photography for this book, I constantly referred to my CDs to look for backgrounds and components to combine with the nude models.

Printers

Desktop color printers have come a long way in the last few years, and you can now produce excellent quality prints up to 11 x 17 inches for a relatively modest investment. Epson, Canon, Apple, and Hewlett Packard all make excellent printers. If you are happy with prints no larger than 8-1/2 x 11 inches, there are several very affordable printers that produce superior images on paper. Having said that, however, you must appreciate that many desktop printers do not deliver photographic-

quality prints (meaning they aren't as good as an actual photograph made from a negative or slide).

In choosing a printer, always make sure you see some examples of color photographs printed on good-quality paper before making the decision to buy. The resolution you will want to maintain for optimum results is at least 720 dpi (dots per inch) of printer resolution. This defines how many dots the printer is capable of putting down on the paper in one linear inch.

When assessing the quality of desktop printers, you must understand their limita-tions. Some colors are difficult for a desktop printer to reproduce accurately. Black, for instance, is not as deep and saturated as you see in the image on your monitor. Unusual shades of color like lime green, mauve, and bright red are also hard to achieve on paper from the inks used in the printer.

Wacom Tablet

I would be remiss if I didn't mention the Wacom tablet I use instead of a mouse. For working on the fine details of a photograph, I find a mouse to be awkward and imprecise. A Wacom unit consists of a tablet and a stylus, which is used like a pen. The stylus (or pen), when it makes contact with the surface of the tablet, moves the cursor on the monitor, just as a mouse does. When I want to single- or double-click, it's simply a matter of touching the stylus once or twice to any place on the tablet. Of the three sizes available, I find the 6 x 9-inch tablet most convenient. Once you get accustomed to working with a Wacom pen, it's difficult to go back to using a mouse.

CD FILM OUTPUTS 57

I keep track of the images stored on CDs by designing pages in Photoshop that show which photos reside on each disc. Once the photographs are written to the CD, I free up the space on my hard drive by dragging them into the trash. The pages are printed on my desktop color printer, an Epson, and then stored in a loose-leaf binder.

2 Inputting Your Photos

When your computer is up and running, you will be anxious to start manipulating photographs. It is time to have your first encounter with a service bureau.

Matching Portable Media

In chapter one, I discussed some of the hardware components necessary to transport digital information back and forth from the hard drive on your computer to the service bureau's. It is very important that the portable medium you have, whether it is a Jaz drive, Zip drive, DAT tape drive, a SyQuest, or any other type of unit, matches what your service bureau uses. If you have a Jaz drive and they don't, you won't be able to transfer information back and forth.

In some cases, even if you have the same medium, you may not be able to transfer data back and forth if the hardware was manufactured by two different companies. For example, I bought a Micronet DAT drive in 1991. When I tried to bring a DAT tape to my service bureau, they couldn't read it because their DAT drive, purchased two years later, was made by APS, another manufacturer. The solution in this case was to bring the Micronet DAT drive to my service bureau where they connected it to their computer and accessed my images. Make sure whatever you buy as the portable medium is completely compatible with your service bureau's equipment.

Portable media are used to bring completed digital files from your computer to a service bureau or to transfer new scans from their computer to yours. Before making a purchase, be sure the unit is either identical to or compatible with the equipment owned by the service bureau.

These two very different interpretations of a nude were saved on a DAT tape which served as archival storage for me before I began using CDs. When I wanted to output the slides, my service bureau couldn't read the information, because their DAT drive was manufactured by a different company. I solved the problem by bringing my Micronet DAT drive to their facility and connecting it to their computer to transfer the digital information directly onto their hard drive. An alternative would have been to bring my external hard drive into the service bureau for the same purpose.

Curves in Photoshop was used to create the wild colors. For the photo on top, I added a gradient to the background to simulate a strobe on seamless paper. For the photo on the bottom, I used Image: adjust: hue/saturation *to change the color scheme, then selected a portion of the model's body, defined a pattern with it, filled the background with the pattern, and applied the distortion filter* Polar Coordinates *only to the background.*

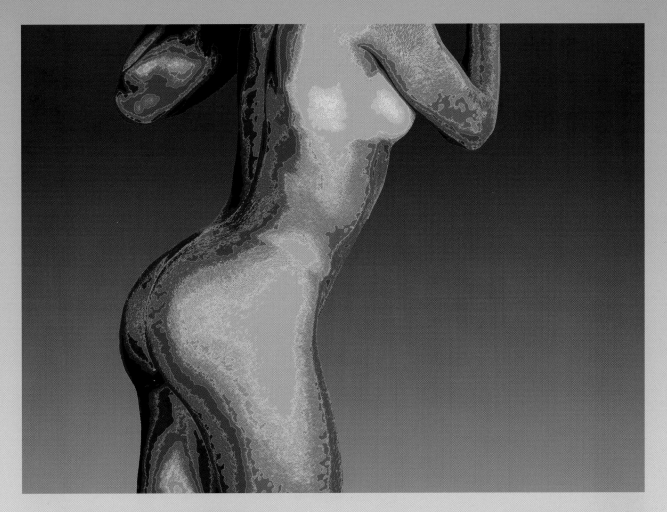

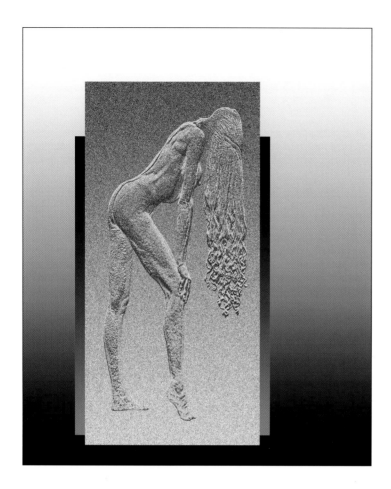

Desktop flatbed scanners are often used to digitize black-and-white as well as color prints. They are relatively inexpensive, and they will save you the time and money of having to use a service bureau to scan your photographs. It is very convenient to scan photographs into your system right from your desktop.

Even though the higher-end units can produce high-resolution scans, the inherent problem with scanning prints is the double-magnification issue. When a print is enlarged from a negative or slide, it is magnified once. When that print is scanned and then output to another print, it is enlarging an enlargement. This results in a significant degradation of quality that should, if possible, be avoided. It is far better to scan the original negative or slide. Some flatbed scanners, such as the Agfa Arcus II, can do this, and the quality is quite good. Having said this, professional scans for high-end use are obtained from either a Leaf 45 scanner or a drum scanner.

This black-and-white graphic image was originally a color transparency that was scanned on a Leaf 45. It was then converted to black and white in Photoshop (Image: mode: gray scale), the Emboss filter was applied, the figure was stretched using Layer: transform: scale, and then a white-to-black gradient was added to the background.

Hi-Res Scans

Your objective with digital manipulation should be to retain the highest degree of sharpness possible. Obviously, a digital scan is a second-generation image, and like a duplicate slide, it won't be as sharp as the original. Similar to the duplicating process, where there are high-quality dupes and lesser-quality dupes, there are high-resolution scans and lower-res scans. The more pixels you have in a scan, the higher the resolution and the sharper the picture will be. To fully understand this, think of a diagonal line comprised of small squares, like steps. Each step represents a pixel. As you increase the number of pixels in the line, the steps become smaller and smaller until, eventually, the line looks perfectly smooth. With ten pixels, the diagonal looks like a staircase. But with 1000 pixels, the same length appears smooth.

How many pixels are required for a high-resolution photo? It depends on what your final output will be. If you are writing the image to 35mm slide film, then the answer is given in the pixel dimensions of the actual area of the film. A 35mm slide or negative is 24 x 36mm. This translates into 2732 x 4096 pixels, which is 32 MB. These pixel dimensions (what is required to fill the frame with a digital image) were given to me by my service bureau. These are important numbers to remember when outputting transparencies. If you use an inexpensive scanner that gives you significantly less resolution, the final output slide will be less than sharp.

When your digital files are converted to prints, dpi, or dots per inch, is the designation used to define the resolution. Within Photoshop, you can specify the resolution in dpi as well as the size of the final print in inches. The many printers on the market have a wide variety of capabilities in reproducing photographs. For example, my service bureau's 3M Rainbow printer uses file sizes at 350 dpi. Some small desktop color printers require digital files to be defined at 150 dpi. An 8x10-inch print at 150 dpi is 5.15 MB. The same print at 350 dpi is 28 MB.

If you are shooting medium format, such as 6 x 7cm, and your objective is to produce digitally manipulated transparencies, the file size for a hi-res scan is 38.4 MB. The correct pixel dimensions are 3277 x 4096. The scan you receive from the service bureau should be close to this dimension, but it won't be exact. You must then resize the digital file before you work on it (more about this in chapter three).

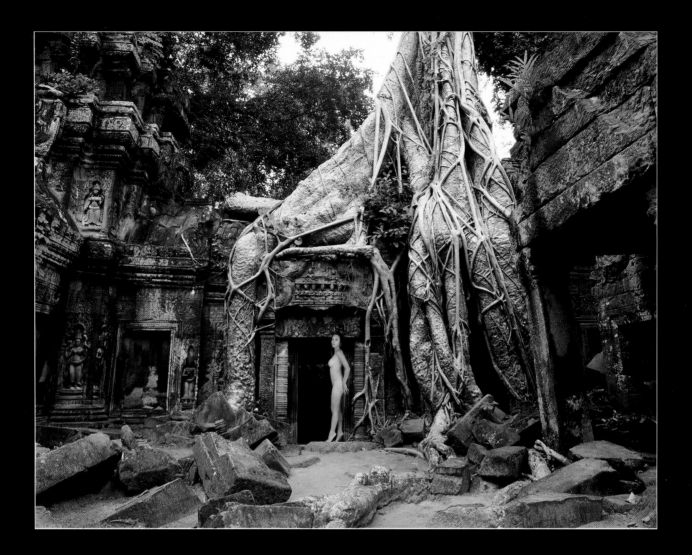

High resolution is especially important when you are working on photographs that contain a lot of detail. Portraits, fashion shots showing clothing, landscapes, architecture, and textures of many kinds demand that the scans you use exhibit as much detail as possible.

This composite of the ancient temple complex of Ta Phram in Cambodia is rich in both detail and texture. The impact of the photograph would be seriously degraded if it hadn't been professionally scanned. Using Photoshop, I cut out the model, who was photographed standing in a doorway, from her original background using the Pen tool and pasted her into the door of the temple. Using Layer: transform: scale, I sized her to fit in the proper proportion.

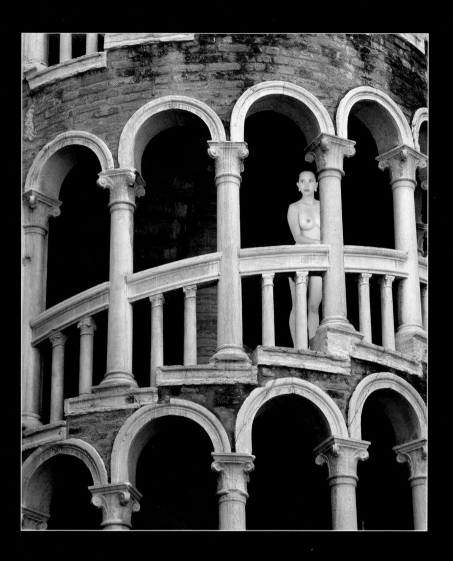

High resolution is only one of the advantages of using professional scanning equipment at a service bureau. The next most important quality advantage is a wide range of tonal values in the scanned photo. While many inexpensive desktop scanners offer to scan your slides and produce hi-res files, the detail in the shadow and highlight portions of the photograph may be lacking. In other words, there is a gain in contrast. The shadows may look solidly black, and the highlights will often appear to be washed out.

An example of an image that would suffer if the scan were to gain too much contrast is this shot of Scala Contarini del Bovolo (snail staircase) in Venice, Italy. The subtle brickwork seen in the deep shadows through some of the arches would have been lost. The photo of the model might have been degraded with an inferior scan due to lost detail in the light skin. If it were washed out, the texture and the subtle contours of the surface of her body could be lost. Even though the young woman appears small in the frame, photo-realism frequently depends on subtle factors like these.

Scanners

There are basically two types of scanners that turn a photograph into a digital file: transparency scanners and flatbed scanners. The former scans slides and negatives, while the latter scans photographic prints (some models can do both). High-end transparency scanners are very expensive, while flatbed units are affordable for most computer owners.

All of the original images in this book were scanned by my service bureau using a Leaf 45 transparency scanner. The scanner is capable of scanning 35mm, medium-format, and 4 x 5-inch films. I like the Leaf 45 because it produces high-quality scans and because my originals do not have to be immersed in oil. Drum scanners offer the highest quality scans, but they are significantly more expensive, and some of them require that the transparency be immersed in oil before it is pressed against the glass drum. This does not hurt the film, since it is washed with the appropriate cleaning agent afterwards. But it is unnerving to see a prized original go through this process.

35mm slide scanners are available for home use and are reasonably priced. They provide decent scans, but the range of tonal values is usually not as good as when a high-end scanner is used. This means that detail in the shadows may be lost by going black, while

The brilliant colors you see on the monitor as you manipulate each photo can indeed be exhilarating. When I was a child, the 64 colors in a box of Crayola crayons excited me. Now, computers offer 16.7 million colors. With filters like Solarize *and* Psycho, *and with the ability to increase the saturation of color to dazzling intensity, brilliant, neon-like colors as well as the most subtle of tones can be seen on the monitor.*

RGB, or red, green, and blue, is the typical color mode used in photo-manipulation programs. However, desktop printers as well as commercial printing companies use the color system CMYK, or cyan, magenta, yellow, and black. When you convert the rich colors in RGB to CMYK, there is a tendency for some of the hues, particularly the bright greens, magentas, and purples, to become desaturated. It is also possible that a color shift occurs, where some or all of the colors no longer accurately represent the RGB version of the photograph.

This image is an example of the type of picture that is difficult for a printing press or desktop printer to accurately reproduce. The intense yellow skin tone isn't a problem, but the colors in the background and in the hair require special attention. A fifth or even sixth color (i.e., a fifth or sixth plate on the press) may be necessary for a commercial printer to match the paper product with the digital file or the color transparency.

I used Fractal Design Painter to turn this photograph into what looks like a painting. The Cloner *brushes I used were* F/X Bubbles: Deep Well *and* Impressionist: Drip. *I then brought the image into Photoshop and used* Image: adjust: hue/saturation *to increase the intensity of the colors.*

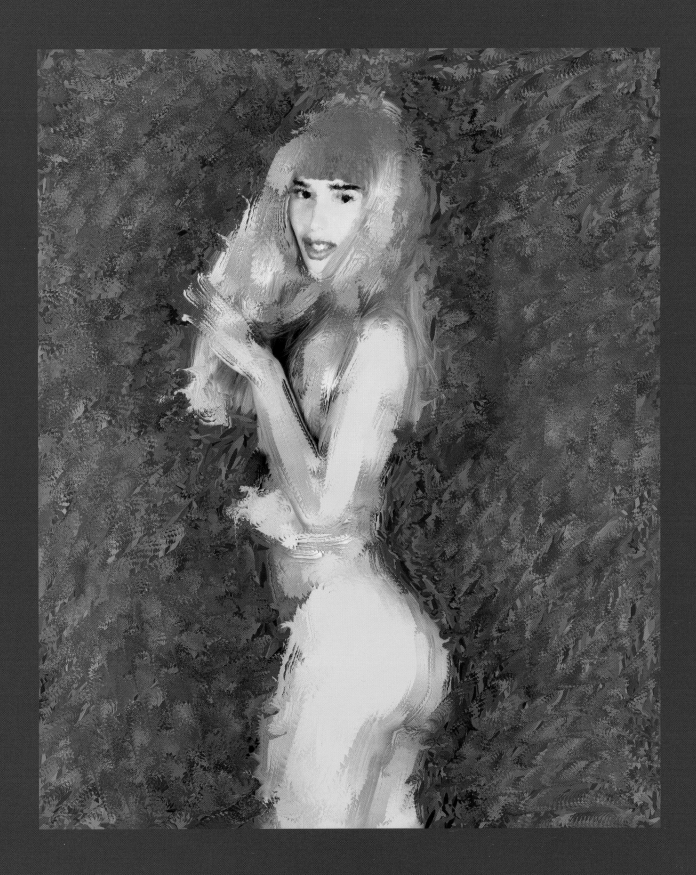

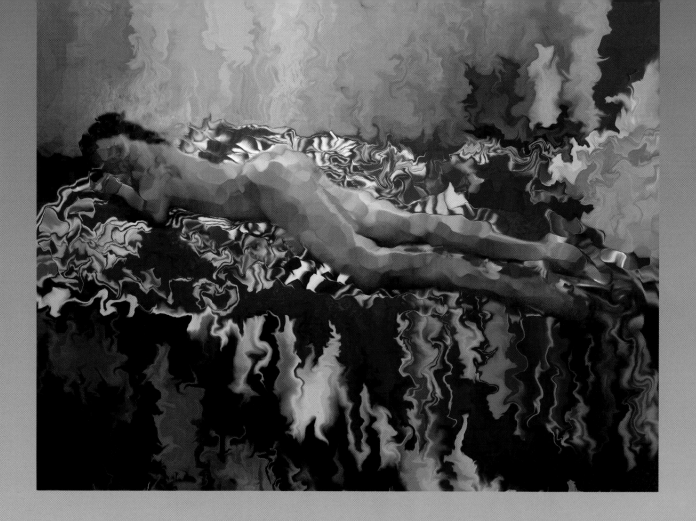

Some of the digital techniques applied to photographs don't necessarily require high-resolution scans. When the colors and shapes within a photograph are distorted to simulate impressionist art, such as this nude, fine detail in hair and skin texture is irrelevant to the success of the picture. Even though I do have all my transparencies scanned at 40 MB, this kind of painterly, abstracted technique can be applied successfully to slides or negatives that have been scanned by desktop scanners or by using the Kodak Photo CD format.

It is interesting to note that when I took this picture, my flash equipment failed to fire due to an improper connection. The ambient illumination came from a ceiling light. I only had one frame of this particular pose, and I wanted to work with it. The shot was two f/stops underexposed, yet within Painter I could turn it into a work of art. Even when a photo is technically flawed but still has the compositional elements to make it a strong image, you can work with it and sometimes salvage a shot that otherwise would have been discarded.

I used two different Cloner brushes for this image. Gooey: Bulge abstracted the model, while Gooey: Turbulence altered the background. If you look closely, you can notice the two different strokes. Then, using Effects: tonal control: adjust colors, also within Painter, I altered the colors and increased their saturation.

subtlety in the highlights may be washed out. Some service bureaus can scan onto Kodak Photo CD discs. These scans are very inexpensive (usually three dollars or less), but the quality is not as good as a Leaf or drum scan. They don't offer the same range of light and dark tones nor are they as sharp. For photographs that are to be reproduced in brochures and flyers, this is quite acceptable. However, when you intend to output to transparency film or make quality prints, I would not recommend this type of scan.

Flatbed scanners allow you to scan photographic prints onto your computer's hard drive. On the higher resolution settings, these scans are quite good, although they are not as good as scans made from negatives or slides. A print is not only second generation, it has been enlarged. When you work on a scan made from an enlargement, and then enlarge it again in the printing process once the manipulation has been made, the effect is a double enlargement. This means that the quality of the original has been seriously degraded. If you shoot primarily negatives, have the service bureau scan the original negative instead of the print.

Calibrating Your Monitor

Before you begin manipulating images, it is essential that you calibrate the color of your monitor to the service bureau's film recorder. A film recorder is the device which takes the digital file of the photo you've created and transfers this information to film, resulting in a slide or negative. If you don't take the time to calibrate, the color and density you see in the im-ages on your monitor may not be the same color and density of the final output.

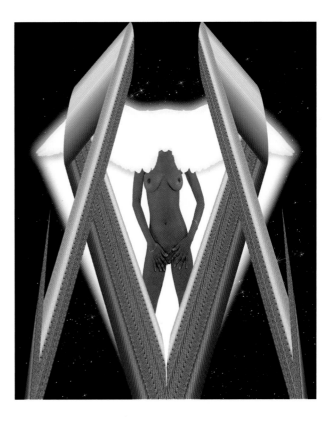

The importance of calibrating your monitor to match the film recorder at your service bureau can not be overstated. There is no point in spending time to choose the precise color scheme and density of an image on the monitor only to be disappointed when you see that the film output doesn't match. Take the time to adjust the gamma on your system until you are satisfied that your monitor matches the test slide provided by your service bureau.

This is particularly important with skin tones. If the skin coloration of a model is off color on the film or print output, the picture will simply not be acceptable unless you purposely want to make an artistic statement. This composite is an example where I chose the skin coloration to blend with the surreal environment, rather than strive for realism. However, even here, calibration is important to prevent an unwanted color shift.

Here's how the process works. The service bureau should give you a calibration test image. This is a transparency that exhibits a large range of bright colors as well as clean whites and rich blacks. They should also give you the digital file of this image. When you bring the test image up on your monitor, you view the transparency on a light table that is color corrected to daylight illumination, which is 5500 degrees Kelvin (you could also use a white poster board in sunlight outside a window as a means to view the slide). As you compare the two images, you adjust the gamma of the monitor until the image on the screen matches the color and density of the transparency as closely as possible.

What and where is gamma? The gamma feature is built into the program Adobe Photoshop and is a way for you to adjust the color balance and brightness level of your monitor. You'll find the *Gamma* dialog box under the sub folder "calibration" in the Adobe Photoshop folder on your hard drive. When you double-click on the gamma folder, it opens up and you'll see slider bars for adjusting the color. As you move the slider bars, the color balance of the monitor changes, allowing you to match the two images. If you need help in this, ask your service bureau for guidance. They want your business, and they should be willing to walk you through the process.

RGB vs. CMYK

There are two color modes that computers use to derive color. They are RGB (red, green, and blue) and CMYK (cyan, magenta, yellow, and black). Photographers who output their work to slide film always use RGB. This mode offers the most brilliant and saturated color, even in challenging areas like hot pink, peach, lime green, and blue-purple. Printers who take digital files and reproduce them on paper for calendars, posters, books, greeting cards, brochures, and other paper products must use CMYK.

When a beautifully colored photograph created in RGB is converted to CMYK for reproduction, sometimes the saturation of certain colors is lost, and other times there is an actual shift in hue. Printers try their best to correct any loss, but with certain colors it is impossible to fully adjust the combination of CMYK inks to faithfully match the original RGB colors. When other people see the finished printed piece, most aren't aware of any change. The photographer, however, is often disappointed in the alteration of the original colors.

With the addition of extra colors, some or all of this change can be corrected. For example, if a particularly intense shade of red would be lost when RGB is converted to CMYK, a fifth color—red—can be added. This means that instead of printing with just the normal four process colors of cyan, magenta, yellow, and black, a fifth printing plate is made that is responsible solely for laying red ink onto the paper.

Outputs

You have several choices with respect to how the digital file is output. Most service bureaus will produce a 35mm slide or negative and a 4 x 5 transparency. Very few also offer a 6 x 7cm transparency output, which is the format I use (Imagitech is one of the few companies that offer this service.)

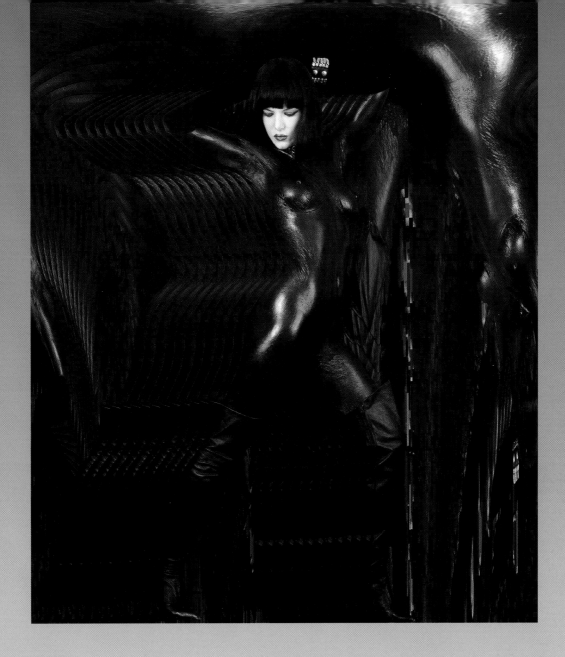

This nude study was unique with respect to the other images in this book. The model was covered with three coats of liquid latex. Each coat was dried with a hair dryer before applying the next one. The black latex was thin enough to show every detail of her skin, yet it allowed complete freedom of movement without tearing. I used two Zap 1000 strobe units and two white umbrellas for illumination. The original background was solid blue.

In Photoshop, I selected the model by first choosing the blue background with the Magic Wand tool and then hitting Select: inverse. Then I held the option key down and offset the image with the Move tool. This created multiple images, one over another.

Next I used the Marquee tool to select part of the latex, and then I made a pattern with it by choosing Edit: define pattern. This pattern was pasted into the background with Edit: fill (and by using Pattern in the dialog box). With the background still selected, I used Filter: style: extrude and then Filter: distort: polar coordinates to abstract the pattern behind the model. In Hue/Saturation I altered the color scheme slightly to complete the image.

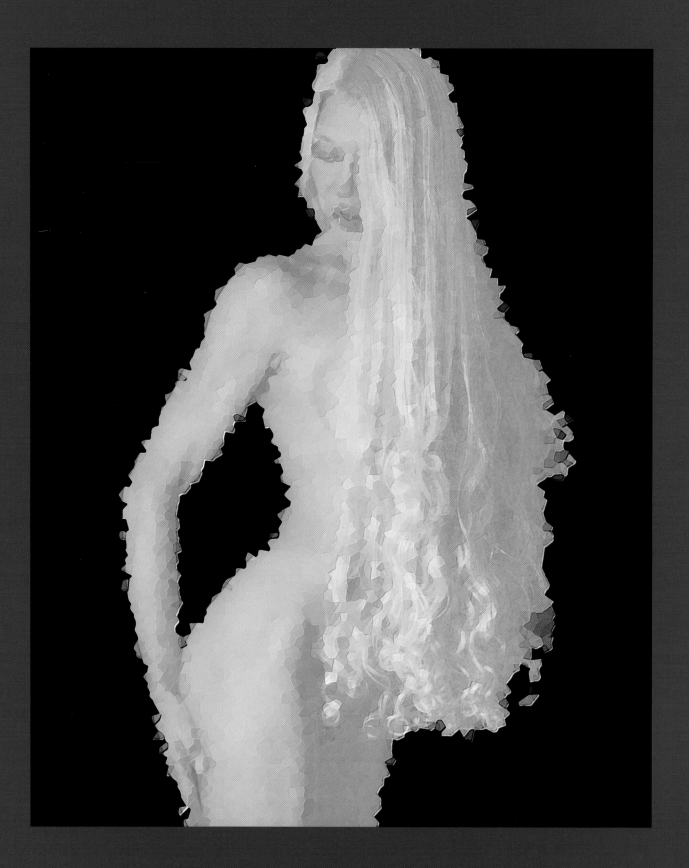

Desktop printers available for under $500 are excellent for most middle-toned images. However, when they are faced with the challenge of an image that has solid black components, don't expect the combination of inks and paper to reproduce the dense black you see on the computer's monitor. I use black backgrounds frequently because they drama- tize the colors and the form of the subject.

This portrait was first altered in Photoshop by applying Filter: artistic: neon glow. *Next,* Filter: pixelate: crystallize *abstracted the image into small chunks. I saved the image at this point, then applied* Filter: stylize: emboss. *The* Emboss *filter rendered the image in tones of gray while creating a relief effect. The em- bossed picture was saved to the clipboard, and then I chose* File: revert. *The saved version of the photograph returned, and I pasted the embossed image over it. In the* Layers *palette, I used 33 percent opacity and chose the* Hard Light *mode.*

There are also a number of options you have regarding prints from the digital files. A dye sublimation printer, the 3M Rainbow, offers a maximum size of 11 x 17 inches, and prints are of photographic quality, meaning they look as if they were made in the darkroom using conventional means of photographic printing. Fujix printers are considered even better than Rainbows because of their ability to reproduce a wider spectrum of color with great accuracy. I have made many prints from both printers, and my preference is the Fujix. The outputs are exquisite.

Some service bureaus and digital imaging companies also offer Iris prints. These exquisite prints are expensive, but they are definitely worth the money. They can be made on any kind of art paper, as well as on a piece of can- vas, fabric, or even mylar. The largest Iris prints are 35 x 47 inches.

A new machine called the Light Jet 5000 from Cymbolic Sciences will take a digital file and transfer the information directly to photo- graphic paper. At this time, few labs offer this service. The largest print is 50 x 50 inches. After exposure, the paper is developed normally.

If you are publishing a poster, calendar, post- card, flyer, or brochure that uses color photos, the digital file is used to create the color sepa- rations that a commercial printer uses to make the actual printing plates for the press. Some service bureaus that do pre-press work offer this type of output. If your bureau doesn't make color separations, any printing company will be able to take your digital file and output it to the separations.

3 Adobe Photoshop

Now that we have discussed the hardware you need to get started with digital imaging and important aspects of working with a service bureau, it is time to delve into perhaps the most brilliant computer program of the decade—Adobe Photoshop. Although there are a number of other programs that permit you to alter photographs, my recommendation is that this is the one you should own.

When you first purchase the program, it must be installed on your hard drive. Insert the CD-ROM that contains Photoshop into your CD drive, and then simply follow the instructions that appear on the monitor for a successful installation. If you have any problems, call Adobe's technical support. The number is listed in the instruction manual.

Learning Photoshop

Every computer program on the market today comes with a thick instruction book that tells you how to use it. Adobe Photoshop is no exception. The amount of information provided is overwhelming. Trust me, there is no way you can sit down and read the entire book and be an expert in photo manipulation. There is simply too much information to digest and absorb in a short time.

I found that the easiest way to learn Adobe Photoshop was to preconceive a particular effect and then find out how to do it in the computer. For example, I knew how to make a sandwich with two slides in conventional photography, so one of the first things I wanted to learn was how to achieve this familiar photographic technique using Photoshop. Then I

With the Paintbrush *tool or with the pull-down menu* Edit: fill, *Photoshop will fill a selected portion of a photograph with the color that appears in the foreground color box near the bottom of the* Tool *palette. The model posing dramatically with a bow and arrow was photographed originally with even front lighting in the studio. To make sense as a component at twilight on the Oregon Coast, she had to be transformed into a silhouette. I selected the model with the* Pen *tool and using* Edit: fill, *I filled the selection with black. The silhouetted figure was then copied to the clipboard and pasted into the background. Using* Layer: transform: scale, *I sized the model to fit proportionally.*

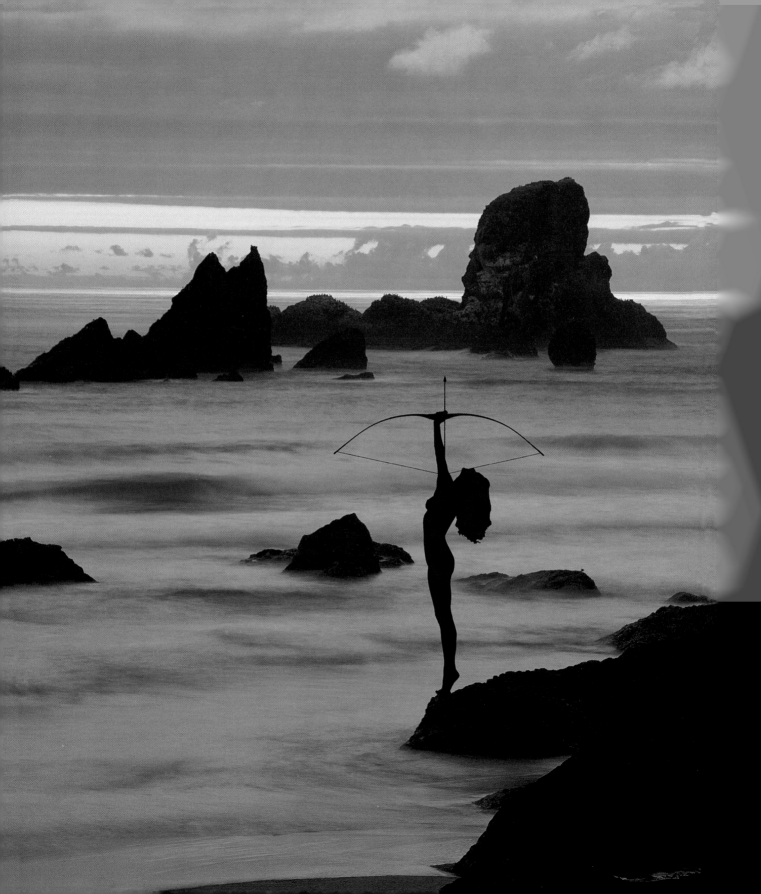

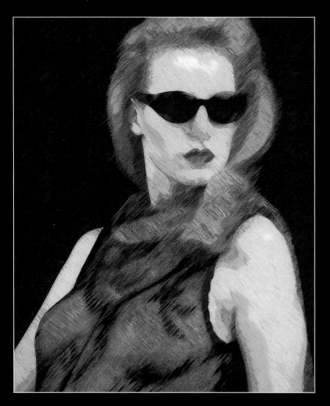

Filters are a very important part of Photoshop. I use them all the time and anxiously await new filters that become available. This one is called Angled Strokes. It can take a long time for the computer to process the effect, particularly when working on high-resolution files. This one took about three minutes with my very fast computer.

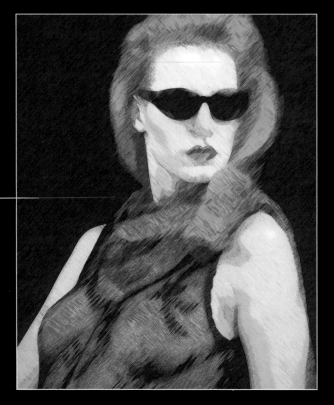

I use Image: adjust: hue/saturation a great deal to change the color relationships in a picture. This variation is only one of virtually an infinite number of possible color relationships that can be achieved simply by working within the dialog box. From ultra-saturated surreal colors to subtle tones simulating a sepia-toned black-and-white print, you can define the nature of the image solely with this one tool within Photoshop.

wanted to know how to make a double exposure. Once I learned these techniques, I went on to discover how to create sepia-toned images, posterizations, various textures, subtle color changes, and so on. In other words, I started with photographic effects I was familiar with and learned how to do the same thing in Photoshop. From there, I expanded my knowledge of the program.

In addition to the manual that comes with the program, there are several excellent books available that teach Photoshop. These are available in most bookstores. Most of us, of course, hate the long hours required to plow through this material. There are videotapes available through Mac Academy in Florida (1-800-527-1914) that make the learning process much less painful. I have found them to be professionally made and very helpful, and they are applicable for both Macintosh and Windows users.

When you find a particular operation that you know will be used over and over—such as *Flip Horizontal* (where the image or a selected portion is flipped left to right) or *Hue/ Saturation* (where you can alter the combinations of colors of your image, increase and decrease the saturation of those colors, and alter the brightness)—you should write down its location so you can quickly find it again. After a while, these locations will be second nature to you. But at first, there are so many commands that it will seem confusing. Learning the shortcut commands may be easier, and they

are certainly faster. For example, bringing up the *Hue/Saturation* dialog box, which I use all the time, is simply Command "U" (Control "U" for PC users) on the keyboard. To change the contrast of an image, Command or Control "L" immediately displays the *Levels* dialog box.

The Program

Adobe Photoshop will change the way you see photography. When you first learn a few of the tools and techniques that are available to you, I promise that your blood pressure will rise in sheer excitement! Over time, as you explore the depths of the program, your appreciation for its capabilities will know no bounds. This incredible program allows you to do almost anything to a photo that your mind can imagine. Every few months Adobe comes out with an upgrade that adds features and increases its abilities.

Once you have a slide, negative, or print scanned by a service bureau or with your own desktop scanner, you must open Photoshop in the computer by double-clicking on the icon of the program. I will begin by introducing you to many of the fundamental tools and menus that you will use all the time. In subsequent chapters, I will delve more deeply into Photoshop's depths.

It is easy to learn the tool bar. Each tool performs a certain function that helps you accomplish whatever change you want to make to the photo. Following are some of the more important tools.

Magic Wand: This tool selects a portion of the photo based on similarly colored areas. Once selected, you can alter only that part of the image without affecting the other parts. For example, if you want to darken an over-exposed sky or alter the color of a sunset, you can select the area to be changed and make the adjustment without altering the landscape. Or, you could change a brown eye to blue without making the rest of the face bluish.

Magnifier: You can enlarge any portion of the photo to examine it in detail. When working on small areas of an image, you will want to blow them up many times for accuracy and precision. In the example above, where eye color was changed, you would want to magnify the eye many times for complete control of the placement of the new color.

Clone (or Rubber Stamp): With this tool, you can copy, or clone, any part of an image onto another portion of the same or another photo. A simple example would be removing a freckle from a face by cloning clear skin over the area that has the freckle. Unattractive power lines can be eliminated the same way by cloning the background immediately behind the wires on top of them.

Similarly, you can change the shape of a nose, or take inches off the waist or thighs of a model simply by cloning the background over the parts of the body you want eliminated. The *Clone* tool is one of the most useful tools in Photoshop.

The Clone *tool (often called the* Rubber Stamp *tool) is usually used to remove blemishes and wrinkles from skin, to restore cracks and missing portions of old photographs, and to blend an image with a background. In this photograph of an apparent approaching storm, I used the* Clone *tool to create a tornado. I began with a shot of a black storm cloud. Using the* Clone *tool, I cloned portions of the cloud downward until I had formed an apparent funnel. Then I pasted into the sky two different images of lightning. In the* Layers *palette, I chose the* Darken *mode to blend the lightning with the storm cloud.*

The landscape was the next component I added. Everything above the horizon line was selected using the Magic Wand *tool, and then the stormy sky was pasted into the selection. In* Image: adjust: color balance, *I changed the original tone of the landscape (which was shot at sunrise) to match the angry sky. In* Image: adjust: levels, *I lowered the contrast of the land as it would appear in this kind of light. I also darkened the bottom portion of the picture.*

The last element was the model. She was simply cut out of the original studio environment using the Pen *tool and then pasted into the photograph. Using* Color Balance *and* Levels *as described above, I adjusted her color and contrast to match the scene. With the* Burn *tool, I added a small drop shadow along the part of her body in contact with the grass.*

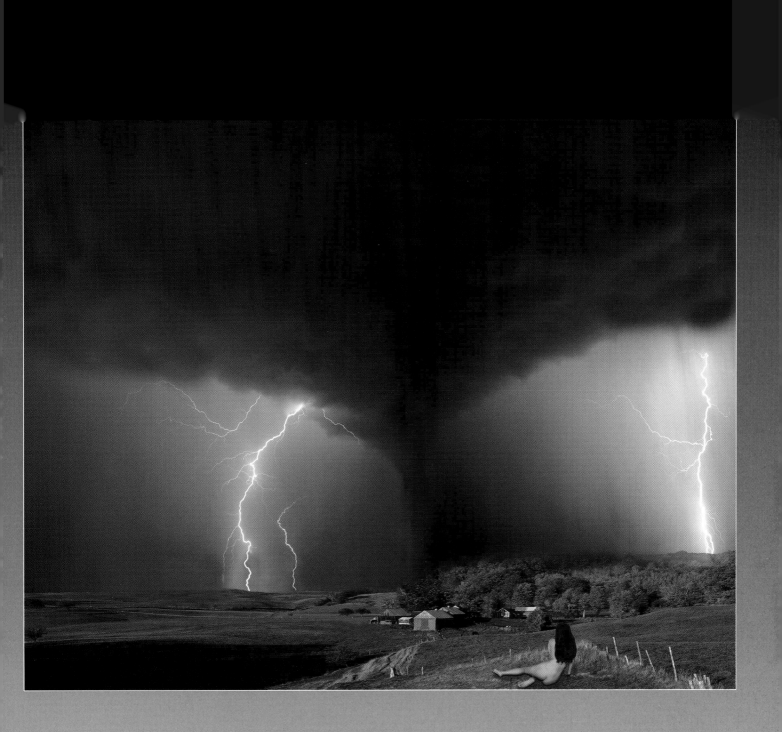

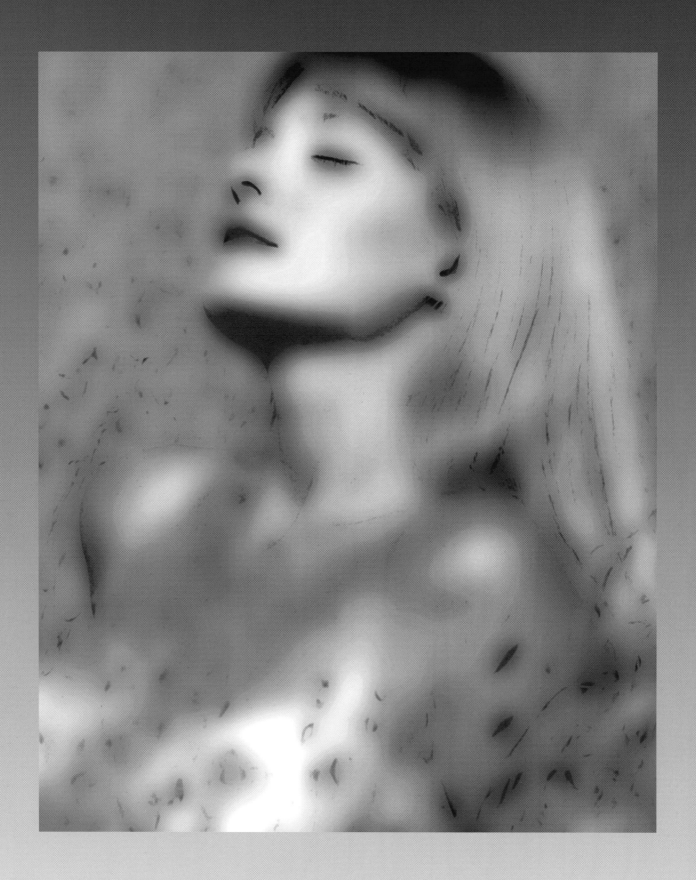

Airbrush: Any color can be applied to the photograph. You can select the width of the spray nozzle, as well as the hardness or softness of the edge of the sprayed color. In addition, you can adjust the opacity of the new color, so some of the detail in the image can be seen through the applied color. I use this tool when I want to apply makeup, such as eye shadow and blush, to the face of a model.

Paintbrush: Very similar to the *Airbrush* tool, this tool applies any choice of color to a photo. Both the *Airbrush* tool and the *Paintbrush* tool take their color from the foreground box, which is the left-hand box of color just below the two columns of tools in the *Tool* palette. By clicking once on this box, a *Color* dialog box appears, and you can select any color desired. Click *OK*, and the foreground box is filled with the chosen color.

Cropping: You can crop any image in any proportion.

Burn/Dodge: Just like in the darkroom, you can increase or decrease density in any portion of an image. The icon in the *Tool* palette toggles back and forth between the *Burn* tool and the *Dodge* tool. I use them for lightening shadows when more detail is desired and darkening highlights when I want to eliminate distracting hot spots. I also use the *Burn* tool for creating shadows when I place a model into a background. By adding a subtle shadow behind the body of the young woman, she appears to be a part of the scene, rather than cut out and pasted there.

The *Dodge* tool, on the other hand, can be used to lighten the whites of eyes, to lighten wrinkles in the skin, and to reveal detail in areas of a photo that are underexposed. With both the *Burn* and *Dodge* tools, you can control the number of pixels affected and the opacity of the change in density.

Every time you double-click on a tool, a small dialog box appears which gives you options to control the tool in specific ways. As you use the tools, experiment with the various options so the full functionality of each tool is at your disposal.

A filter can be applied more than once to the same picture. The effect is multiplied, and often the image appears more like a painting than a photograph. This portrait was taken outdoors in tall, dry grass in late afternoon sunlight. I applied Filter: blur: Gaussian glow *four times until I was satisfied with the amount of diffusion. This filter is available from Kai's Power Tools.*

The original color balance was warm due to the yellow grass and the low-angled sun. In Hue/Saturation *I moved the* Hue *slider bar toward the magenta portion of the spectrum to create the dreamy feeling you see reproduced here.*

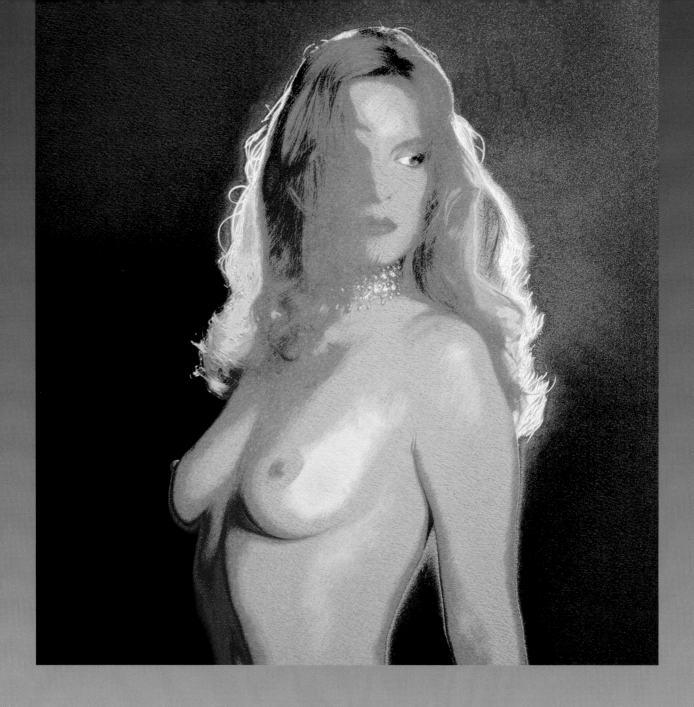

Posterization is a special effects darkroom technique where a photograph is reduced from contin-
uous tones to only a few defined areas of tonality. In black and white, a print may have only three
shades of gray plus black and white. In color, a posterized print may break a photo up into only
five or six defined colors.

 In Photoshop, you can do in a second or two what it takes several hours to do in a darkroom.
Image: adjust: posterize *is the command I used to transform a normal, continuous-tone nude por-
trait into a posterization. In the dialog box, I chose "eight levels" of tonality. Anything less than
this means the image will break up into a bold graphic design.*

 I filled the background with green using Edit: fill *and darkened selected portions of it using the*
Burn *tool. As a final touch, I added a grain texture by choosing* Filter: noise: add noise. *In com-
puter lingo, "noise" is the same as grain.*

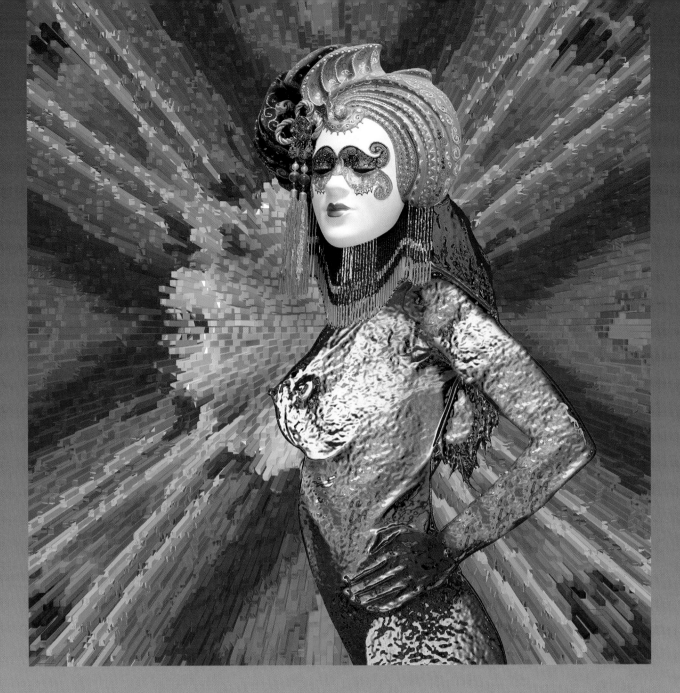

Two different filters were used to create this wild image. First, I selected the model using the Pen tool and then copied the selection to the clipboard and pasted it into the background abstraction. The background colors were generated by creating a color gradient in Kai's Power Tools and then applying the filter Terrazzo to it for a kaleidoscopic effect.

Next, the Chrome filter was applied only to the model. I then clicked on Select: inverse to select everything except the model (i.e., the background) and chose the Extrude filter. Unlike a zoom blur with a telephoto lens, where you zoom in or out during a long exposure to streak the elements in a composition, extrusion zooms blocks of color. Within the Extrude filter dialog box, you can vary the size and depth of the blocks.

The mask was cut out from its original background with the Pen tool, copied to the clipboard, and then pasted into the composite using Edit: paste. I sized it to fit the model's head with Layer: transform: scale.

Pull-Down Menus

When Photoshop is open, you will see across the top of the monitor several words: *File, Edit, Image, Layer, Select, Filter, View, Window.* These are headings for pull-down menus. When you click on one of these headings and drag the cursor down the screen on your monitor, there are many commands allowing you to do a multitude of things to a photo. Here are some examples:

File: save as—This command saves an altered photo and maintains the original.

Edit: undo—This will undo the last Photoshop action you executed.

Edit: copy—A photo, or any portion of a photo, is copied into the clipboard, which is an invisible temporary holding place. From the clipboard, it can be "pasted into" another photo. For example, to place a model into another photo, she is first selected, then copied to the clipboard, then pasted into the second image.

Edit: paste into—This is the command which tells the computer to place the photo (or the portion of a photo) held in the clipboard into another image. If you have a portion of a background photo selected (using the *Magic Wand* tool), the *Paste Into* command will place the image that was copied to the clipboard **within** the selection.

I photographed this model in Brazil as she was standing on a chair clowning around. I used the Pen *tool to isolate her from the background and eliminate the bottom portion of her legs. This selection was then copied to the clipboard. For the background, I opened a photograph of Antelope Canyon in Utah and applied the* Terrazzo *filter to it, changing the contours of the sandstone walls into a fantasy.* Hue/Saturation *was used to alter the color of the background, and then the clipboard selection was pasted into it. With* Layer: transform: scale, *I sized the model to be relatively small in the final composite.*

To make the reflection, I converted the floating layer of the model into a selection by holding the command key down while clicking on her layer in the Layers *palette. Then I held the option key down and dragged the selection downward. This made an exact duplicate image of the young woman. Next, I chose* Layer: transform: flip vertical. *The cloned image was now upside down, and I moved it into place with the* Move *tool. In* Image: adjust: brightness/contrast, *I darkened it simulating a reflection. Clicking* Select: none, *I deselected the image of the model.*

I then used the Lasso *tool to select an area that included the reflection as well as an area around her. I clicked on* Select: feather *and chose a six-pixel feather radius in the dialog box. This softened the edge of my selection so the delineation between the selected portion and the background wasn't defined by a hard edge. Finally, I chose* Filter: distort: wave *and rippled the selection to simulate water. In the* Wave *filter dialog box there are several parameters to choose from that create different kinds of wave patterns. Each situation calls for different settings. I experimented until I found one that seemed realistic.*

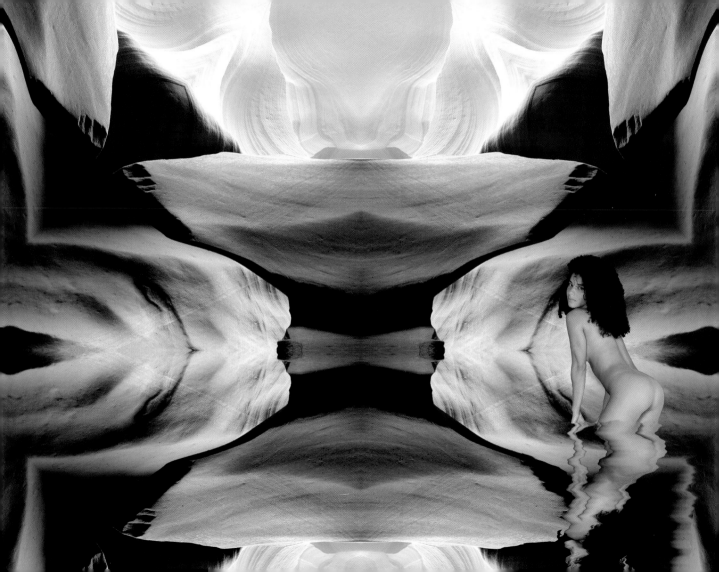

Left: One of my favorite filters is the Chrome *filter. It doesn't work on every photograph, and there is no way to predict its effectiveness. But when it is successful, the effect is dramatic. This nude torso was photographed against a white wall using only the available light from a window. It was shot with a diffusion filter over the lens and was very muted in tonality. The* Chrome *filter totally transformed the shot from soft and subtle to high-tech.*

Right: A completely different approach to the photo on the left was achieved by using the Solarization *filter. Solarization is a traditional darkroom process where a white or colored light is turned on briefly during the development of the film or paper. The result is a partial reversal of shadows and highlights, causing the image to appear partially positive and partially negative. In a color solarization, the color combinations are often surreal.*

The darkroom technique is unpredictable, because there are several factors that are difficult to judge. The length of the second exposure, the distance of the light to the film or paper, the color of the light, and the reflection of the light off the baseboard of the enlarger are all variables. You can't see the results of the solarization until the film or paper is developed. With a computer and Photoshop, however, it happens right before your eyes on the monitor by simply selecting Filter: stylize: solarize. *Once you like the effect, the colors in the solarized photograph can be changed by using* Image: adjust: hue/saturation *or* Image: adjust: color balance. *I used* Hue/Saturation *in this example to change the colors of the original solarization as well as intensify them.*

56

Image: rotate canvas—You can rotate the entire image as much as you want, clockwise or counterclockwise. With this command, you can also flip the entire photo horizontally or vertically.

Image: adjust: color balance—This allows you to shift the color balance of the photo in any direction using three slider bars: green/ magenta, blue/yellow, and red/cyan. The highlights, shadows, and midtones can each be adjusted separately.

Image: adjust: brightness/contrast—With this command, a menu appears with slider bars that permit you to increase or decrease the brightness and/or contrast of a photo. If you use *Image: adjust: levels*, you can accomplish the same function but with more control.

Image: adjust: hue/saturation—I use this all the time. *Hue/Saturation* allows you to boldly or subtlely change the color relationships in the photo. When you move the saturation slider bar all the way to the left, a color photo is transformed into black and white.

Layer: transform—When you paste an image or part of an image into another photo, this command allows you to manipulate the pasted image in several ways. Within the *Transform* submenu, you can rotate, scale (change the size of), distort, and flip it.

Layer: flatten—When you paste one or more images into another photo, each of these "layers" increases the size of the file in terms of megabytes. When you save the file with all the layers intact, the file size can be quite large, but you can also move and alter each component layer as long as the various layers are saved with the file. When you flatten the image, all the layers merge into the single image. This reduces the file size, but it also means the pieces of the composite can no longer be moved or manipulated separately unless they are re-selected.

Select: inverse—If you have selected an area of the photo, you can change your selection to include everything <u>except</u> the original selected area. This is very useful in situations where a model who is dressed in a variety of colors is photographed against a uniform background, such as white studio paper. Instead of using the *Magic Wand* tool to select the model, who is comprised of many colors and contrasts, you first select the white background. The tool can easily select the single color of the background. Then, using *Select: inverse*, everything except the background is selected, which means that the model is now selected (instead of the background) and ready for photo manipulation.

Select: all—The entire photo is selected.

Filter: noise: add noise—A grain texture, similar to film grain, is added to the photo. You can select the amount of grain with a slider bar, and you also have the choice of monochromatic or multicolored grain. The former is comprised of gray granules, while the latter contains red, green, and blue specks.

Filter: distort—There are several filters in the *Distort* submenu that affect your image in a variety of ways. Included here are *Spherize, Wave, Zig Zag, Polar Coordinates, Twirl,* and *Ripple*. These filters are each unique, and they alter the image in remarkable ways. For example, the *Spherize* filter converts all or part of an image into a bubble-like shape, complete with appropriate distortion. One of the options in the *Zig Zag* filter is creating pond ripples, with your choice of the size of each ripple and the total number of ripples. It's difficult to describe what the *Polar Coordinates* filter does. Suffice it to say that it's really wild.

There are a number of independent companies that make filters called plug-ins for Photoshop. The filter that created this pattern is called Weave, and it's part of the Eye Candy filters.

Within the Weave filter dialog box, you can choose the width of the woven strands, the amount of space between them, the length of the threads in each strand, and other parameters. As in most dialog boxes, there is a preview window to give you an idea of how the filter will look on a small portion of the photograph.

View: show rulers—Along the right and top of the photo are measurements in inches or millimeters that aid in the precise placement of components.

View: zoom in—A portion of the photo can be enlarged many times.

Window: show layers—This command displays the *Layers* palette. I keep this open all the time.

Many of these commands have shortcuts on the keyboard. For example, Command "Z" on a Macintosh (Control "Z" on a PC) is undo, Command "A" is select all, and Command "C" is copy a selection to the clipboard. The short-cut symbol, if there is one, is seen next to the command in the pull-down menu.

Filters

One of the wonderful aspects of Photoshop is the filters. In conventional photography, as we all know, filters change the color of our subjects or they introduce some type of diffusion, distortion, or star effects. The filters that come with Photoshop and those that work within Photoshop (purchased as plug-ins through independent companies like Andromeda Software and MetaCreations) are absolutely amazing. Some of these filters include: *Colored Pencil, Emboss, Motion Blur, Charcoal, Bas-Relief, Solarization, Reticulation, Psycho, Wave, Film Grain, Fresco, Palette Knife, Glowing Edges, Paint Daubs,* and *Rough Pastel.* I'm sure you can imagine the possibilities!

There have been many times when I have created remarkable variations and abstractions of an image simply by using the many filters available in Photoshop. One photo can appear to be completely different when two or more filters are applied to the original. For example, the *Colored Pencil* filter produces a completely different effect than *Find Edges*. If you combine filters, dozens of amazing photos can be created, some of which become totally abstract, while others may look like they were composed on an artist's canvas and seem to have no relation to photography.

Most filters are accompanied by a dialog box that gives you several parameters to choose from. These usually have to do with the degree with which the filter is applied. Thus, a single filter can have more than one type of effect. The possibilities are really endless.

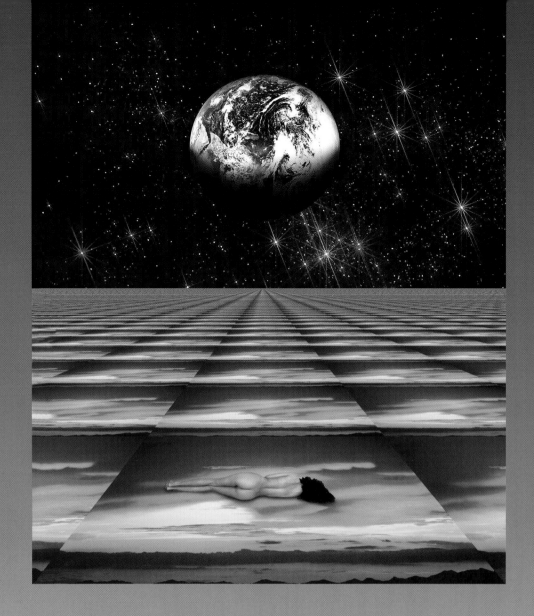

There is a command within Kai's Power Tools 3.0 called Planar Tiling. It lays a photograph down into a perspective plane complete with a vanish point. The plane in this image comes from a sunset shot. I selected the portion of the frame above the horizon using the Magic Wand tool, and using the command Edit: paste into, I pasted in an image of "stars." This component is actually a picture of glitter sprinkled on black velvet and photographed with a star filter over the lens. I then pasted into the sky a picture of the earth which I obtained from the Johnson Space Center in Houston. Using the Burn tool, I darkened a portion of the earth suggesting the direction of the sun.

The model was photographed laying on a bed. I separated her using the Pen tool, made a selection by choosing Make Selection in the Paths palette, and copied it to the clipboard. I then pasted her onto the perspective plane. To make a drop shadow, I converted the floating layer (the model) into a selection by holding the command key down and clicking on the layer in the Layers palette. I feathered the selection four pixels and filled it (Edit: fill) with a dark gray color. At this point, the model was no longer visible. Her form was seen as dark gray with a soft edge around it. I pasted her selection on top of the shadow and, using the Move tool, moved her body up in the frame slightly. The drop shadow was now visible beneath her body.

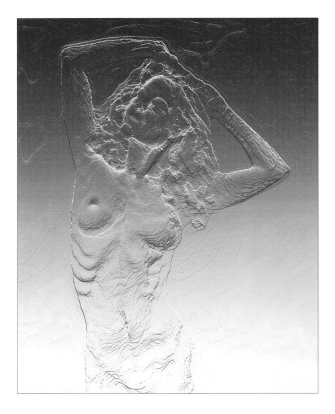

One of my favorite pictures in this book is this nude that looks like an ice sculpture to me. It was created by using two filters. First, I applied Filter: artistic: palette knife *and then* Filter: sketch: bas-relief. *One of the interesting things to note about Photoshop filters is that they typically have a different effect on different photographs. I experimented with the* Bas-Relief *filter on other images for this book, but none of them turned out as dramatic as this one.*

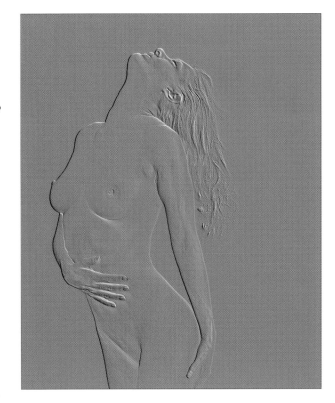

The Emboss *filter* (Filter: stylize: emboss) *creates a relief effect of a subject against a middle gray environment. If the original background consists of a solid color, such as black in the original shot of this model posing in front of velvet, the background generally appears uniformly gray after the filter is applied. The subtle color that is typically retained around the edges of the subject contrasts nicely against the uniformity of the middle gray. The dialog box that opens up when the filter is selected enables you to vary the apparent height at which the subject appears to be raised, or embossed, from its surroundings.*

4 MetaCreations Painter

The second most important program you should own, after Adobe Photoshop, is MetaCreations Painter. Painter is widely used by illustrators who create a drawing or other artwork and then embellish it within the program. Unfortunately, I can't draw more than a stick figure. However, there are aspects of MetaCreations Painter that can be used in conjunction with photographs, and this is where the excitement begins.

Painter can be used on any original photograph you've taken, or it can be applied to images already manipulated in Photoshop. There are four major ways in which this incredible program can be used to enhance and abstract photos in artistic ways. Please understand, though, that there are entire books devoted to Painter. This chapter is only an introduction to the program as it applies to photography. You'll want to explore other facets of Painter's capabilities on your own.

The Program Overview

There are a number of similarities between Painter and Photoshop that should make you feel somewhat at ease when you open Painter for the first time. Both programs have a similar tool palette, and both have pull-down menus. Many of the commands are intuitively simple to recognize.

A photograph is opened in Painter simply by using the *Open* command under the *File* pull-down menu, just as it is in Photoshop. You then select the image on the hard drive, and in a few moments, it opens within the program, usually magnified too much for the monitor. Simply use the *Magnify* tool in the *Tool* palette, hold the option key down, and click on the photo until its reduced size fits the screen.

Painter has several unique palettes that provide controls for achieving painterly effects, including *Advanced Controls, Art Materials, Brushes*, and *Controls: Brush*. The controls

Like Photoshop, Painter has a variety of lighting effects that give you the option of changing the way a subject is illuminated. The dialog box provides small icons that show how the new light spreads over the photograph. The spotlight on the model's face in this portrait was achieved by selecting Effects: surface control: apply lighting, *and then I simply clicked on the type of light that appealed to me.*

The effect I used on this image was actually achieved by using Photoshop filters. I first applied Palette Knife *and then* Poster Edges. *The eye shadow above the model's eyes was created using the* Airbrush *tool and darkened with the* Burn *tool. I changed the color with* Color Balance *and finally created bangs on her forehead by cloning her hair with the* Clone *tool.*

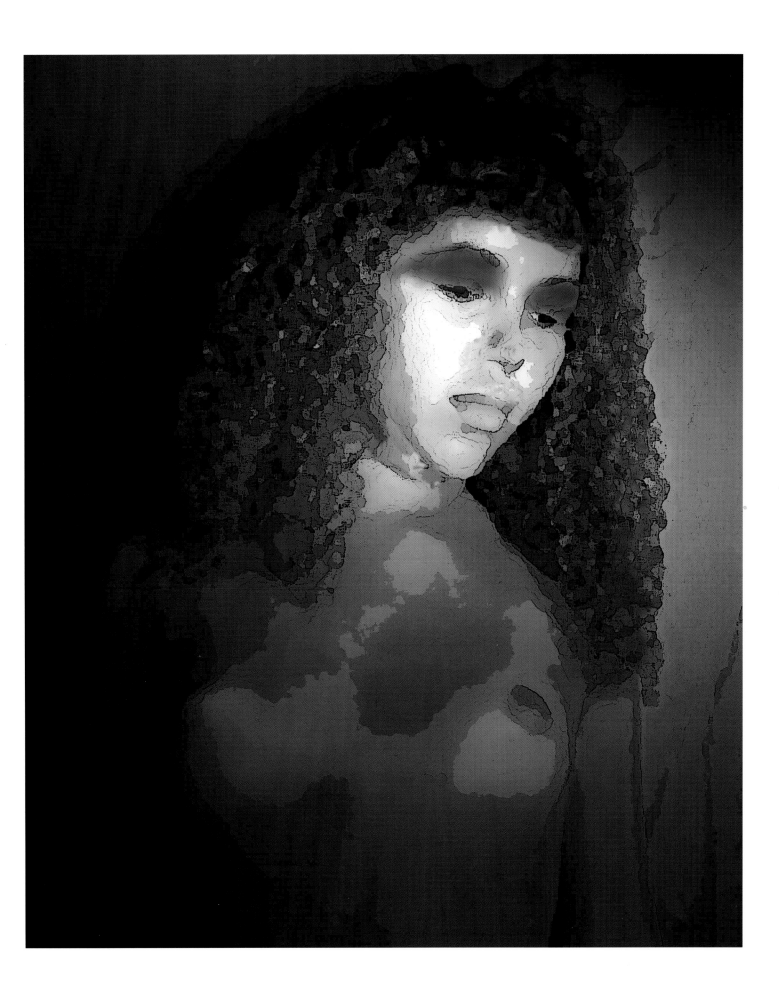

I photographed this model against a white background to make it easy to use her as a component. I opened the shot in Painter and then selected the New Cloner *brush called* Photo *(the icon with the camera) and then chose the subcategory* Hue Add. *When I then clicked on the* Paintbrush *tool, I could paint a wild color pattern over the model. By applying more pressure with a Wacom pen, the colors intensify and vary.*

To create the vertical pattern, I first named and saved the image and then opened it in Photoshop. I selected a vertical portion of the colored pattern on the model's body and using the Move *tool and holding the option key down, moved it into place. This cloned the colored segment to another part of the frame. The young woman's patterned skin, however, was intact. If the option key had not been depressed, the vertical section would have been*

moved, and in its place, the background color (the color in the lower right box under the tools in the Tool *palette) would be there.*

Since the cloned segment wasn't long enough to extend from the top of the frame to the bottom, I repeated the process just described, connecting the segments until seven verticals were in place. The juncture where one segment ended and the next began didn't flow nicely, so I used the Clone *tool to smooth that transition.*

The last step was to replace the model's eyes with those of a New Caledonian prehensile-tail gecko (which is a very bizarre reptile). I opened the shot of the gecko in Photoshop, selected just the eye using the Lasso *tool, copied the eye to the clipboard, and then pasted it into the model's face. I used the* Layer: transform: scale *pull-down menu to size the eye correctly and then the* Clone *tool again to blend the edge of the eye with its new environment.*

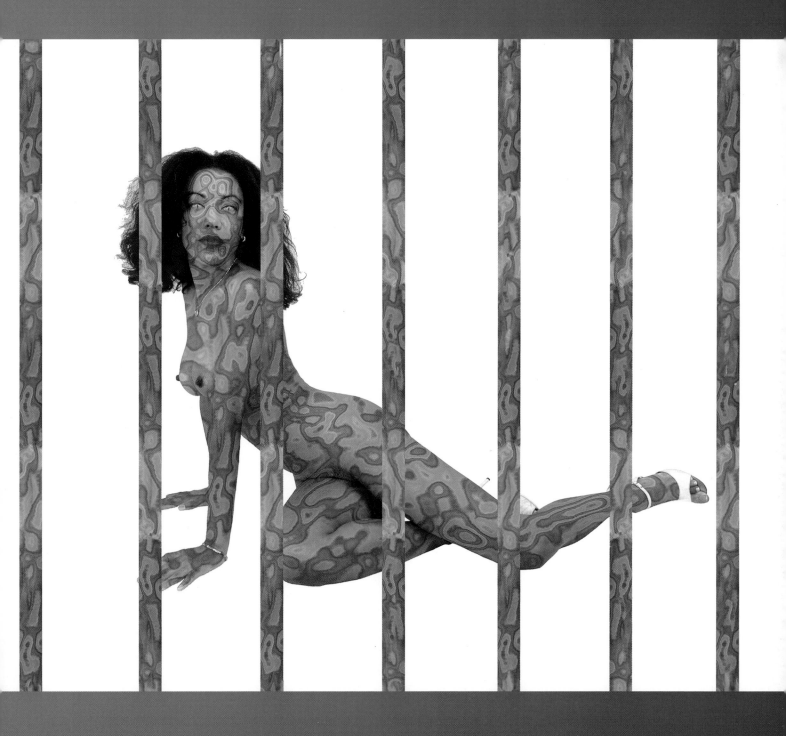

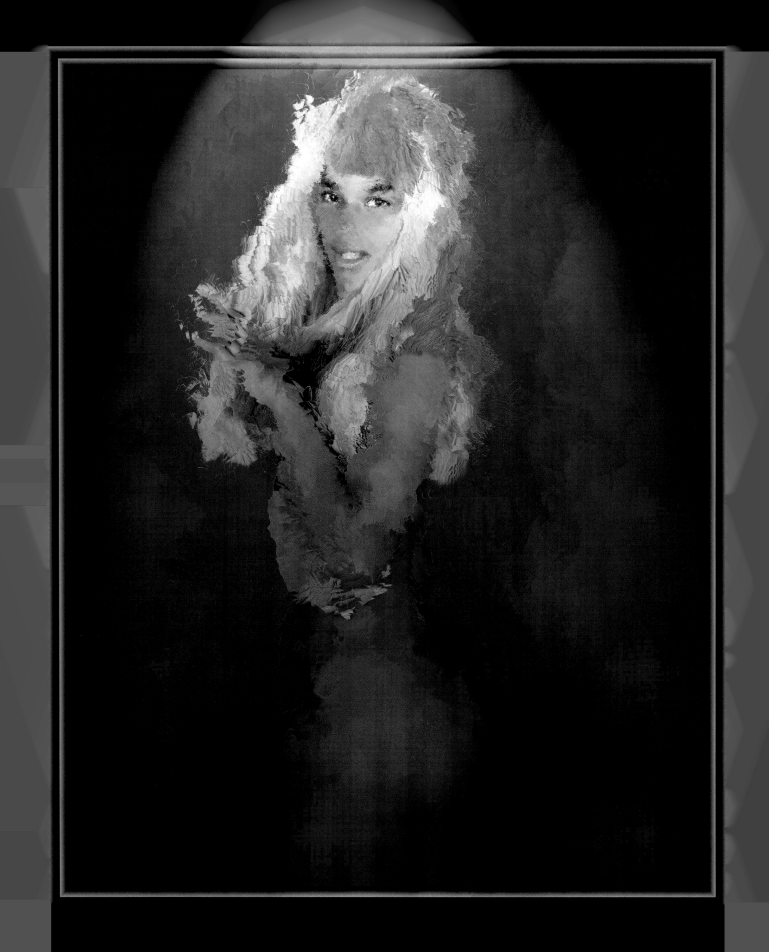

within these palettes allow you to turn your photos into beautiful paintings that would impress even Van Gogh and Rembrandt. As I discuss what the program has to offer in this chapter and in chapter six, I will explain what these palettes do.

Let's look at the four techniques unique to Painter that make it a very special program for photographers.

Cloner Brushes

Cloner brushes are found on the *Brushes* palette. These amazing tools allow you to turn a photograph into what looks like a traditional painting using one or more "brush strokes" that smear or splatter the color in the original per your instructions. Once you select the type of brush, you can then choose its size, opacity, and amount of grain in the *Controls: Brush* palette using slider bars. Then it is simply a matter of using the mouse or Wacom pen to paint over the photo until you like what you see. The smaller the brush size, the more detail will be retained from the original image. Larger brushes tend to abstract the photo to a greater degree.

Cloner brushes only work on a cloned image. Under the *File* pull-down menu, choose *Clone*, and Painter will make a duplicate of the open photo. All of the *Cloner* brushes are now enabled.

Within the *Brushes* palette, I usually start with the group of brushes called *Cloners*. Click on the small icon that looks like two parallel planes with a small, red arrow between them. Once selected, you will see four subgenera appear, each offering many ways to customize the *Cloner* brush. Some of my favorite *Cloner* brushes are *Impressionist*, *Driving Rain*, and *Melt*. When you choose any of the *Cloners*, click on the *Paintbrush* tool and begin applying the effect to the cloned photograph.

There are two interesting Photoshop filters at work in this photograph. First, I used Filter: render: lighting effects *to add what appears to be a spotlight above the model. Notice how the illumination falls off in intensity, how it spreads across the image normally, and how it enriches the colors in the portrait in the center of the beam more than at the periphery. This remarkable effect is entirely digital. I did not shoot this model with a light above her.*

Second, I used a program called Frame Curtain, which consists of Photoshop plug-in filters, to create the frame around the picture. There are several different kinds of frames available in this group of filters. This particular frame is named Bat Wing Wave. *Instead of simply overlaying the frame on the image, the frames are formed from the colors and textures around the periphery of the picture.*

The painterly effect applied to the picture was done in Painter. I first cloned the image (File: clone) and then used the Cloner *brush* F/X: Shatter 2. *I varied the size of the brush as I transformed the image. A larger brush was used for the background, while a smaller, finer brush worked on the face of the model. If a photograph is abstracted too much, it will no longer be recognizable for what it is. I typically use smaller brushes on faces for this reason. The size of the brushes are changed in the* Controls: Brush *palette.*

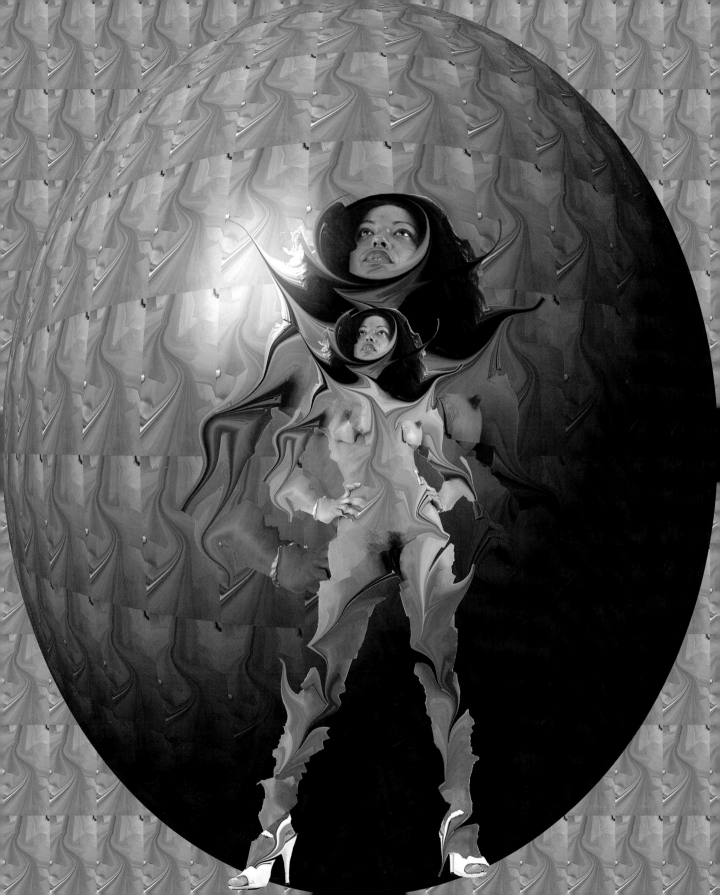

By applying several Cloner *brushes to a photograph, you can achieve some absolutely wild results. It's very difficult, if not impossible, to preconceive what might happen when you mix and match the various effects, but that's part of the fun.*

This model was photographed against a plain white background. The shot was opened in Painter, and I selected File: clone *to activate the* Cloner *brushes. First, I applied* Palette knife: diffuse pull, *then* Palette knife: bulge, *and finally* Palette knife: pinch. *These three brushes distorted the lines of the nude in a unique way. I saved and named the photo.*

I then opened the new image in Photoshop. A small portion of the model's abdomen was selected using the rectangular mode of the Marquee *tool, and I clicked the pull-down menu* Edit: define pattern. *This command creates a pattern out of the area I selected (you can't see the pattern yet). Using the* Magic Wand *tool next, I selected the white background. I then chose* Edit: fill, *and within the dialog box, I clicked on* Pattern. *This pasted into the background the pattern defined by the rectangular marquee selection.*

The last step was to apply Filter: KPT glass lens *to the background only. This is a Kai's Power Tools filter, and it spherizes the selection and creates an apparent reflective surface. As a finishing touch, I opened the* Hue/Saturation *dialog box and manipulated the color balance.*

If you want the size of each stroke to be different, or if you want to adjust the opacity or grain of the strokes, use the slider bars in the *Controls: Brush* palette. Small brush strokes will alter the image in subtle ways, similar to fine brush strokes of a painting. Large strokes can totally abstract the original image. When you change the size of the brush, a dialog box appears and instructs you to click on the *Build* button. Do so, because this instructs Painter to execute your instruction.

Another *Cloner* brush I use is *Liquid*. Select the icon in the *Brushes* palette that looks like a paintbrush with a water drop on the end of the bristles. In one of the subgenera, I often choose *Smear Mover*. By applying this effect to a photograph, the colors are smeared almost identically to the actual smearing of paint on an artist's canvas. It's truly amazing to watch an original photograph be transformed into what looks like a painting.

Experiment with the other *Cloner* brushes, and you will find many interesting effects. There are an amazing number of combinations of techniques. Keep a notepad beside your computer, and record the steps and settings used to create an image should you want a similar effect.

Nozzles

One of the unique features of Painter is a procedure where the computer can sequentially lay down a straight or curvaceous series of images as if it were sprayed out by a hose. This is referred to as a nozzle. The first time I was introduced to this technique by my best friend, Scott Stulberg, I was awed by the creative potential.

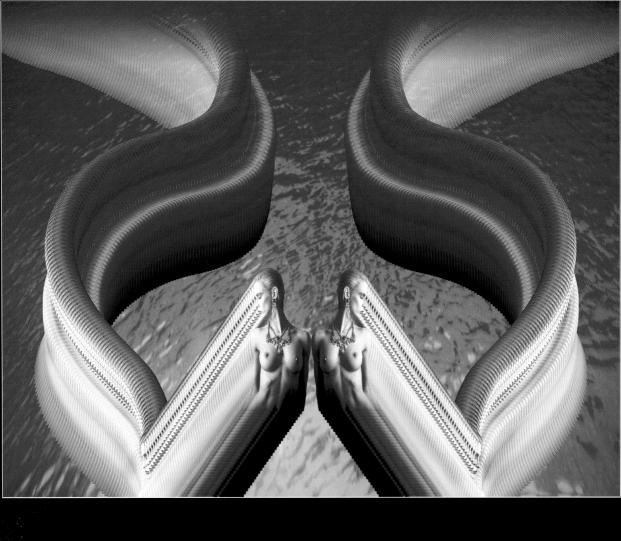

The background photograph in this composite was taken through glass in one of the huge pools at Sea World in San Diego, California. I angled the camera toward the sky.

The "snake" figure was created in Painter using the nozzle technique described in the text. By clicking on the Freehand button in the Controls: Brush palette, I was free to create any type of design, curved or otherwise. I used a Wacom pen to form an attractive "S" curve, and the result was one-half of the design you see reproduced here. To draw a perfectly symmetrical mirrored curve by repeating the process would have been very difficult, if not impossible. I therefore saved the nozzle, opened it in Photoshop, and cloned it. This was done using the same technique I used for the wings in the photo on page 78.

I pasted the mirrored nozzle into the underwater background and used Color Balance to shift the skin tone of the nude to blue. To attenuate the tail of the nozzle, I selected Layer: add layer mask: reveal all. With the foreground/background colors black and white respectively, I used the Gradient tool to subtly blend the upper portion of the tail into the water.

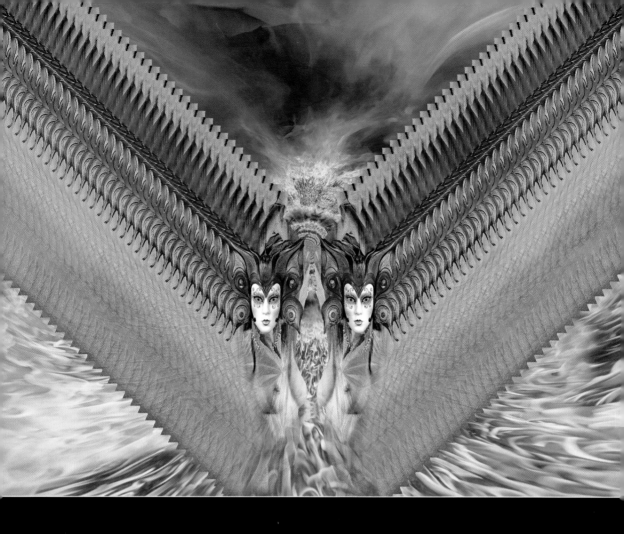

The combination of techniques makes this image, and many others in this book, seem complex and difficult to replicate. But it is simply a series of individual commands that are used to build the images.

The mask was pasted over the model in Photoshop, and then I inserted the eyes of a cat using the same cut-and-paste technique. Over the body of the model I pasted a floral design, and in the Layers palette, the opacity of the pattern was lowered to allow the body to show through the abstraction.

The finished nude was named and saved and then opened in Painter. I created a nozzle pattern following the steps in the text, but unlike the photo on page 70 where the design formed an "S" curve, I clicked on the Straight Lines button in the Controls: Brush palette to define a straight nozzle pattern. In this instance, I chose to make a diagonal.

The nozzle design was named and saved and then opened in Photoshop. I created the mirror image as described on page 79 and then pasted the entire nozzle image into the fire background, choosing Luminosity in the Layers palette so the two images seemed melded together. The photograph of fire had previously been manipulated by using the Vortex command in Kai's Power Tools

You can make a nozzle out of any photograph or any portion of a photo. The nozzles I made for this book were created using nude models, but any subject can be used to make an interesting nozzle. I've used a flower, a mask, the head of a lizard, and a colorful abstraction. Once I create the nozzle, I will then combine it with other elements for a final composite.

Following are the step-by-step instructions for making a nozzle.

1. In Adobe Photoshop, select a portion of a photograph to be made into a nozzle, and copy it to the clipboard.

2. Again in Photoshop, open a new file *(File: new)*, and in the dialog box, define the size of the image as approximately 3 to 5 MB. In the same dialog box, in the bottom section under *Contents*, click on *Transparent*. If you don't do this, the procedure won't work. Paste the image being held on the clipboard into the new file, and then save the image. If the photo that is pasted into the new file is too large to fit into the area, reduce it in size by using the pull-down menu *Layer: transform: scale*. A box forms around the image, and using the mouse or Wacom pen, you can bring in each corner of the box until the image is smaller. Name the new file (let's call it **Nozzle 1**), and then save it. Make a mental note on which of your hard drives the new image now resides. I typically save the file to the desktop so it's easy to find.

3. Close the program Photoshop *(File: quit)*.

4. Open the program Painter. Open **Nozzle 1** *(File: open)*.

5. Click on the *Hand* tool in the *Tool* palette (the hand with the pointing finger) and click and drag the photo itself onto the *Brush Controls: Nozzle* palette, dropping it right over one of the other picture icons shown.

6. Open a new file in Painter *(File: new)*. A dialog box appears where you define the size of the new file. Make it large enough to accommodate **Nozzle 1**. If **Nozzle 1** is defined by pixel dimensions of 1200 x 1500, then the new file in Painter should be the same size or slightly larger, such as 1300 x 1600.

7. Click and drag the **Nozzle 1** picture icon in the *Brush Controls: Nozzle* palette onto the new file. Make sure you are still selected on the *Hand* tool.

8. In the *Objects: Floater List* palette, click on the *Floater* icon. This expands the palette downward, and you now click on the *Trim* button, then the *Group* button.

9. From the *Brushes* palette, click on the icon that looks like a hose. The headliner of the palette should now read *Brushes: Image Hose*. Just under this headliner, click on the pull-down menu *Nozzle* and select *Load Nozzle From Group*.

10. Under the *File* pull-down menu, choose *Save As* and in the dialog box, name the file as **Nozzle 1,** or whatever name you wish. Choose the RIFF format and click *OK*.

11. Close all open files.

12. Open a new file, and size it as you wish. This is the final working area.

13. In the *Brushes* palette, click on the *Nozzle* pull-down menu and select *Add Nozzle to Library*. Then select *Load Nozzle*. Choose **Nozzle 1** in the dialog box and click *OK*.

14. Select *Paintbrush* tool from the *Tool* palette and begin making straight or curved lines with your mouse or Wacom pen on the new, blank file. Painter will then lay down a sequential pattern of your new nozzle.

I often combine Photoshop and Painter techniques to produce unique effects that may not be possible using only one of the programs. This multiplies the capabilities of each.

This model was photographed sitting in a 1913 Ford Roadster. Strong backlighting from the sun gave her red hair a beautiful halo. The original shot was horizontal, but when I reconsidered the design of the image, a vertical composition held more appeal to me. In Photoshop, I cropped the picture using the Crop *tool* and then applied two Photoshop filters, Palette Knife *and* Colored Pencil. *I saved this new picture and then opened it in Painter.*

Painter 5.0 has a group of brushes called New Cloner *brushes. I used one of these, named* Gooey *(the icon with the distorted checkerboard pattern) and then chose the subcategory labeled* Runny. *I clicked on the* Paintbrush *tool and simply smeared the colors to simulate a painting.*

Next I selected Effects: tonal control: adjust colors *to create two more versions. Both Photoshop and Painter have* Hue/Saturation *controls, and in this instance, I used Painter's. It is somewhat different than the one in Photoshop in the way it puts together various combinations of color.*

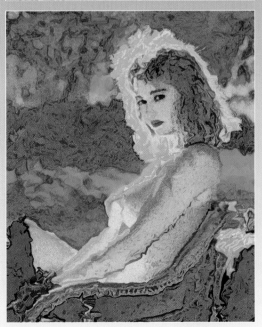

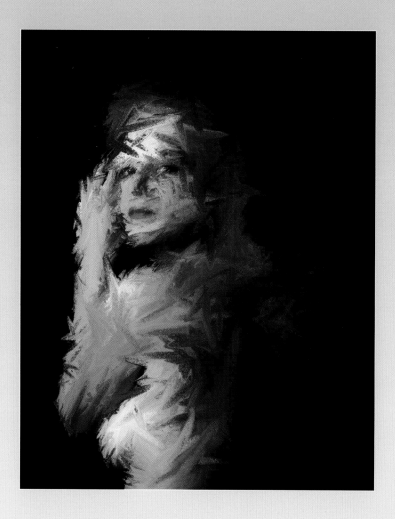

I could spend years doing nothing but turning my photographs into paintings using Cloner *brushes. The possibilities are endless. One of my favorites is* Artists: Flemish Rub. *When a large brush stroke is chosen in the* Controls: Brush *palette, the details of a photo are transformed into large swaths of paint.*

After choosing File: clone *to make a clone of the original, I used the* Paintbrush *tool to apply the Flemish Rub. The only problem was that because the brush strokes were so large, the details in the face were lost. I wanted the eyes and mouth to be recognizable, but what I saw were abstractions of color in place of a face. To bring some of the detail back, I selected* Cloners: straight cloner. *The Straight Cloner is a way to bring back some or all of the original photographic detail. Remember, underneath the cloned photograph that is being manipulated is the original picture. When the* Straight Cloner *is applied, it takes its information from this underlying photo.*

In the Cloners: Brushes *palette, I adjusted the opacity to minimize the* Straight Cloner's *effect. Clicking on the* Paintbrush *tool, I gently applied the technique to the eyes and mouth. If too much of the underlying original came through, I hit* Undo *and tried again until the model's facial features were delineated but the* Flemish Rub *strokes were still visible.*

Surface Textures

Painter offers a number of textures that can be applied to photographs that alter the appearance of the image. These additions can be subtle or dramatic, depending on the chosen texture and the parameters selected within each dialog box.

The surface textures are primarily available in the pull-down menus you see on the top of the monitor's screen, or the desktop. Under *Effects*, you will see *Surface Control*, and from there you can highlight the submenu *Apply Surface Texture*. The dialog box that opens offers several ways to vary the textures that are applied to your photograph. Among them are direction of light, amount of texture, shine, reflection, and exposure. My two favorite textures to apply are *Paper* and *Image Luminance*.

Under the pull-down menu *Effects: focus: glass distortion*, you will find another effect that is very useful. An old technique that photographers have used for years is to photograph subjects behind textured glass. Flowers, portraits, color abstractions, and even photographic prints can be shot through textured glass to distort the subject. This can now be accomplished digitally, and you can choose several different types of textures as well as the degree to which they are applied. In the preview box, you can see a portion of the photo change as you move the slider bars back and forth.

Another unique surface texture can be found under *Canvas: make mosaic*. You can make any photograph look like it was created by cutting colored tiles and grouting them together to form an image. In the dialog box, you can choose the size of the tiles, the space between them, and even the color of the grout. To apply the tiles, first click on the *Paintbrush* tool. Then open the *Mosaic* dialog box by selecting *Canvas: make mosaic*. Click the box *Use Tracing Paper*. Make a clone by selecting *File: clone*. In the *Art Materials* palette, click the box *Clone Color*. After you select the size of the tiles and the other parameters in the *Mosaic* dialog box, you can now paint tiles over the photograph. The tracing paper allows you to see the underlying photograph as the tiles are applied.

If you want to lay geometric textures over a photograph, look under *Effects: esoterica: custom tile*. Bricks, triangles, crosses, squares, and other designs can turn an image into an interesting work of art. The geometric patterns use the colors in the underlying photo to make the individual pieces of the pattern.

Turning a photograph into a mosaic tile design is another remarkable feat Painter can do. As with other techniques, there are various parameters from which to choose that provide complete control over the project.

I opened this image in Painter and cloned it. I then selected from the pull-down menu Canvas: make mosaic. A dialog box opens where you can opt for the size of the tiles, the spacing between them, and even the color of the grout. I like to check the Use Tracing Paper box, which allows me to see the background image with a lowered opacity while the new mosaic tiles are laid down. The dialog box must be left open while the new image is being made.

I have found that when using a Wacom pen or mouse to create the tiles, the finished image will be more striking and a more accurate representation of the original if some of the important lines in the photograph can be defined by the way the tiles are placed. For example, the eyebrows in this portrait were underscored by following their curvature with my Wacom pen. The tiles actually define these features, rather than blend them into the rest of the design at random. I did the same for eyes, nose, lips, and nipples to emphasize those parts of the mosaic. Notice also how I laid down a single line of tiles under each breast to define their shape.

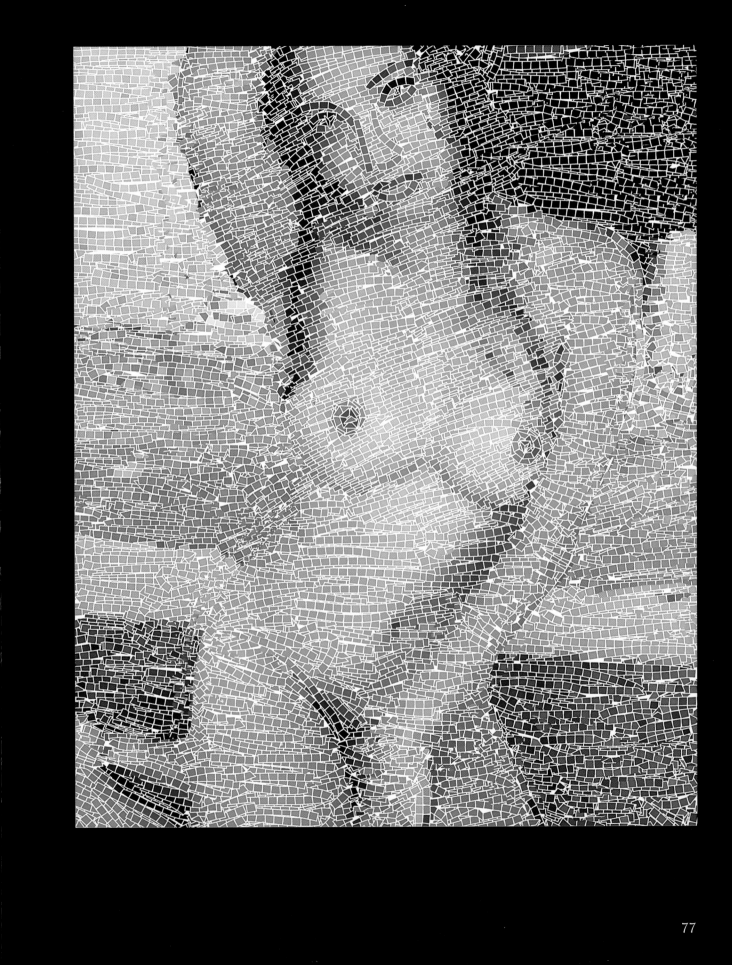

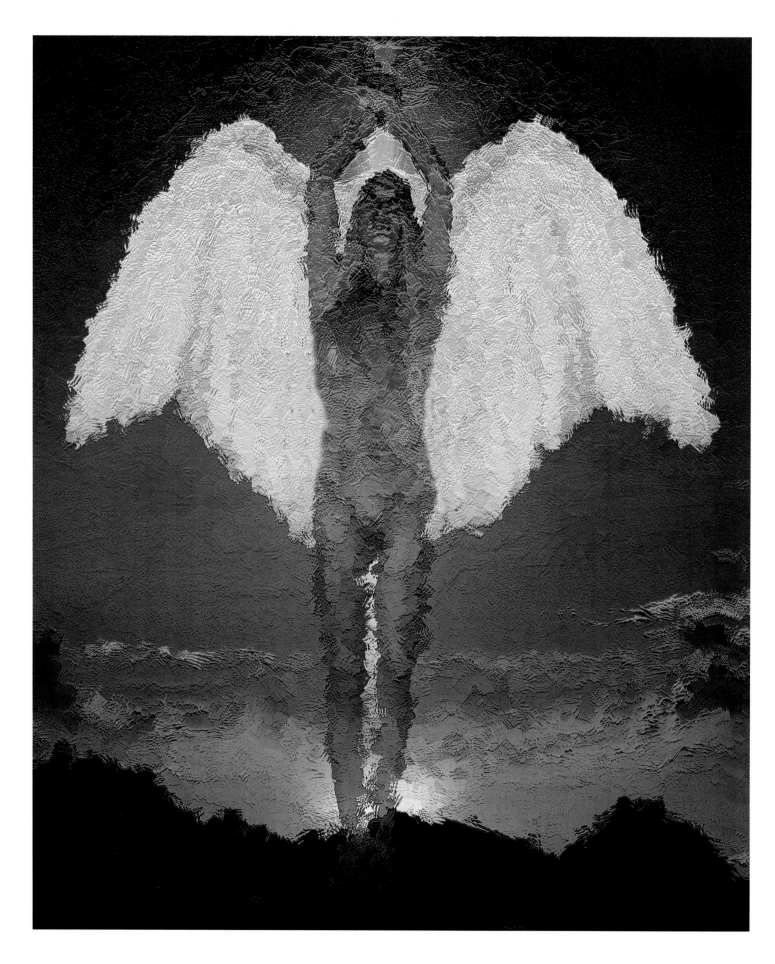

Lighting Effects

One of the unique features of Painter is the ability to actually change the lighting in a photograph. There are, of course, limitations on what can be done, but the control that you do have is remarkable.

Use the pull-down menu *Effects: surface control: apply lighting* to open the dialog box that again gives you many options. The types of lighting available have names like *Center Spot*, *Track Lighting*, *Drama*, and *Three Colors*. Each one of these choices adds a different type of light onto the original photograph. With each choice, you can add additional lights. For example, one light might dramatically illuminate the background while another may only highlight the face of a model in the foreground. A small preview window shows you the results of your selections before the change is made to the photo.

In addition to choosing the type of light source, you can also control the brightness, the apparent distance of the light to that portion of the photo being affected, the spread of the beam, the ambient light relative to the introduced lights, and the exposure. You can also adjust the color of each light as well as the color of the ambient illumination.

These lighting effects can be used with any unmanipulated photograph, or they can be applied to an image that has been altered significantly. For example, using the *Cloner* brushes, you may turn a photo of a nude into what looks like a Van Gogh painting. Then, using the lighting effects, you can illuminate the face while the rest of the body and the environment is rendered in shadow. Of course, this type of lighting could have been accomplished in the original photo session, but if that hadn't been done, you can create the look of an image that was lit by a master photographer simply by using MetaCreations Painter.

This composite was first assembled in Photoshop then opened in Painter, where I applied a Cloner *brush. I then imported the image back into Photoshop for further work.*

The background is a sunrise over Haleakala, the extinct volcanic crater on Maui. The wings were from a white egret photographed in a Florida swamp. I cropped an extended wing with the Crop *tool, separated it from the background with the* Pen *tool, and then cloned it by selecting the wing with the* Magic Wand *tool, holding the option key down, and dragging the clone away from its source with the* Move *tool. With* Layer: transform: flip horizontal, *I flipped the wing into a mirror image and moved it in place with the* Move *tool.*

The double wings were pasted into the sunrise, then the model was pasted over the wings. In the Layers *palette, I chose* Luminosity, *which turned her into a black-and-white figure with some of the colored background visible through her body. I named and saved the image. I opened the picture in Painter, made a clone (*File: clone)*, and applied the* Cloner *brush* Special: Shower Door, *which gave the picture a relief effect.*

Back in Photoshop I applied the Bas-Relief *filter. I copied the result to the clipboard and selected* File: revert *to return the image to what it was prior to the application of the filter. The bas-relief variation in the clipboard was then pasted over the reverted photo. In the* Layers *palette, I chose* Exclusion. *Then* Hue/Saturation *increased the intensity of the colors.*

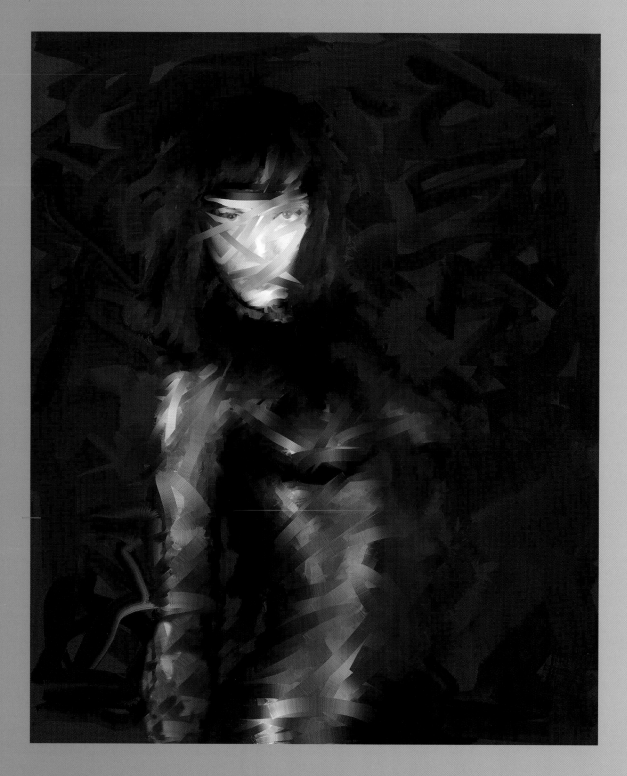

This model had been painted with black liquid latex as described on page 41. The photo was
opened in Painter and cloned by choosing File: clone. I used the Cloner brush New Paint Tools:
Sargent Brush, choosing two different brush sizes, one for the background and one for the body.
Effects: tonal control: adjust colors was used to alter both the color balance and saturation.

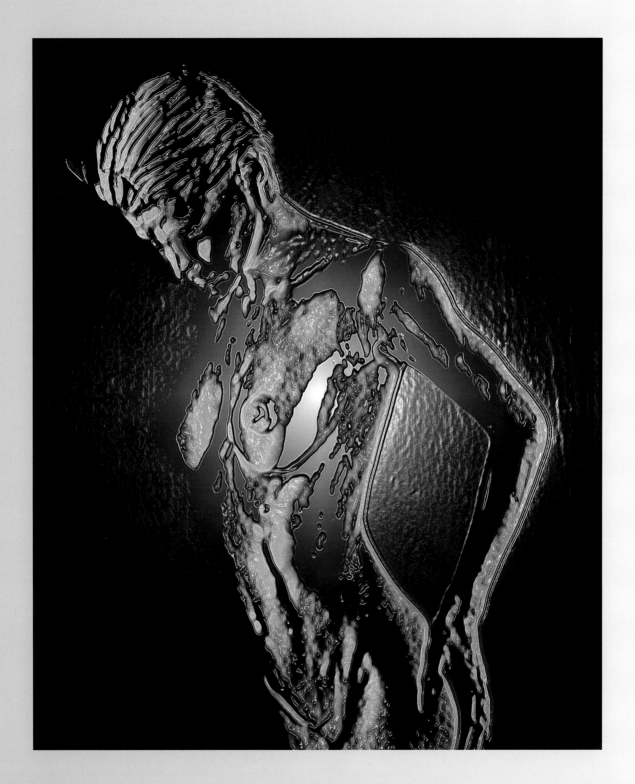

The techniques available within Painter are quite varied. This unique abstraction of a model was achieved by choosing Effects: surface control: apply surface texture. Within the dialog box that appears, I used Image Luminance. The original nude was photographed against a black background with two Zap 1000 strobes, one with a cyan gel and the other with a magenta gel.

5 The Photo Shoot

I am often asked how I come up with my ideas. Do I have an image in my mind before I take the pictures, or does a concept occur to me after I have all the various components on film? Do I sometimes stumble upon an idea while playing around with it in Photoshop or Painter, or do I know which effect is best beforehand?

The answer I would give to each of these questions is "yes." I do all of the above. Sometimes I know precisely what I want, and other times I will open an image in a program and try different effects until I like what I see. If nothing good comes from the session, and I'm frustrated because I just can't create an image I like, I'll turn the computer off and go to a movie or have some Chinese food until my creative juices start flowing again.

With respect to composite photographs, where I combine two or more images into a final shot, I often lay a couple dozen slides out on my light table: landscapes, travel locations, models, abstracts, animals, sunsets, and so on. This helps me visualize possible combinations.

During a photo shoot, when I know that the photographs I am taking are destined to be combined with other images or turned into painterly abstractions, I shoot from a different perspective. Even if I don't know exactly how I will use a shot, there are unique factors that should be considered to make the final manipulated image look good. If I am shooting to later combine a model with a background, the realism of that combination will depend in large part how I photograph her.

I have a large collection of components that were photographed specifically to be used as pieces for digital composites. This Venetian mask is one example. It represents one of several masks that I've photographed separately and from different angles, knowing that they could be placed on a model (or elsewhere in an image) at a later time.

I altered the colors of the mask in Photoshop using Hue/Saturation, *and with the* Gradient *tool, I filled the eyes with color. The mask was then cut and pasted onto the nude, and using* Layer: transform: scale, *I sized it appropriately. The color and apparent lighting of the background is a result of using the* Gradient *tool again. Within the dialog box, I selected* Radial *rather than* Linear, *which spreads the color from a central point outward. The* Gradient *tool works by blending the colors in the foreground and background color boxes in the* Tool *palette. I chose a light magenta and a dark magenta, respectively, for those two boxes. Notice how the lighter color was placed behind the model's head, suggesting a highlight on the background.*

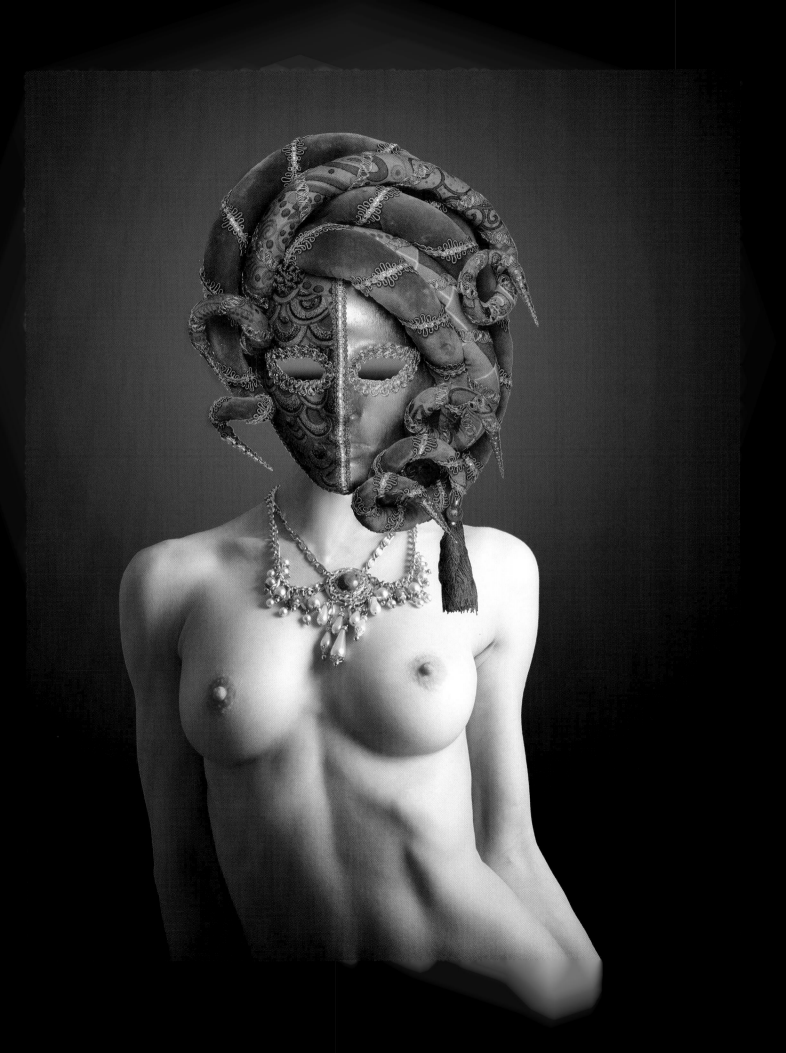

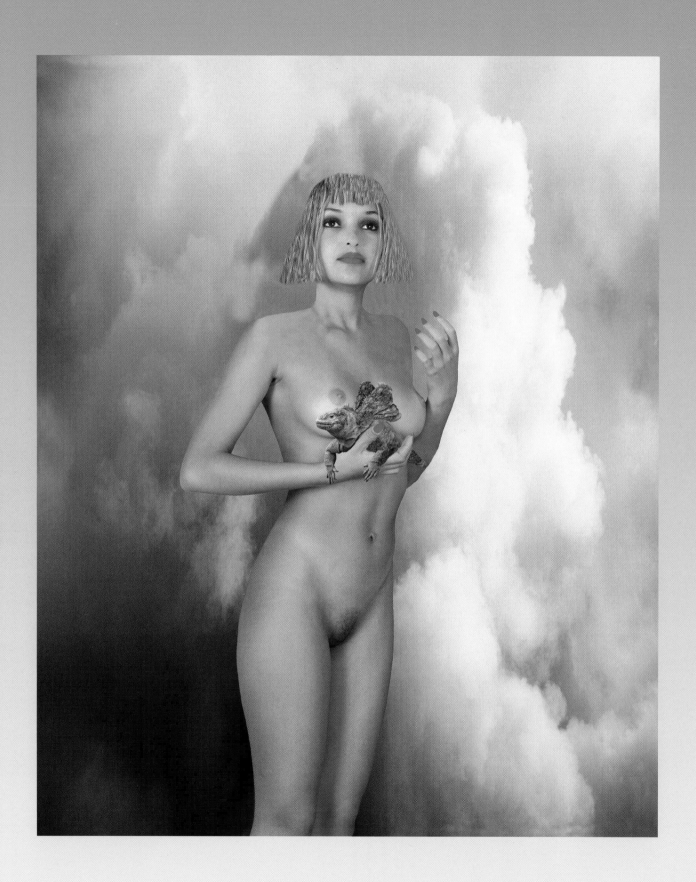

Equipment and Film

Which conventional photographic equipment to use is a very personal choice. For photos used for digital imaging, it doesn't matter what conventional camera system you use, assuming the lenses offer excellent optics. The speed of the lenses (f/2.8 versus f/4, for example) also does not matter, and while the latest automation may aid picture taking, it isn't relevant to a successful digital manipulation.

What is relevant is that you take every step possible to insure sharp pictures. This means you should use a tripod whenever possible. It means that slow, fine-grained film should be used where conditions permit. The images in this book were taken with Kodak Professional Ektachrome E100S film, which is extremely sharp and has a very tight grain structure. I also like Fujichrome Velvia and Provia 100. Color balance and color saturation, which are crucial considerations in conventional photography, aren't as important in the digital world because the colors can be modified and enriched in the computer.

The format you use is a serious consideration. Digital 35mm slides from 35mm original scans are excellent, but if the end use will be large prints, posters, or commercial print ads, I would recommend using a larger film format. All of the pictures in this book (with the exception of the underwater shot) were taken with the Mamiya RZ 67, which produces a

The land iguana from the Galapagos Islands and the smoke from a house fire were not shot to be components, but in this composite I've used them as such. I photographed the model as if she were holding something, and this allowed me to get creative and place something unexpected in her hand.

Two aspects of this photo are interesting. First, the smoke was originally a horizontal shot. Using Image: image size, *I typed in vertical dimensions, and the computer made the change, stretching the smoke. Second, the model's hair was quite different from what you see here. She didn't have bangs, and it was several inches longer, covering her shoulders. Using only the* Clone *tool, I reshaped her hair into an almost Egyptian look. Since I eliminated the long hair which partially covered her shoulders, I had to clone skin from her chest to rebuild this part of her body. Remember, when you remove an element from a photo, something has to replace the space that that item occupied.*

Iguanas don't have wings, of course. I cut the wings from a photo of a Western tiger swallowtail and pasted them onto the back of the reptile. In Layer: transform: scale, *I sized the wings correctly and then used the* Clone *tool to copy scales from the animal's head onto them. When the winged iguana was finished, he was cut out of his environment and pasted into the model's hand.*

2-1/4 x 2-3/4-inch transparency or negative (this corresponds to 6 x 7cm). The large size of the original image means there is more information in the film and hence the 6 x 7cm outputs have more information in them than do their 35mm counterparts. 4 x 5-inch and 8 x 10-inch originals, of course, produce even sharper results.

Digital cameras offer another way to approach the shoot. For controlled studio photography, where you have an adequate power supply for both lighting and the digital camera, very high resolution images can be captured directly onto the hard drive of a computer. This saves you the necessity of developing film and then scanning each transparency. Over time, the savings can be significant. The downside is that the cost of the digital camera is enormous. At this writing, high-resolution digital cameras start at about $27,000.

For shooting on location, there are presently no digital cameras on the market that offer high resolution. When you don't have the luxury of an AC power supply, the camera must hold in its memory all of the images it captures. For 35mm, high resolution is defined as 32 MB per photo, and for medium and large format, the memory requirements are larger. Digital cameras simply don't have the storage capacity at this time to hold this amount of information. Most handheld digital cameras offer 3 MB per photo or less. This may be fine for producing a nice-looking 5 x 7-inch print, but you could never get a decent large print or slide out of it, since both require higher resolution to appear sharp.

The lighting equipment you use to photograph models indoors or as flash fill outdoors can be any brand. Some strobes vary slightly in color temperature from the standard daylight "white" of 5500 degrees Kelvin. However, this becomes irrelevant considering Photoshop's ability to alter color.

Many of the components I use have already been manipulated in Photoshop or Painter. For example, the background in this image is a shot of a white orchid. In Photoshop, I used Filter: distort: twirl *to abstract the flower and then* Image: adjust: hue/saturation *to alter the color. It was then cloned to make a mirror image (see the caption on page 79).*

The model was cut and pasted into the background, and then she was cloned and moved into place in the same way I created the mirrored background. Finally, I chose the KPT Gaussian Glow filter to add the diffusion to the picture.

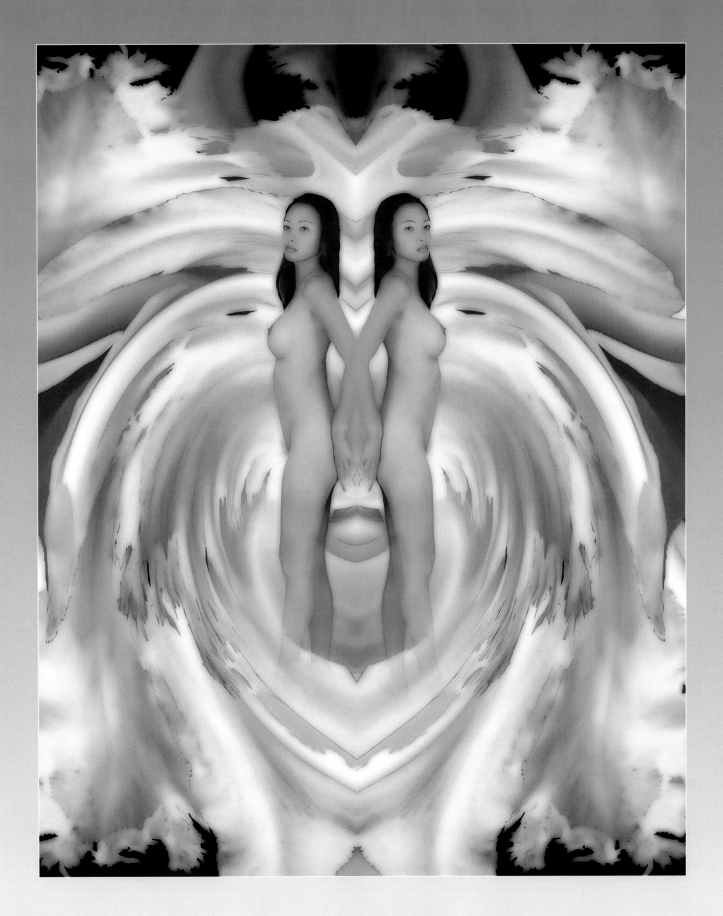

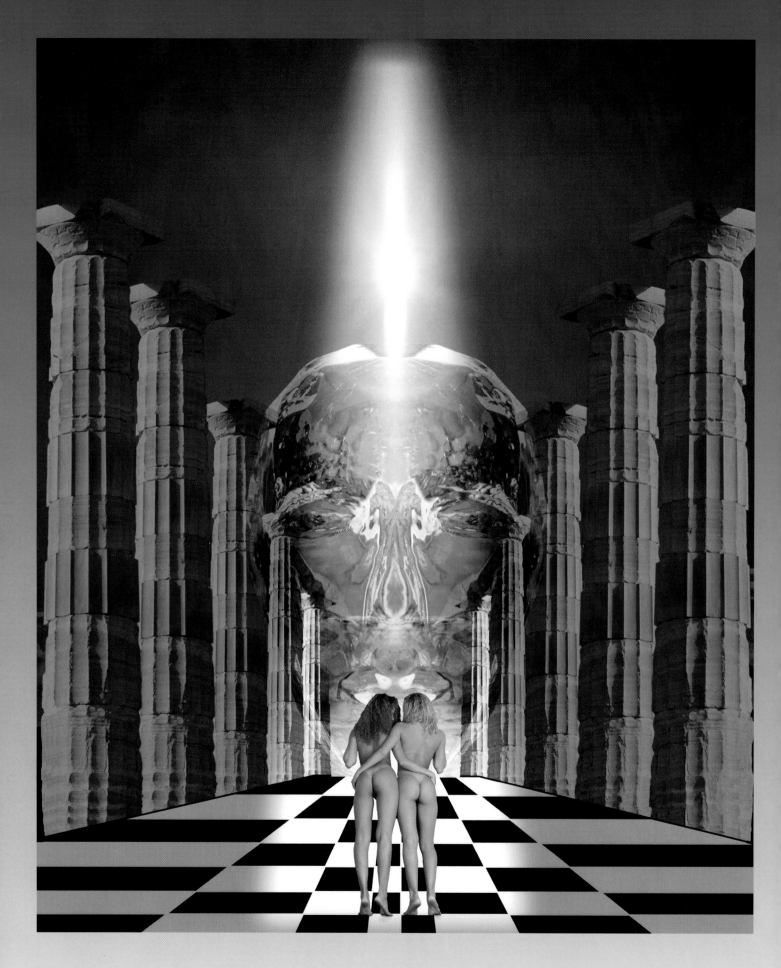

I use my components in various combinations in many different digital composites. The background in this image is the same Haleakala sunrise used for the image on page 78, and the same shot of these models was used on page 92. The finished manipulations are quite different from each other, which underscores the immense potential of using the components in your files. A component photo that was shot for a specific conceptualization may very well work in another composite that didn't occur to you at the time.

The other pieces of this image are the Greek columns, which is actually one column that was repeatedly pasted into the picture in Photoshop and sized smaller. It came from the temple at Sounion south of Athens, Greece. The head is an ice sculpture that was carved for me, and the floor is simply a pattern I created in Photoshop using the Line *tool. I placed the perspective lines, and the* Paint Bucket *tool filled the spaces with black or white. The shaft of light is a selection I defined with the* Lasso *tool that was first feathered (*Select: feather*) 30 pixels and filled (*Edit: fill*) with white at 25 percent opacity.*

All of the components were cut and pasted together, and after the models were sized and positioned, I used the Burn *tool to darken the floor around their feet to suggest a faint drop shadow.*

Lighting

If the lighting on a model is from the front, and the background into which she will be placed is a sunset—where the light comes from behind the subject—the combination of the two will look foolish if realism is the objective. Similarly, a silhouette of a model shouldn't be placed into another photograph where the illumination is derived from the midday sun, such as a landscape shot at noon.

The obvious lesson to be learned from these examples is that the lighting on the subject should match the lighting on the background. As I discussed in chapter four, sometimes you can actually change the lighting on a subject, but you shouldn't depend on this solution to add realism to the combination of two or more images. In the example above where you want to combine a front-lit model with a sunset, it is possible to turn the woman into a silhouette in Photoshop (select her form and then choose *Edit: fill,* where you fill the selection with black at 100 percent opacity), and then she will look correct with respect to the backlighting from the sunset. However, you can not do the re-verse. You can not put detail back into a silhouette if the original photograph didn't have it.

My point is that your life will be made a lot easier if you plan ahead. Classic studio lighting for portraiture, where a main and fill light are used in front, a hair light separates the model from the background, and one or two lights illuminate a backdrop, may not work with a particular background or with other elements that may be used in the final composite.

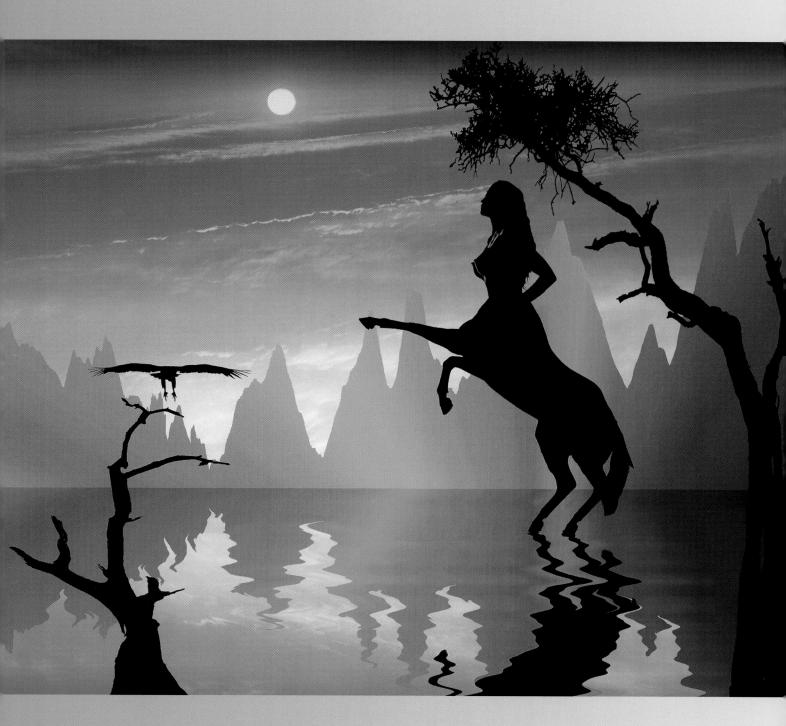

Dramatic side lighting might be more appropriate, or maybe simple front lighting that is even and diffused should be used. If you don't plan ahead, you may find that you are limiting the types of pictures that can be considered in the final composite.

These considerations apply to both studio and outdoor location shooting. If a model is to be photographed under a cloudy sky, the results will be very different than at sunset or under a bright midday sun. An overcast day produces soft, diffused, and even light, while a low sun means either bright front light, strong side light, or a rim-lit silhouette, depending on the direction the model faces with respect to the light. Midday sunlight is harsh and unattractive and should be avoided in all instances unless a diffusion panel is used above the model to soften the overhead light.

I used eight different components to create this fantasy female centaur. When I was in Africa, I specifically photographed strangely shaped trees for digital use when I returned home. The white-backed vulture was also photographed in Africa. The horse was hired to rear on command and was photographed on a hilltop with a light sky behind him. This allowed me to easily separate him from the background. The nude was photographed against a plain, white background in the studio.

All of the images were turned into silhouettes by filling their forms with black (Edit: fill) in *Photoshop. The mountains are real, even though they look like a digital creation. I first selected them and then compressed and stretched this Alaskan range using* Layer: transform: scale. *I pasted into the selection a gradient abstract created in Kai's Power Tools. The sunset was pasted into the composition above the mountains and then tweaked with the* Color Balance *command.*

The reflection of the background mountains and sky was created by selecting them, holding the option key down, and with the Move *tool, dragging the selection downward. It was then flipped upside down with* Layer: transform: flip vertical, *moved precisely in place to mate with the upper portion of the picture, and then I applied* Filter: distort: wave. *By experimenting with the various parameters in the dialog box, such as wave length, amplitude, and number of generators, I found a wave pattern that looked real. I then darkened the "water" by choosing* Image: adjust: brightness/contrast. *All reflections appear darker than what they reflect.*

The model and the horse silhouettes were merged using the Paintbrush *tool. By narrowing the horse's neck and slightly widening the model's waist, I made the two fit together. Since both figures were on white, I painted with white to shave the width of the horse's neck, while I added black to the model's waist to widen it.*

All of the silhouettes were then pasted into the scene. I created the secondary reflections in the same way as described above.

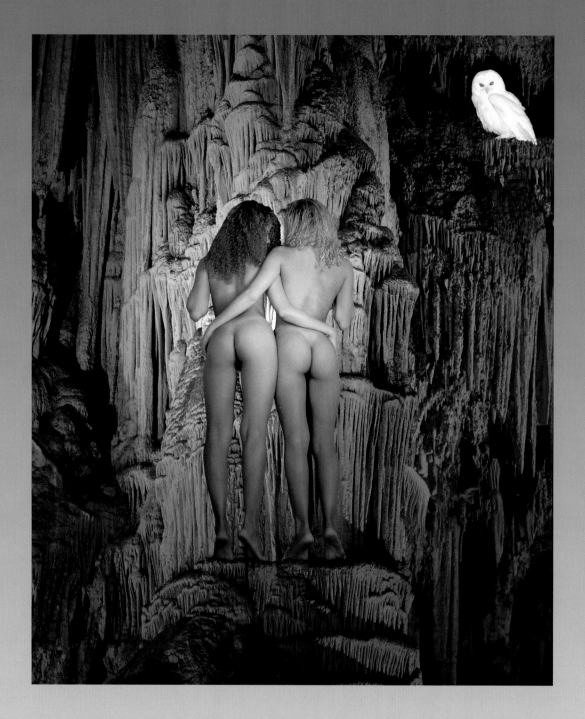

Used in a very different way, the same shot of the models from page 88 was pasted into the interior of a cave in southern Spain. A very rare albino barred owl was positioned in the upper corner, and using the Clone tool, I cloned portions of the limestone to create the illusion of a ledge.

The colors on the stalagmites and stalactites came from the artificial lighting in the cave, but I added the center spotlight focused on the models. Notice how the light attenuates outward. This was done in Filter: render: lighting effects within Photoshop. I chose a center spotlight, defined the ambient light and other parameters, and changed the illumination on the entire scene.

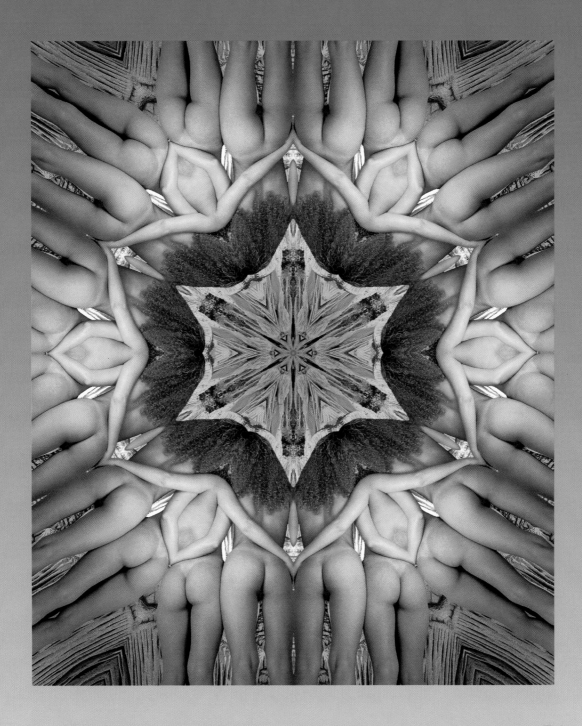

Once in a while a finished composite photograph becomes, in essence, a component. This kaleidoscoped image (Filter: other: Terrazzo) was made from the photo on page 92. I've produced about half a dozen versions of the original composite using the different options within the Terrazzo dialog box. This one is perhaps the most compelling.

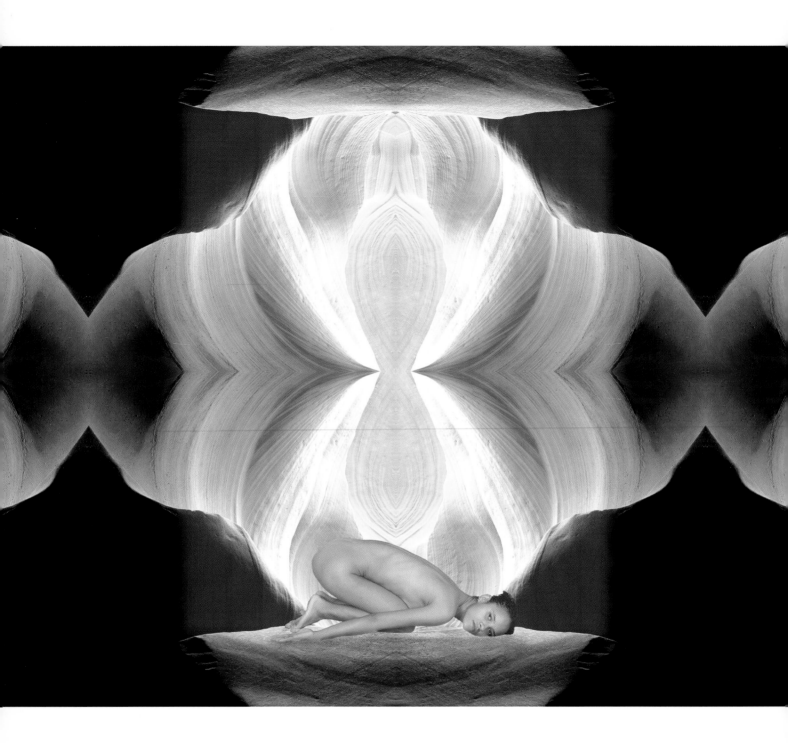

Components

In creating photographs for digital manipulation, you will find that the approach is somewhat different than for a conventional shoot. For example, when a model is to be placed into a different environment, the background is no longer relevant. She could be photographed in a living room or in the desert. Since she will be cut out of the original scene in Photoshop, it doesn't matter where the portrait session takes place.

In essence, she becomes a component. The only consideration (besides the lighting) is the strategy used in Photoshop to separate the model from the background. In other words, if a medium gray backdrop is used behind a model with dark hair wearing a red dress, the *Magic Wand* tool can easily select the background without grabbing any portion of the woman. Then, using *Select: inverse*, everything will be selected *except* the background, which means only the model will be selected.

However, if you photographed the model against a background that was similar in color and/or contrast to her clothes, hair, or skin, the *Pen* tool should be used to cut her out. This takes longer and is a rather laborious task.

Eventually, you will want to have a collection of components, already separated from their environments, which you can use in combination with other images. The range of subjects that can be used for this purpose is endless. Your list may include windows, doorways, animals, flowers, mannequin heads, geodes, tree silhouettes, ice sculptures, masks, bubbles, and so on. When possible, it's a good idea to photograph these objects against a uniform background that will allow you to digitally separate them easily in Photoshop.

All of my components are stored on CDs. When I want to use a particular image, it takes only a few moments to copy it from the CD onto my hard drive. To identify which images reside on each CD, I make one color print for each CD using my Epson color printer. It shows thumbnail images of each component along with an identifying number. Flipping through these pages in a loose-leaf binder, I can quickly view hundreds of images and identify the components I wish to use in a new composite photograph.

Sometimes as I manipulate an image, it suddenly occurs to me that I've created a unique component. This background design is actually a shot of Antelope Canyon near Page, Arizona. I applied Filter: other: Terrazzo, *which kaleidoscoped the sensual contours of the canyon walls into a graphic image. This conveniently offered a platform on which I could place a model.*

The model was not photographed in this position to fit into this background, but it worked out perfectly. I cut and pasted her into the scene, sized her to fit, and then selected a large rectangle that coincided with the white glow enveloping the model. I used the Pen *tool to define the area, and with* Select: feather, *I chose 30 pixels as my feathered edge. I filled the selection with 25 percent opacity white using* Edit: fill *to suggest a wide beam of light focused on the model.*

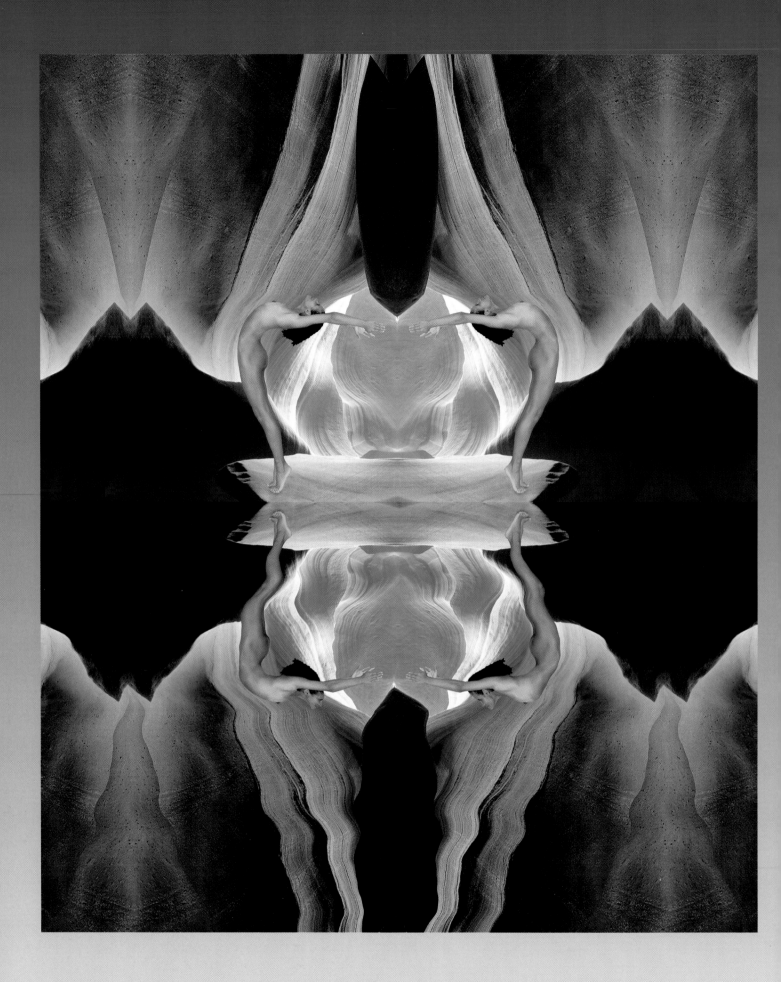

The Terrazzo *plug-in filter is one my favorites, as you've probably deduced since there are several examples of it in this book. It can produce remarkable designs out of any photograph, and I never tire of its possibilities. This exquisite background comes from the same original shot of Antelope Canyon as the background in the image on page 94. A single photograph can generate literally dozens of amazing images using* Terrazzo, *and these two pictures illustrate this dramatically.*

Months before I photographed this model, I had taken pictures of a ballerina who was so limber she could gracefully bend backward at a 90-degree angle. I wanted to do the same thing with this model, but she couldn't come close to assuming the same position. I took two separate pictures of her: one with her arms above her head and the second bending backward as far as she could. I then did a little digital surgery and pieced the two shots together. I used the Lasso *tool to select the parts of both images, the* Move *tool to reposition the pieces, and then the* Clone *tool to smooth the transition. I also used* Layer: transform: rotate *to change the angle of her upper body.*

*Once I liked her body position, I pasted it into the background twice, flipping one of the shots horizontally (*Layer: transform: flip horizontal*). The entire upper portion of the picture was then flipped, distorted with the* Wave *filter, and darkened to simulate water. See the caption on page 91 for a description of creating a reflection.*

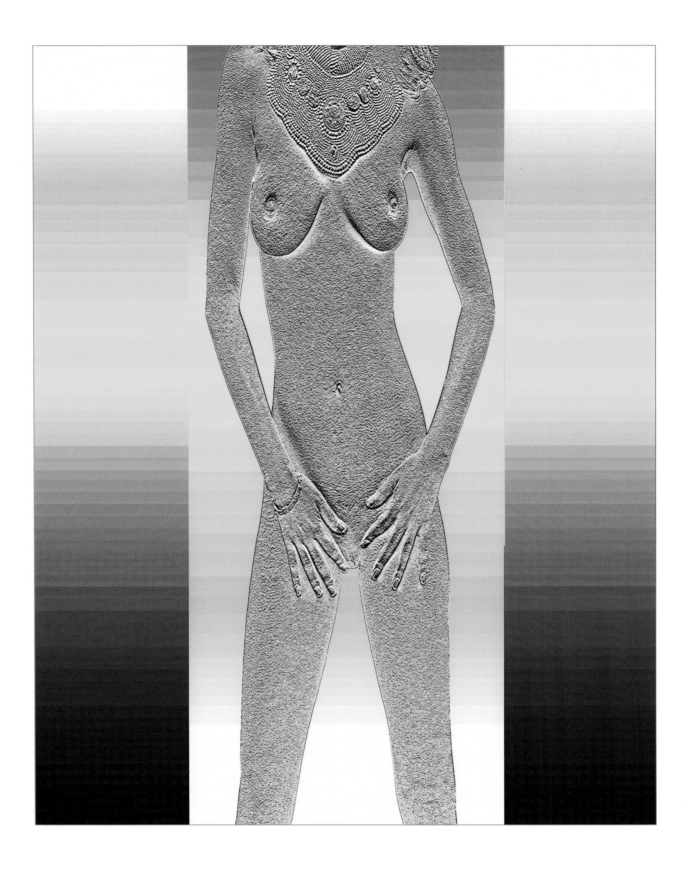

Location

One of the most important components you will need is a variety of locations. For photo composite work, the environment into which all of the other pieces are placed is obviously important. Depending on the type of images you want to create, your locations could include moody interiors such as an upscale but dimly lit restaurant or an English pub, a cavernous room in a European castle, a fall foliage composition in Vermont, clouds photographed from an airplane window, an underwater shot in Hawaii, a high-tech office interior, or perhaps a fantasy environment in Disney World.

In creating the images for this book, I studied several hundred possible backgrounds for the many composites reproduced on these pages. In several instances, I specifically photographed a model so she could be combined with a background. In other cases, I looked for a location or environment to photograph that would work with a pose I already had on film from a previous photo session.

I would recommend that the location images you take for possible digital manipulation be shot on fine-grained film. When you combine images, grainy slides don't look good with fine-grained images. For example, if you combine a model shot on 50-speed film with a sunset taken with 400-speed film, the discrepancy in grain will be unrealistic and disturbing. Should you want a grainy appearance in the final composite, you can add as much grain as you want to any photo using the pull-down menu *Filter: noise* in Photoshop. However, if the original is grainy, you can not digitally convert that picture into one that has fine grain.

I have a collection of nude torso components, because there are so many varied techniques that can transform an ordinary mid-body shot into a work of art. I usually use shadowless front lighting, knowing that practically anything can be done later in the computer. This original torso was photographed using two white soft boxes on either side of the model. She wore a neck piece I bought in India.

I first stretched the figure in Photoshop using Layer: transform: scale. *Next I applied* Filter: sketch: bas-relief *to it. The background was monochromatically off-white; when I selected it with the* Magic Wand *tool, I opened the dialog box for* Curves (Image: adjust: curves) *and manipulated the diagonal line bisecting the box. This created the unique background, and after working with* Hue/Saturation, *I settled for the brilliant yellow hues.*

The nude torso and the banded background were then pasted into another version of the same background and flipped vertically.

99

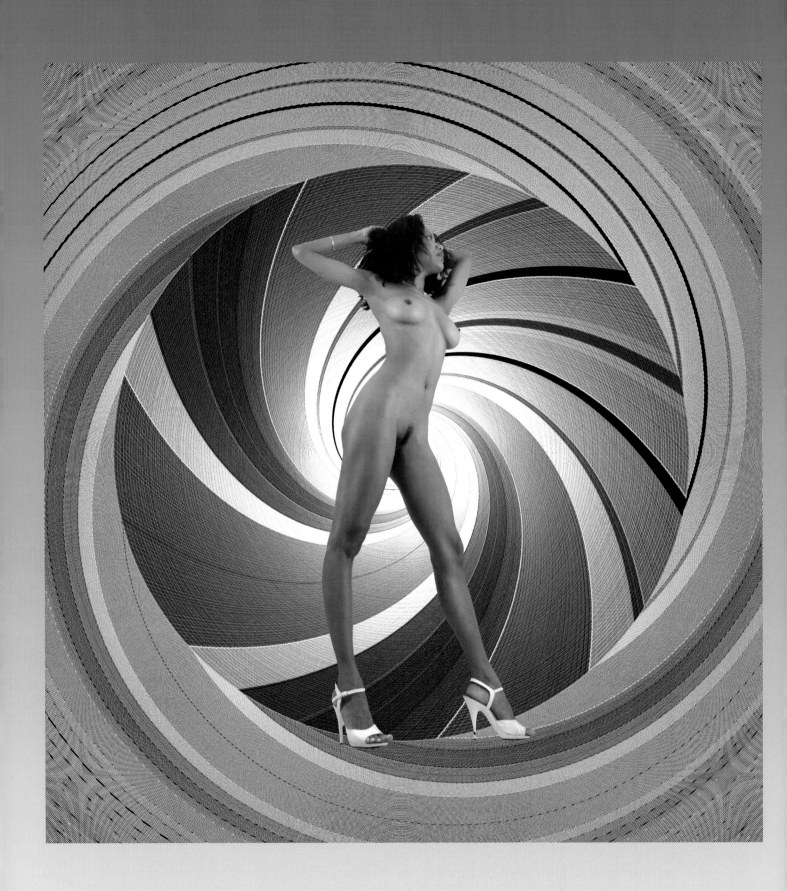

Some of the components I use are entirely computer-generated. The background in this image is a Kai's Power Tools abstract generated by using their Gradient Designer. Then in Photoshop, I applied Filter: distort: twirl *to produce the swirled design. The model was simply cut and pasted in.*

100

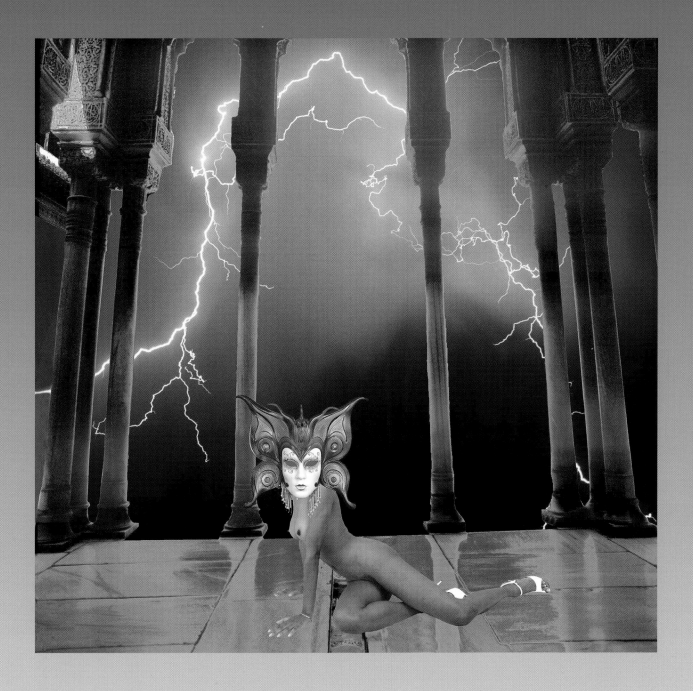

This image consists of four elements, all photographed on fine-grained film so that sharpness and detail match. The lightning was photographed in Nevada, the architecture is a portion of the Alhambra in Spain, the model was photographed in a studio, and the mask was hanging in my living room and photographed on the wall.

I first applied, in Photoshop, Filter: stylize: solarize *to the architecture. The lightning was then pasted into the spaces between the arches, and the model was pasted into the foreground. The mask was added last. Using* Hue/Saturation, *I altered the color scheme of the entire composition. I then selected the eyes of the mask with the* Magic Wand *tool and chose* Edit: fill *to make them purple. The color seen in the foreground box at the bottom of the* Tool *palette is the color that is placed into a selection with the command* Edit: fill. *You can choose any color by clicking on the box and selecting a color.*

Hair

The biggest problem you will face in separating a model from her background is the hair. It's a frustrating problem. Unless the hair is wet or tied tightly against her head, it is impossible to cut around each individual strand of hair.

There are three solutions to this problem. First, as I've already suggested, choose a hairstyle that makes it easy for you to separate it from the background. If the hair is wet, or if it forms tightly to the head, it is a simple matter to use either the *Magic Wand* tool or the *Pen* tool in Photoshop to execute the separation.

Second, photograph the model in front of a color that matches very closely the color that will be behind her in the photo composite. If you are planning to paste her into a landscape where her head will be in front of a blue sky, then take the original portrait of her against a similar blue color. Now, instead of cutting closely around the hair to isolate the model, you can include some of the blue background, which in turn will allow you to capture all of the hair. When the woman is pasted into the landscape, you can use the *Clone* tool to blend the two shades of blue together.

Third, you can use a program specifically designed to realistically outline hair and other challenging subjects, such as smoke. One of the most sophisticated, and expensive, of these programs is Amusematte, which is designed to be used when the model is photographed against a solid blue color. The specific type of blue that is required, often referred to as blue screen, is available either in fabric or paint. An alternative program available for the same purpose that costs less and is used in conjunction with Photoshop is Primatte S100.

The original photograph of this nude came from the latex series described on page 41. I used Levels *and* Hue/Saturation *to sharply increase contrast and alter the colors. Then I selected a small portion of the model's body, chose* Edit: define pattern, *and then filled the background using* Edit: fill *(and choosing* Pattern *within the dialog box). I abstracted the pattern with* Filter: distort: wave. *Within that dialog box, I adjusted the parameters until I liked the wild design.*

Finally, clicking on two different parts of the model with the Eyedropper *tool, I chose a color for the foreground and background boxes in the* Tool *palette. I then selected the eyeglass lenses with the* Magic Wand *tool and used the* Gradient *tool to fill the sunglasses with colors that matched the rest of the picture.*

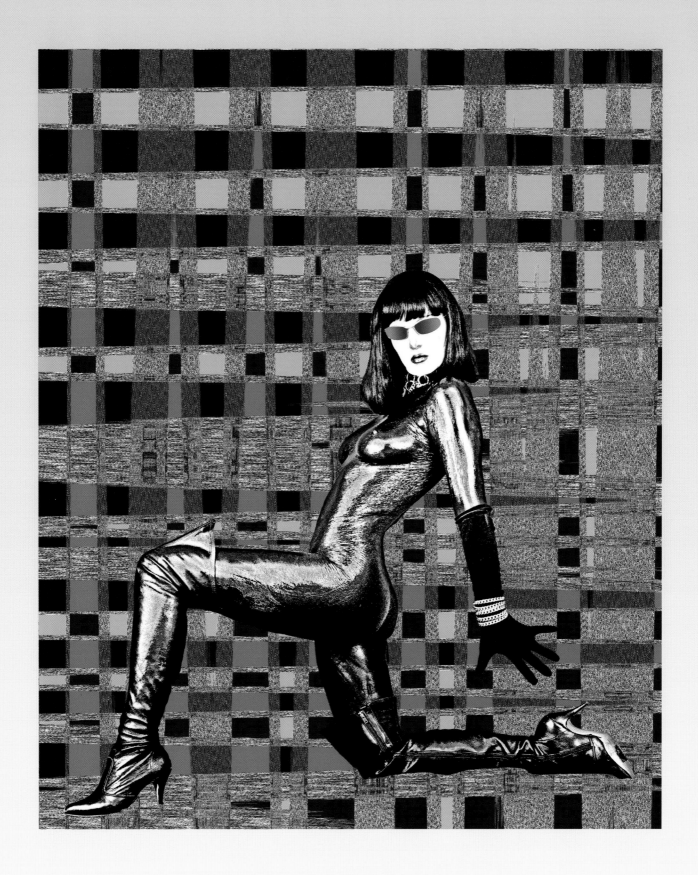

6 Turning a Photograph Into a Painting

There are techniques within both Adobe Photoshop and MetaCreations Painter that allow you to make any photograph look like a painting. Different painting styles are available depending on the commands used. You can abstract a photo to any degree and make it look like paint was actually smeared on a canvas, you can create images using pointillism, you can convert your favorite portrait into a charcoal sketch, and you can even imitate the brush strokes of Van Gogh, Monet, and other artists. The range of possibilities is truly remarkable. Some of the techniques can be done quickly and virtually without effort, while others require finesse and a deeper knowledge of the program.

I have divided the techniques I use to achieve a painterly look into four categories. Each is capable of producing unique and exquisite renditions of your original slides, although a technique that works well on one photo may not be as successful on another. You won't know until you try it.

Filters

In conventional photography, filters are used to alter color, control light, or produce a creative effect in a photograph. Made of glass or optical-grade plastic, conventional photo filters are usually placed in front of the lens. Typical creative effects filters include star filters, multiple-image prisms, diffusion, and colored filters, such as orange, blue, yellow, and so on. In the digital world, filters are also used for special effects purposes, but the types of effects available to you go so far beyond conventional photographic filters that it is almost like com-paring apples and oranges.

In Photoshop, you find all your filters under the pull-down menu *Filters*. Many filters are included in the software package when you purchase Photoshop. Plug-in filter programs can be added, such as those from Andromeda Software, MetaCreations, Xaos Tools, and others. Eventually, you will want dozens of filters. They are a simple and easy way to achieve fantastic effects. I use them all the

A filter in Photoshop that I frequently try is Find Edges. *It turns an image into what looks like a sketch or a pen and ink drawing. After I applied the filter, I altered the color using* Hue/Saturation *and then added grain by selecting* Filter: noise: add noise.

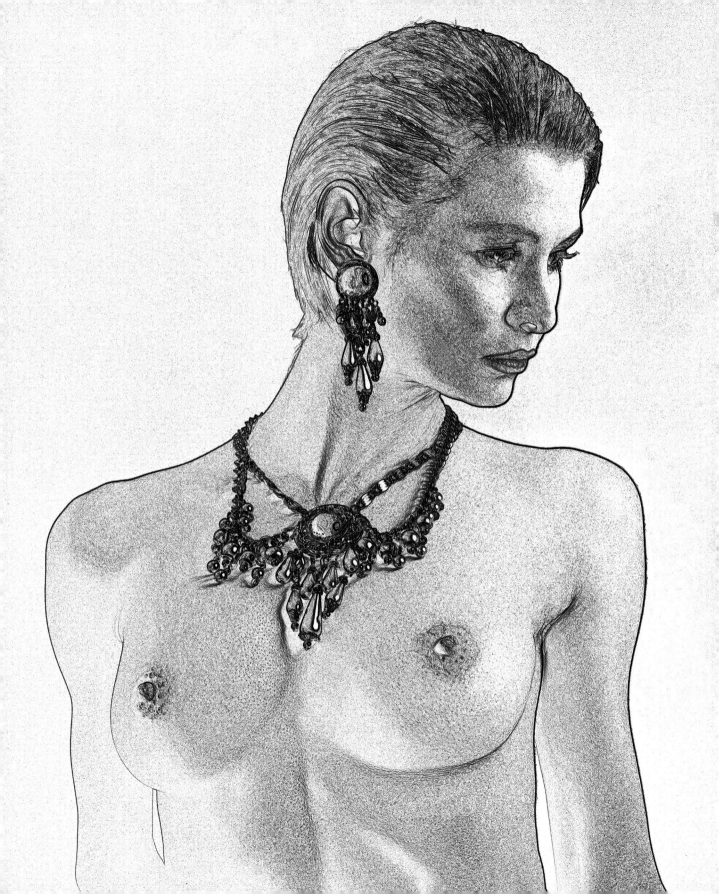

time, and I'm continually intrigued by how they transform my photographs into exciting works of art.

A filter may not affect all photographs in the same way. For example, the filter *Colored Pencil* can be applied to three different photos, and the results will appear to be quite different. Many factors affect how a filter responds to an image. The combinations of colors, the contrast between highlights and shadows, the type of lighting on textured surfaces, and the amount of fine detail all influence the result. Sometimes the *Chrome* filter works brilliantly, and sometimes the effect isn't pleasing at all. I've used the *Bas-Relief* filter and turned a nude into what looks like a sculpture in ice, and then I applied the same filter to another photo with a very different, and disappointing, result. You will want to try many filters on each photograph to find the effects you like. Many times there will be several filters that work well on a single image.

When you combine filters, the original photo moves further away from a realistic image and becomes much more like a drawing or painting. For example, the *Accented Edges* filter can be applied first, then *Poster Edges*, and then *Palette Knife*. Every time another filter is applied, the original become more and more abstract in different ways.

Some filters will take longer than others because the mathematical calculations being made are more complex. Be patient—a dramatic filter effect is worth waiting for. When you apply filters to high-resolution images (32 MB for a 35mm slide), the computer must make millions of calculations. The more RAM you have, the faster your machine will deliver the results. If you don't like what the filter did to your pictures, simply use the *Undo* command and try another effect.

My favorite filters are: *Accented Edges, Poster Edges, Emboss, Extrude, Chrome, Spherize, Palette Knife, Terrazzo,* and *Bas-Relief.* I use these all the time.

One of the techniques I use to create the look of a painting is to apply a filter to an image and then paste the new image over the original. In the Layers *palette, I select a mode that blends the two pictures together in an artful way.*

I applied Palette Knife *and* Chalk and Charcoal *to this portrait in Photoshop, and then copied the result to the clipboard. I clicked* File: revert *to change the altered image back to the original version. Then the clipboard image was pasted* (Edit: paste) *over the original. In the* Layers *palette, I chose* Hue *and flattened the image by clicking* Layer: flatten image, *meaning the floating layer was permanently blended with the underlying original. Then I applied the* Palette Knife *filter again.*

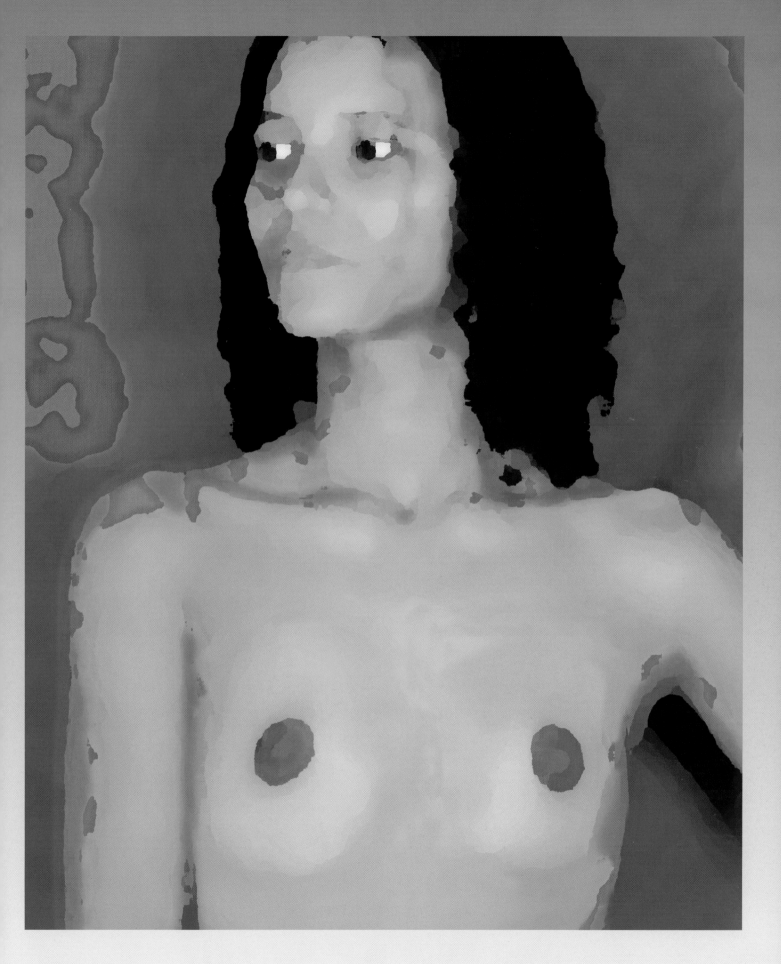

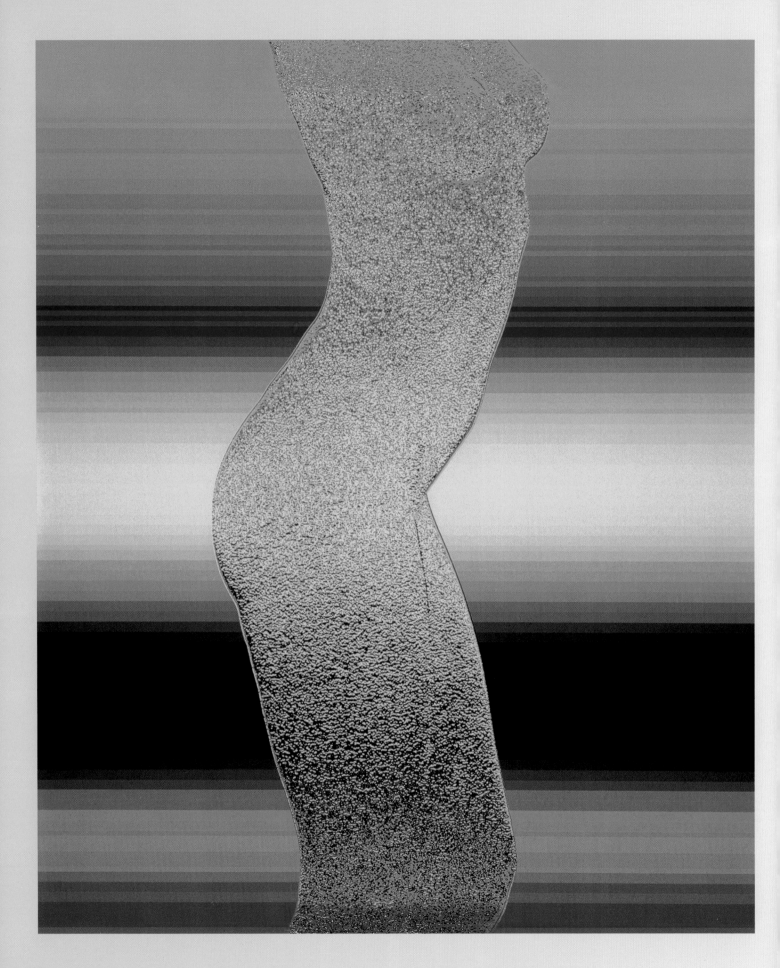

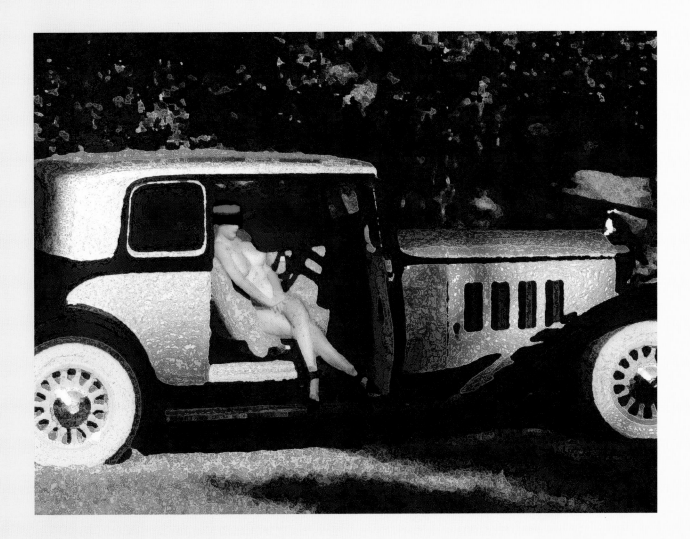

Combinations of Photoshop filters can turn photos into paintings. This picture of a nude posing in a 1932 Pierce Arrow was first abstracted by using Palette Knife *and then* Ink Outlines.

Left: The Bas-Relief *filter, like so many of the filters in Photoshop, will produce a variety of results depending on the colors and contrasts in the original photograph. I used this same filter with the image on page 61, and notice how different the effect is.*

With this particular image, the nude torso was photographed against a blue background. I selected the figure by first selecting the background with the Magic Wand *tool and then using the* Select: inverse *command, which grabs everything except the background. The filter was applied to the model. Then I re-selected the background with the* Select: inverse *command and used* Image: adjust: curves *to obtain the horizontal abstract lines. In Hue/Saturation, I altered both the color scheme and the saturation of those colors.*

Curves

In Photoshop, click on the pull-down menu *Image: adjust: curves*, and a dialog box opens with a diagonal line dividing a grid. You can bend and distort this line, and as you do so, the colors in the original photograph change dramatically. In addition, the light and dark relationships change. This means that areas of the photo may, depending on how the diagonal line is bent, go from positive to negative and then back to positive as you continually experiment with the movement. Some of the highlights will become shadows, and as the line is manipulated, you will see an amazing display of abstract colors and tonal values.

The wild display of colors you see occurs on all three color components: red, green, and blue. If you want to manipulate only one of these, click on the arrow at the top of the dialog box (next to RGB) and pull down one of the three colors. As you bend the diagonal line, only a third of the spectrum will be affected in the photo. If you don't like what you've done and want to start over, hold down the option key on the keyboard and click reset.

At times, as you watch how your photo is abstracted, you will be reminded of the traditional darkroom technique, color solarization. Sometimes your photo will look like another darkroom procedure, posterization. The changes you make can range from subtle to wild and psychedelic.

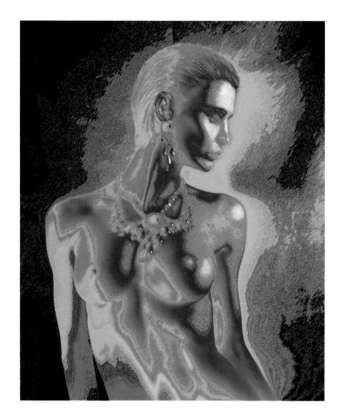

Psychedelic colors and patterns can be easily produced by using Image: adjust: curves *in Photoshop. Depending on how the colors are manipulated within the dialog box, an image may begin to look less and less like a photograph. Not only are colors drastically altered, but portions of the picture will be positive while others are negative. This interplay will produce some amazing results with virtually any photograph.*

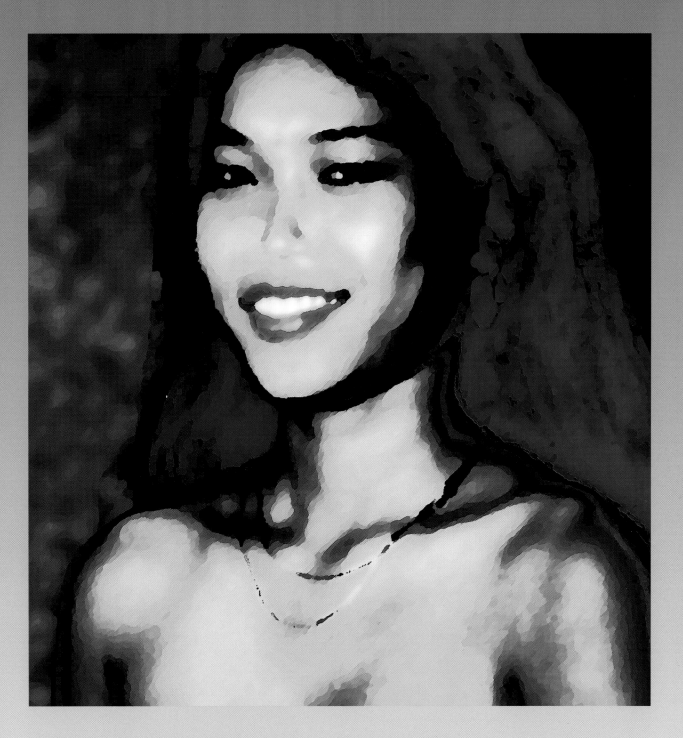

It's easy to create a painterly feeling to a photograph when multiple effects are applied, all super-imposed over each other. This is a perfect example. In Photoshop, I used Curves *to alter color. Then I pasted the result over the original, choosing the mode* Overlay *in the* Layers *palette. In* Hue/Saturation, *I changed the color balance and then applied two filters:* Palette Knife *and* Dark Strokes. *Next I adjusted the contrast using* Levels, *and finally, I selected the lips with the* Magic Wand *tool and increased the depth of their color with* Hue/Saturation.

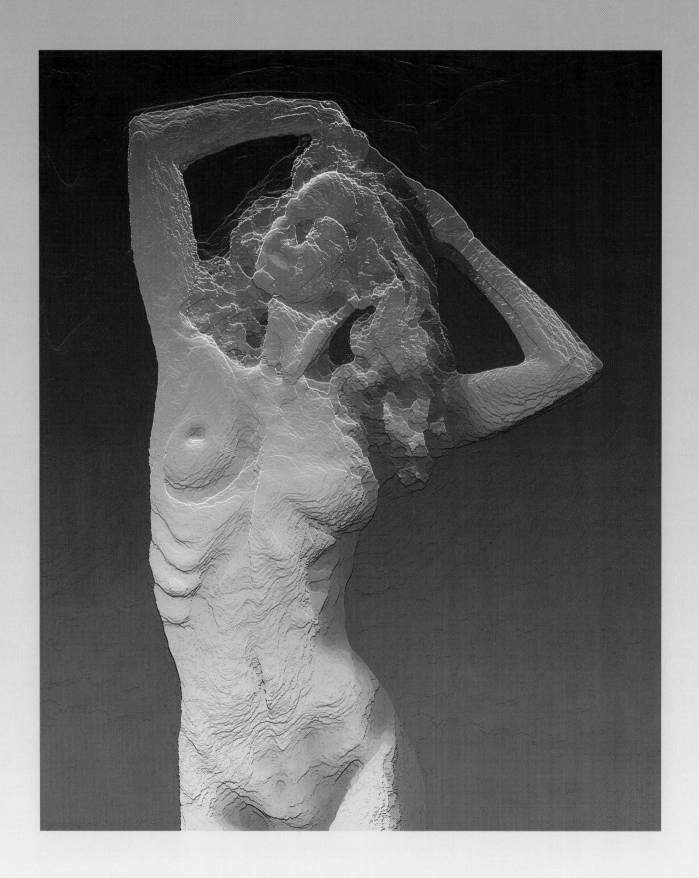

Layer Upon Layer

One of the unique methods for creating painterly images from photographs is the technique of pasting an original photo over a manipulated version of itself, or vice versa. Sometimes I paste one manipulated version over another of the same photo.

In Photoshop, let's say you applied the filter *Pointillize* to a photograph and saved it as a new file. Let's call it **Pointillize 1.** When you copy **Pointillize 1** to the clipboard and then paste it over the original, unmanipulated version, you now have a floating layer. At this time, all you can see is **Pointillize 1**, but underneath is the original photograph. In the *Layers* dialog box, you can now combine the two images in a variety of ways. For example, by moving the *Opacity* slider bar, the opacity of the floating layer (the filtered version) can be adjusted so you can see the original photo through the pointillized effect of the floating layer.

There is a small, rectangular box in the upper left corner of the *Layers* dialog box where you can see the word *Normal*. If you pull down the arrow just to the right, a list of words appears. Each of these words indicates a unique way in which the two photos can be combined. Try *Luminosity, Overlay, Soft Light,* and *Multiply.*

These often work well. You'll want to experiment with each one to see if you like what they do. By working with the opacity at the same time, you have yet another method of altering your photos and creating painterly images.

Cloner Brushes

I discussed MetaCreations Painter's *Cloner* brushes in chapter four, but they are such a unique and wonderful aspect of digital manipulation that I wanted to go into more detail here. Some of my favorite images in this book were created using various *Cloner* brushes. They are easy to use, and as you convert a conventional photo into a painting by smearing and distorting the colors and shapes within the image with one or more brushes, you will be amazed at the wonderful works of art you are capable of making.

The *Cloner* brushes are accessed in the *Brushes* palette. By clicking on any of the icons in the palette, you select one of the brushes. Each brush has several variations in the way it smears and distorts the color in photographs. For example, the *Water* brush can be used with *Big Frosty Water, Water Rake, Water Spray,* and several more. The brushes called *Cloners* (when you click on an icon, the name of that

This image is also a manipulated photo pasted over itself. I opened the image on page 61, copied it to the clipboard, and then opened the original nude portrait that was used to create the image on page 61. I pasted the clipboard picture onto the original with Edit: paste. *In the* Layers *palette, I chose the mode* Soft Light *from the pop-up menu. By choosing different modes, the floating layer and the underlying photo are blended in different ways. The opacity of the floating layer can be changed in all of the modes, giving you even more control of this painterly technique.*

group of brushes is displayed after the word *Brushes* at the top of the palette, e.g., *Brushes: Cloner*) offer many of my favorite variations. These *Cloners* include *Melt, Impressionist, Van Gogh, Driving Rain,* and *Pencil Sketch*.

To begin using these amazing tools, first click on *File: open* from the pull-down menus and open a photo in Painter. Then click on *File: clone*. Painter makes a duplicate copy of your photo, and this is where all of the action will take place.

Having selected the *Cloner* brush and one of its variations, go to the *Controls: Brush* palette and select the size of the brush. Start with the default and then change it as you wish for different effects. Small brush strokes will give you more detail in the final painterly version of the image. Larger strokes will abstract the photo to a greater degree. Initially, leave the opacity and grain controls at their default settings.

Next, and this is very important, go to the *Art Materials* palette and click on the color icon in the upper left corner. This brings up a color wheel, if it is not already showing. Click on the *Cloner* color box. This tells Painter to affect the actual colors in your photo as you brush them. If you don't do this, the program will paint over the photo with new colors taken from the color wheel.

You are now ready to begin. Click on the *Paintbrush* tool in the *Tool* palette and begin applying the effect you've defined to the photo. If you don't like the results, simply undo them and try again, perhaps with a different brush or with another variation of the same brush. When you are satisfied with your work, save it as a new file.

As you work on the clone of your photo, you will see the entire photo plus the portion that is being altered. If you don't want to be distracted by the original photo and only want to see the painterly effect as it is being laid down, try this approach. With the cloned photo open, click on *Select: all* in the pull-down menu. Then hit the delete key. The cloned photo is now solid white. As you apply any one of the *Cloner* brushes, the effect will be visible without seeing the rest of the unaltered photo.

There are so many possibilities for creating fantastic images using *Cloner* brushes that you could be kept busy for years.

I have used the Cloner *brush* Artist: Flemish Rub *in Painter for many images because it does such a good job in simulating actual brush strokes on canvas. The way it smears and mixes the colors in the original photograph depends on the size of the brush. In the* Controls: Brush *palette, slider bars allow you to change the size, opacity, and grain of the applied strokes. The difference between a small and large brush size can dramatically affect the photo.*

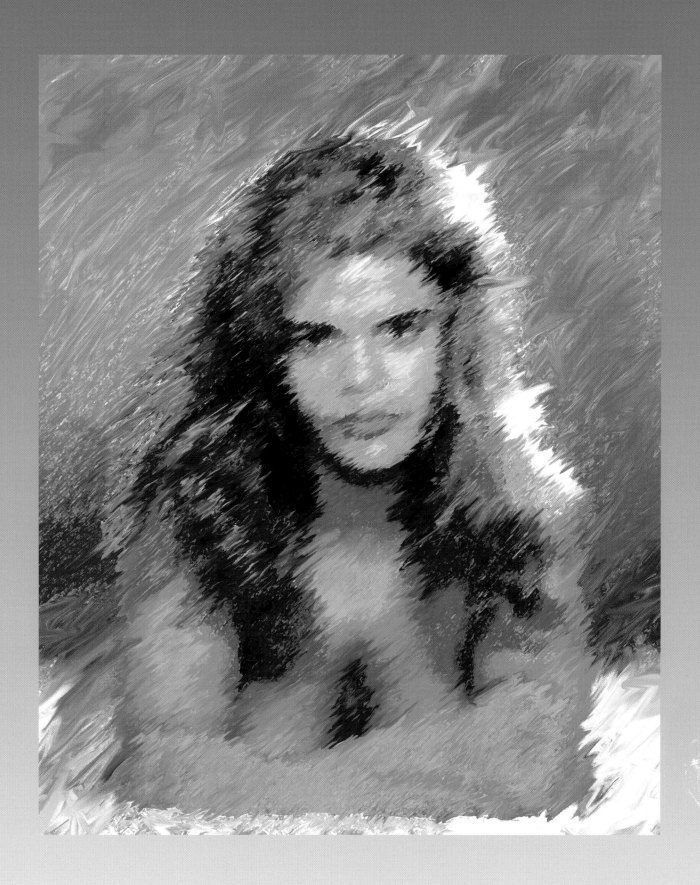

Fantasy Nudes

Using Cloner *brushes is a favorite technique of mine, but it's important to make sure that as the colors and graphic shapes of an original are distorted, the subject doesn't become unrecognizable. The lines of breasts and the features of a face, for example, can easily be smeared beyond recognition with large brush strokes. Beautiful hair and long legs can likewise be abstracted to a point where the model is hardly distinguishable from the background. When I've gone too far with a brush, I use* Undo *and try again.*

This shot was manipulated in Painter using the Cloner *brush* Square Chalk. *I applied diagonal strokes and then altered the colors within Photoshop with* Hue/Saturation *command.*

As I've shown in previous chapters, the Cloner *brushes in Painter are a tremendous resource for turning photographs into paintings. I used* Mouse: Spirex *for this shot, smearing the colors in the image as if I were actually using a brush and oils on a canvas. Using the digital brush, I extended the length of the model's hair with downward strokes.*

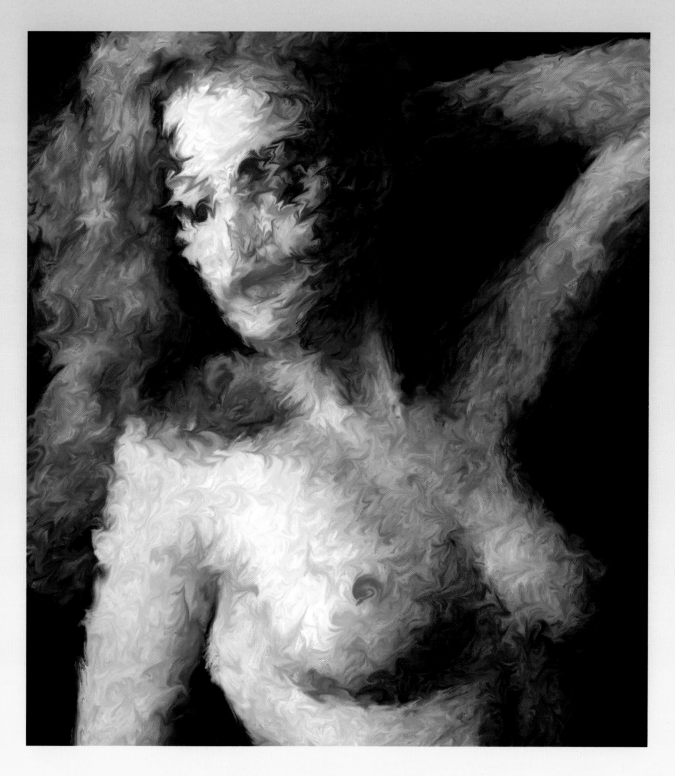

One of the Cloner *brushes that most simulates the application of paint on a canvas is* Liquid: smeary mover *in the program Painter. As I was transforming this nude portrait, I was amazed by how the colors blended together in the same way that paints do. Either a mouse or a Wacom pen will work in producing the effect, but I prefer the pen because it provides much more control.*

Auto Van Gogh

Auto Van Gogh is simply an automated way to use a *Cloner* brush on a photo. Instead of manually applying the effect by moving the *Paintbrush* tool over the entire photo, you can define all the parameters, and Painter will transform the photograph into a painting while you're having lunch. Depending on the speed of your computer, the amount of RAM you have allocated to Photoshop, and the size of the digital file, it will indeed take some time. My 200 MHz Macintosh PowerPC 9500 takes about twenty minutes on a 38.4 MB file.

This command can be found under the pull-down menu *Effects: esoterica: auto Van Gogh.* Once you have selected the brush and its variation, clicked on the *Cloner* color box in the *Art Materials* palette, and chosen a brush size in the *Controls: Brush* palette, select the *Auto Van Gogh* command, and the computer does the rest.

Do keep in mind, of course, that by using the automated method you lose some control over how the brush strokes are laid down. When you apply the effect manually, you can emphasize certain portions of the photo. For example, you may want to dramatize the shape of the eyes by painting along the contours of the eyelids and eyebrows. With *Auto Van Gogh*, Painter lays down random strokes that will give a different end result.

Sometimes I use non-photographic elements that combine with photography in a way that suggests a painting. The background in this conceptual composite, for example, was generated almost entirely from abstracting a silver gradient produced in Kai's Power Tools. First, the abstraction was wrapped onto a column using the 3-D capability of Andromeda's Series 2 3-D filter, and then the same abstract was laid out in a plane using KPT Planar Tiling. The column was cut out and pasted in front of the plane in two places. A photograph of stars (glitter on black velvet) was pasted into the frame above the horizon of the plane. (See page 151.)

This entire composition was then pasted into a new file that measured twice the width (instead of 4096 x 3277 pixels, it measured 4096 x 6554). I pasted it in a second time and flipped it vertically, creating the mirror image. With the circular Marquee *tool, I defined a circular selection in the center of the picture and applied* Filter: distort: glass lens, *another Kai's Power Tools filter. The model, who had been photographed from above, was isolated from her background with the* Pen *tool, copied to the clipboard, and then pasted into the sphere. In the* Layers *palette, I adjusted the opacity of the floating layer (the model) to 60 percent. The last step was to use* Image: image size *and resize the image to the proportions I use for a 6 x 7cm output to film, 3277 x 4096 pixels.*

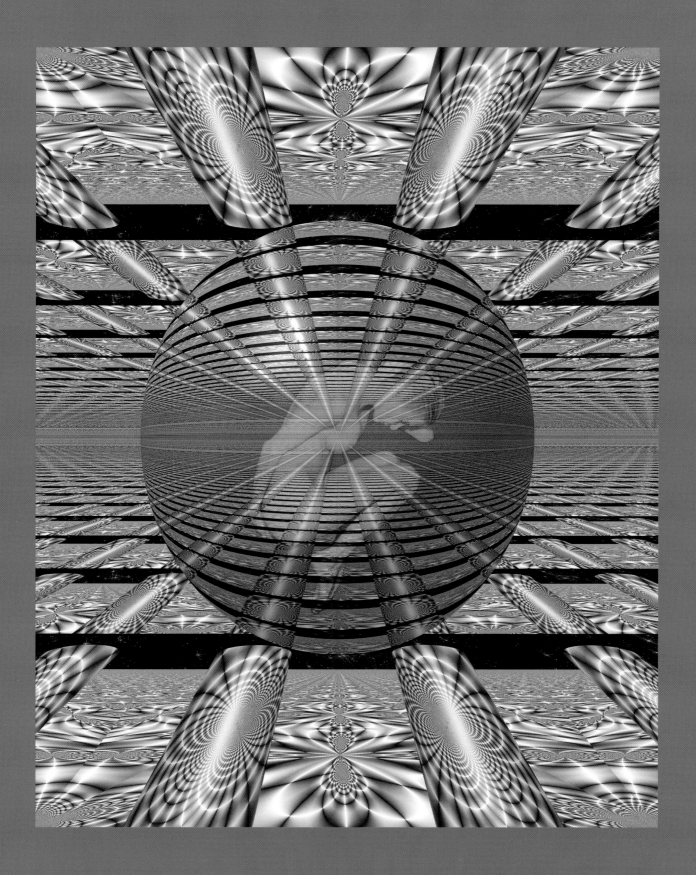

7 Compositing Two or More Photos

One of the most powerful aspects of digital manipulation is the ability to assemble two or more photographs into a single composite image. Although traditional darkroom methods can accomplish the same end, you have infinitely more control over the process in the computer, the work is less painstaking, and you are not standing in the dark breathing fumes from photo chemicals. In addition, you can see the result of your work in real time on the monitor, whereas darkroom work can only be accessed after the exposures are made and the film or print is developed.

This is the most exciting work I do on the computer. There are no artistic boundaries, no constraints of any kind to limit my imagination. I can create fantasy, I can simulate reality, I can imitate the Renaissance masters, or I can visually go off the deep end. With the ability to juxtapose and combine photographs, all of the slides in my collection can be viewed anew. Now, instead of a beautiful landscape, a lovely macro shot, a compelling portrait, or dramatic wildlife study, I see pieces that when assembled with other pieces will give me a totally original and unique image.

This beautiful interior, the Galleria Emmanuel Vittorio II, was the first indoor shopping mall in the world. It was built in the nineteenth century in Milan, Italy. I photographed it with a fisheye lens, which is why there is unlikely curvature in the picture. It was shot with available light at twilight. The illumination was mercury vapor, which produced a blue-green cast on the picture. I first eliminated the blue-green color using Color Balance *within Photoshop by adding magenta and yellow, the complements of blue and green.*

I then opened the image of the model and separated her from her background with the Pen *tool. The compositing of the architecture and the model was done in two stages. With the* Magic Wand *tool, I selected the young woman's figure without including her garment. This selection was pasted into the image of the Galleria, sized with* Layer: transform: scale, *and positioned with the* Move *tool. I then selected only the white garment from the original studio portrait and pasted it in place. At this point, the model and her garment are each separate layers. In the* Layers *palette, I adjusted the opacity of this garment layer to 60 percent until the architectural detail could be seen through the thin fabric.*

With the Clone *tool, I touched up any imperfections where the white fabric mated with the model's arms and torso. There were minute gaps in a few places that were easily eliminated.*

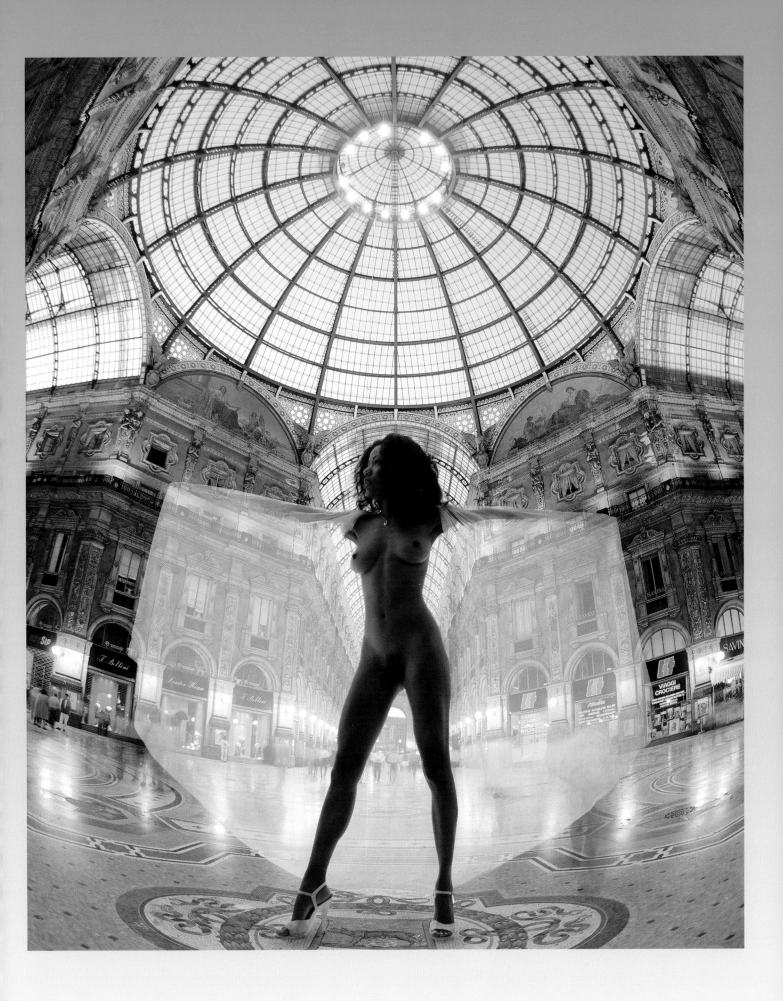

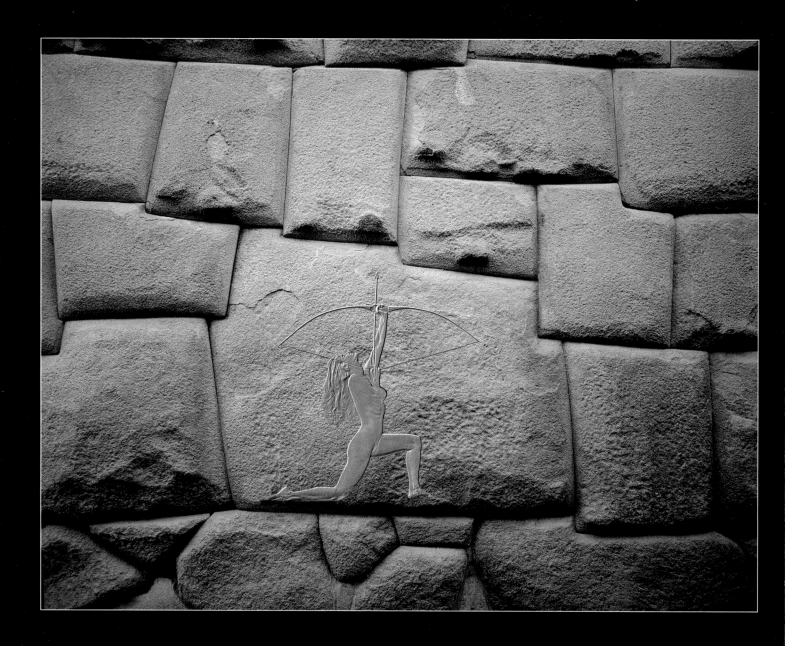

Choosing the Components

In chapter five I discussed the importance of choosing photos for your composite that are believable when combined. There are a few details you must always keep in mind. For example, the lighting on the various pieces must match. A front-lit model photographed with a strobe should not be composited with a side-lit flower or a backlit animal. Similarly, a grainy subject photographed on 35mm film should not be combined with a fine-grained background shot on medium format. In fact, you shouldn't combine any 35mm slide with a medium or large-format picture unless the 35mm subject will be a small part of the whole. If both the 35mm shot and the medium-format subject are prominent in the frame, there will be a sharpness discrepancy. The medium-format component will appear significantly, and disturbingly, sharper than the 35mm component.

The color of each component is not as critical, because it is easy to alter the color balance of any element in the picture. A front-lit model photographed with a strobe can be combined with flowers front-lit by a setting sun. In the computer, the model can be altered to look like she was photographed using the same sunset.

Think twice about using components that are difficult to cut out of their backgrounds. Feathers, fuzzy animals, smoke, blurred subjects (like a picture of a bird in flight photographed at 1/8 second), and clouds are all difficult to isolate and use in another image. It can be done, but the results will be largely dependent on your expertise with the tools within Photoshop.

Blending components together into a composite means making sure the color of each piece makes sense. For example, a model photographed in sunset light shouldn't be combined with an outdoor location photographed under an overcast sky unless the color balance of one or both were altered to match the other.

These stone blocks were formed by the Inca people of Peru centuries ago. They didn't have mortar, so they cut the blocks to fit. The picture was taken in deep shade, which reproduces as blue on film.

I wanted to suggest that an ancient etching had been made on the wall, so I photographed a model with a bow and arrow and then in Photoshop applied Filter: stylize: emboss. *The* Emboss *filter simulates a relief effect which was perfect for this scenario. I pasted the embossed nude onto the center block and selected the* Overlay *mode in the* Layers *palette. I then selected* Layer: new: adjustment layer *and clicked on* Color Balance. *This allowed me to change only the color in the floating selection, which was the model. I made the image of her blue to match the background and then applied* Layer: flatten image.

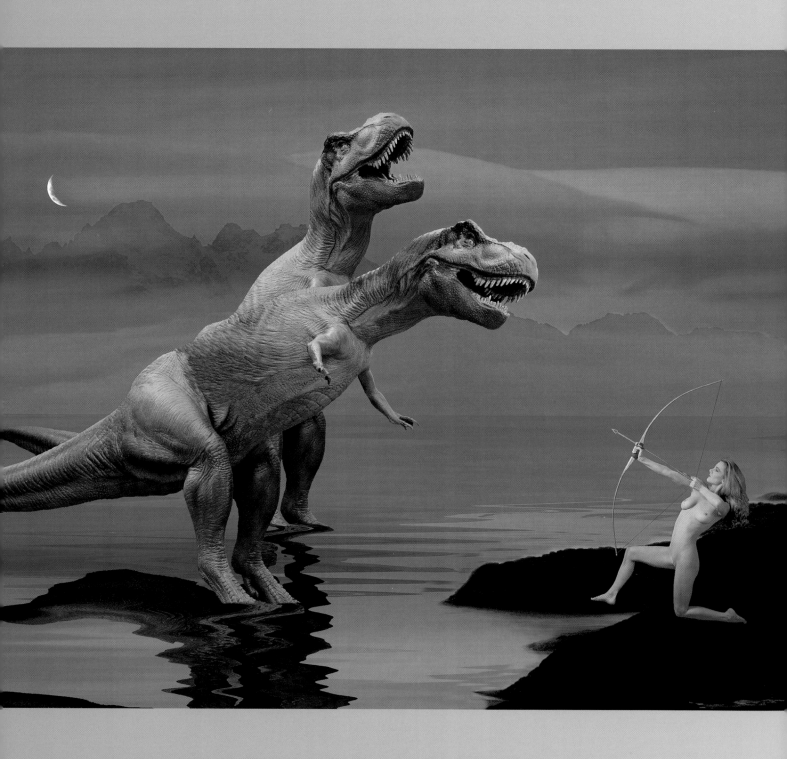

This picture consists of six components: the mountains of Alaska, the moon and clouds photographed in Arizona, the nude photographed in a studio, a shoreline in Oregon, and a single 30-inch dinosaur model photographed in my backyard.

I began with the background photo of the mountains. I pasted a picture of ethereal clouds over the sky and mountains and, in the Layers *palette,* adjusted the opacity of the floating layer until I was satisfied. The moon was pasted in, sized appropriately, and then positioned. In the Layers *palette, I chose the* Lighten *mode, which eliminated the hard edge around the moon and blended it with the sky.*

I created the virtual water, complete with waves, using the same steps as described on page 91. The T-rex photo was separated from its environment using the Pen *tool. However, instead of including the feet in the selection, I cut them off where the "water" level would be. The dinosaur was copied to the clipboard and then pasted into the foreground, sized, and positioned. I chose* Select: save selection. *This created an* alpha channel, *which simply is a means to recall the selection around the dinosaur whenever I hit* Select: load selection.

Next I chose Select: inverse, *which selected everything in the picture except the dinosaur. The clipboard still contained the dinosaur image, so I clicked on* Edit: paste into *to place a second dinosaur into the scene, but this time it was behind the first one. I moved it into position with the* Move *tool.*

Notice how the two dinosaurs appear different. I used the same model for both, but I thought it would look foolish to have identical body and head positions. To change the angle of the head and tail, and to open the mouth more, I used four actions: Select, Rotate, Move, and Clone. When I worked on the head and neck, I selected a portion of it using the Pen *tool, and using* Layer: transform: rotate, I *rotated it to the desired angle. The selection was then grabbed with the* Move *tool and repositioned to meet the rest of the body. I used the* Clone *tool to fill in the gaps left by the decapitation and reattachment. The same procedure was used for the tail and the mouth.*

From the photo on page 45, I selected the foreground rock jutting into the water and pasted it into the lower right corner of the frame. The model was then pasted onto the rock, sized correctly, and rotated (Layer: transform: rotate) *so the arrow was pointed in the appropriate direction.*

The Selection Process

Once you've chosen the component photographs that will make up the final composite image, the next step is to separate them from their environments. If you photographed a nude at the edge of a swimming pool, she would have to be removed from the backyard before she could be combined with other elements and another background. If you were going to digitally place a mask on her face, then the mask would likewise have to be separated from its background.

The two selection tools in the Adobe Photoshop *Tool* palette I use most often for compositing photos are the *Magic Wand* tool and the *Pen* tool. They work differently, and the situation dictates which tool I use.

The *Magic Wand* tool selects areas of the photo based on color and contrast. Double-clicking on the tool opens a dialog box that allows you to adjust the "sensitivity" of the tool. The default is 32. When a smaller number is chosen, the tool is more sensitive and will select only those areas of the image that are very similar in color and contrast to the

Many times I preconceive a composite photograph and shoot a model to fulfill my vision. In other instances I come up with an idea after the fact, when all the photography has been done. I didn't have a particular concept in mind when I shot this pose, but the model's incredible hair (yes, it's really that long) and figure provided a dramatic graphic design to use as a starting point to experiment with various tools within Photoshop.

I began by applying two filters. First, I chose Poster Edges. *At this point, I saved the result as a new file, calling it* **Jeannie poster.** *I then applied* Paint Daubs *and changed the colors with* Hue/Saturation. *This image was copied to the clipboard with* Edit: copy.

Next I selected File: revert, *which reverted* **Jeannie poster** *back to the saved version where only the* Poster Edges *filter had been applied. The clipboard image was then pasted over that using* Edit: paste, *and in the* Layers *palette, I chose the* Overlay *mode. At this point I flattened the picture with* Layer: flatten image.

With the Marquee *tool, I selected a portion of the hair and chose* Edit: define pattern. *The* Magic Wand *tool was then used to select the background, and with* Edit: fill *(in the dialog box I chose* Pattern*), the entire area behind the model was filled with a pattern made from her hair. I applied the filter* Find Edges *to decolorize the pattern. Finally, I used the filter* KPT3 Spheroid Designer *from Kai's Power Tools to create the colorized oval.*

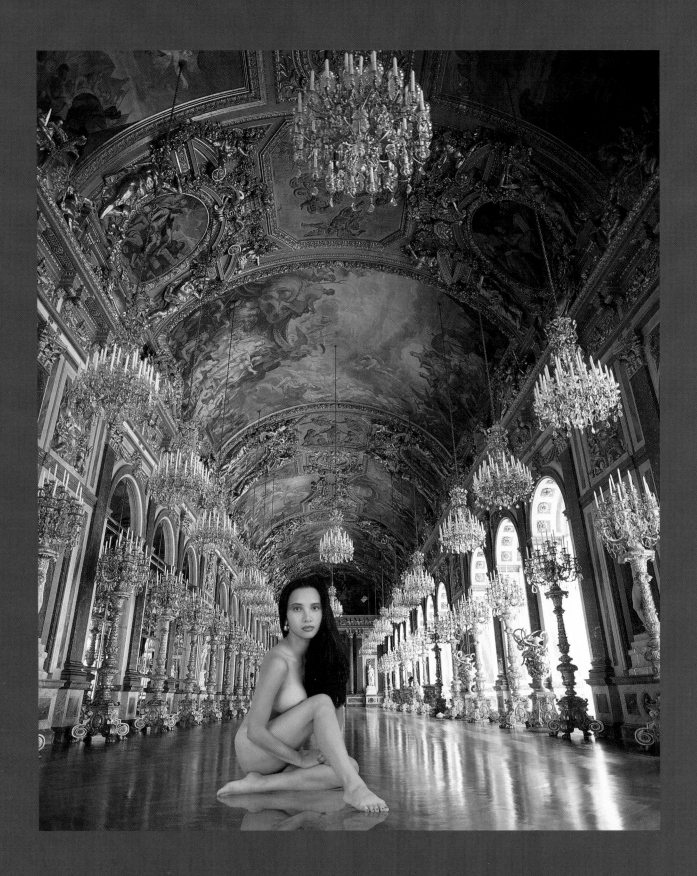

specific place on a photo where the mouse or Wacom pen is clicked. If the number is higher, the *Magic Wand* tool is less sensitive, whereby it will grab a wider range of colors and contrasts.

Let's say you are working on a landscape image consisting of an overcast sky contrasted by a dark mountain range. The sky may consist of varying shades of gray and white. If you want to select the entire sky without selecting the mountains below, you use the *Magic Wand* tool and click on the sky. If the sensitivity of the tool is, say, 15, and you click on a very

light portion of the sky, the selection you get may include other light portions of the sky but exclude the darker gray clouds. If the sensitivity is raised to 40, the entire sky may now be included in the selection. If the sensitivity of the tool is raised to 90, the selection may include some of the muted highlights on the mountains.

You can use the *Magic Wand* tool to select a subject only when there is a definitive contrast between the subject and background. A blond, light-skinned model photographed against a

I photographed this spectacular interior corridor in Herrenchiemsee, one of the castles of King Ludwig II of Bavaria. It was easy to cut and paste the model into the scene, but the challenge was the reflection of her body on the polished floor. The other reflections I've discussed so far have involved straight horizon lines. If you look at the position of the model's legs, however, one foot is closer to the camera's lens while her folded leg is a few inches away from it. It was not possible to simply flip her vertically to create a perfect reflection. If I matched her forward foot and its mirror image, the folded leg would be too far from its own reflection.

The solution was to reflect each portion separately. First I selected the foot with the Pen *tool, copied it to the clipboard, and chose* Edit: paste *and then* Layer: transform: flip vertical. *With the* Move *tool, I positioned the inverted image to mirror her foot. I repeated the same process with the folded leg.*

The lighting on the model also had to be considered. She was originally lit by two soft boxes that created soft, front illumination. The light in the corridor is diffused and comes from the side. I therefore used the Burn *tool to slightly darken the side of the face away from the windows.*

The last alteration I made was to apply makeup to the model's eyes, checks, and lips. Using the Airbrush *tool at 30 percent opacity, I sprayed a dark color above the eyes for eye shadow and a reddish color on the checks for blush. I selected the lips with the* Lasso *tool and chose* Edit: fill *at 40 percent opacity to make them red. Again with the* Lasso *tool, I selected the iris in each eye, and for additional drama, changed the brown to green with* Hue/Saturation.

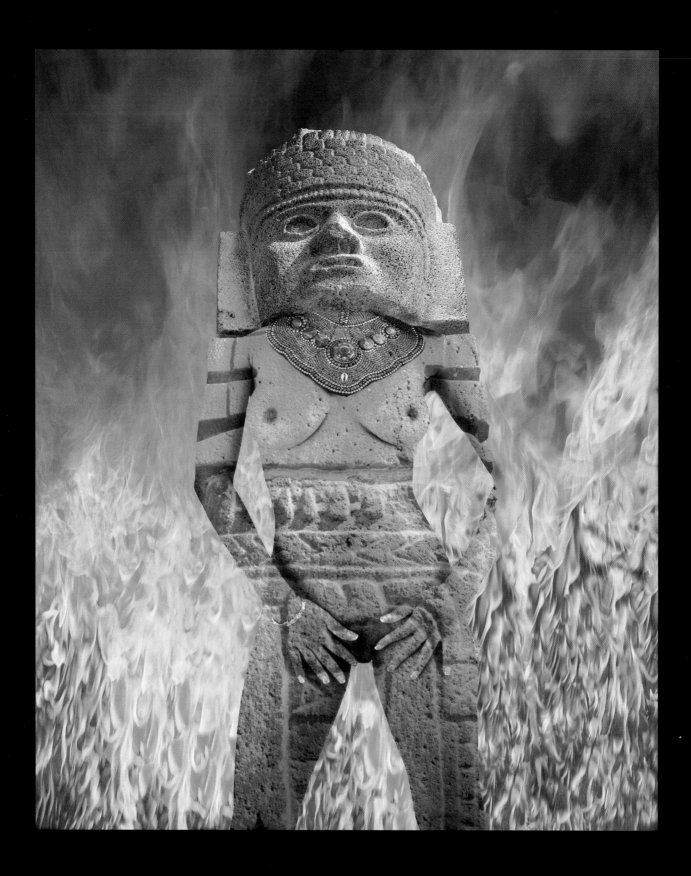

Three photographs went into making this composite: the model, a statue from the archaeological ruin at Tula, Mexico, and a full-frame shot of fire.

The fire served as the background. I cut and pasted the Tula statue into the fire, and in the Layers *palette in Photoshop, I used the* Luminosity *mode to blend the two components such that the fire could be seen through the ancient carving. The model was then pasted over the statue and sized to fit with* Layer: transform: scale. *I used the* Luminosity *mode again to blend the model with the background.*

To make the statue (which was wider than the model's figure) conform to her shape, I turned the layer (the model) into a selection. This can be done by holding down the command key and clicking on the layer in the Layers *palette. A marquee now appears around the model. I then chose* Select: inverse, *selecting the entire picture except the model. Clicking on the* Clone *tool, I cloned the fire over the statue where it could be seen between the arms and the body and between both legs. The added fire did not affect the statue where it combined with the model, because that portion of the picture wasn't selected.*

Finally, I selected the jewels in the necklace with the Lasso *tool and used* Hue/Saturation *to intensify their color.*

solid black background will be easy to separate. You simply select the solid color and then choose *Select: inverse* from the pull-down menu in Photoshop. Everything except the background—which means the subject—is now selected. However, if the same fair-skinned model had jet-black hair, you'd have a problem. The *Magic Wand* tool would not be able to distinguish between the black background and the black hair. Even if there were highlights on the hair, the background was solid black, and the sensitivity of the *Magic Wand* tool was set to zero, parts of the hair may be indistinguishable from the background.

In these instances, the *Pen* tool is a better choice. This gives you the ability to make a series of dots around the subject, and then when the path is closed by the final dot, the selection is defined. In the *Paths* palette, click on the *Paths* pull-down menu and choose *Make Selection.* This turns the path into a selection. Hit the delete key twice and the path is eliminated, leaving only the marquee (the moving dotted line) around the subject. To make sure you retain this selection for future projects, choose the pull-down menu *Select: save selection.* Now, whenever you want to recall this selection, choose *Select: load selection* from the same pull-down menu.

Always use the *Pen* tool at high magnification so you can see the precise edge of the subject. The magnification of a subject is changed with the *Magnify* tool. I usually use 200 percent. If a dot is placed incorrectly, click on the *Pen* tool with the minus sign next to it and eliminate it from the path.

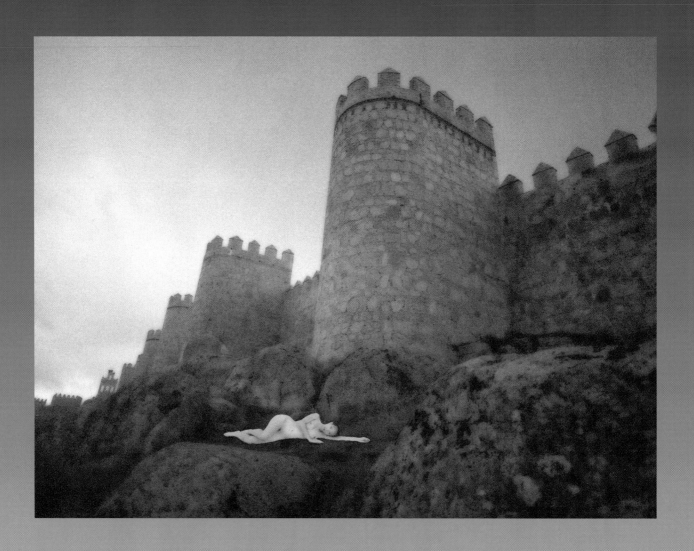

The walled city of Avila, Spain, serves as the backdrop for this ethereal image. In Photoshop, I used Image: adjust: color balance to shift the photograph toward the blue end of the spectrum. I then chose Filter: noise: add noise to introduce a grain texture. A slider bar in the dialog box of this filter allowed me to select the amount of grain.

 The model was isolated from her background with the Pen tool, pasted into the scene, and sized to fit using Layer: transform: scale. With the Clone tool, I cloned small amounts of the ground to cover the bottom edge of her body so she wouldn't look like a cutout. I also added a bluish tone to her skin in Color Balance to match the environment. Finally, I used Filter: blur: Gaussian glow for the dreamy quality that makes this picture so effective.

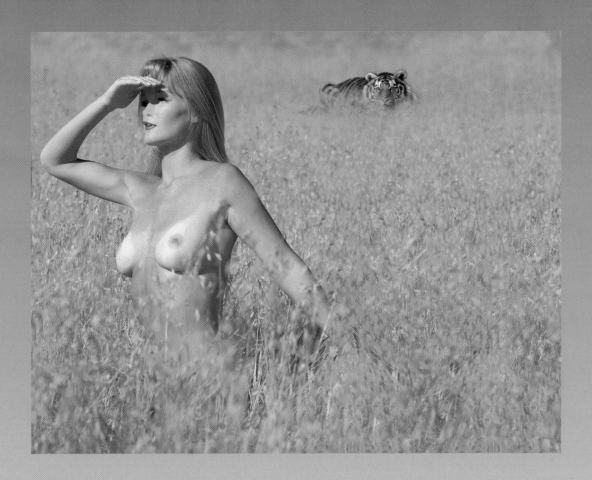

When compositing images, it's important to remember photographic principles. For example, depth of field is always a factor when taking pictures, and with telephoto lenses, the depth of field is particularly shallow. It's very easy when working in the digital arena to assemble several photos together and maintain complete depth of field, even if it defies the laws of optics. If realism is the objective, this shouldn't be done.

This model was photographed with a medium telephoto lens as she kneeled in tall grass. The background was out of focus due to the limited depth of field. The Siberian tiger had been photographed in a snowy forest in winter, and the original transparency of the animal was tack-sharp. Had I maintained the sharpness of the cat in the composite photograph, it would have looked highly improbable. A telephoto lens could critically focus on either the model or the tiger, but not both. A small lens aperture would have helped, but it would have forced me to use a slow shutter speed, which is not acceptable when shooting people and animals (unless the photographer's intention is to blur the subject).

When I pasted the tiger into the background, I used Filter: blur: Gaussian blur. This softened the cat and blended it with the out-of-focus grass. I then chose the Clone tool to superimpose the surrounding blurred grass over the bottom of the animal to imply he was laying low in the grass to stalk the model.

Feathering

Before the selection is copied to the clipboard and pasted into another picture, it's a good idea to feather it. This softens the edge so the image pasted into the background doesn't look like it was cut out with sharp scissors.

Choose *Select: feather* from the pull-down menu. A dialog box opens and you're asked to define the feather radius. When I paste components into a background, I usually use a one-pixel radius. If you use more than two, the edge starts to look inappropriately soft in contrast to the sharper background.

Assembling components into a successful composite means that you must pay close attention to detail. Notice in this rather bizarre image how the rear portion of the model's body is positioned behind two slender tree trunks. Instead of simply pasting her into the scene in front of the trees, I wanted her to appear to be in the midst of them.

To do this, I used the Pen *tool to make a precise selection around the two trunks.* Select: inverse *changed the selected portion of the picture to include everything <u>except</u> the two trees. I feathered the selection by one pixel using* Select: feather *to soften its edge slightly. The model was then pasted into the selection with* Edit: paste into. *I sized her (*Layer: transform: scale*) and used the* Move *tool to place her where I wanted. Because the two tree trunks were not selected, wherever I moved the model, she always appeared behind them.*

The face of a mountain lion was used in place of a human countenance. I opened the wildlife shot in Photoshop and used the Lasso *tool to roughly outline the feline face. This was copied to the clipboard, and then I again used the* Lasso *tool to outline the model's face and make a selection. I feathered the selection by one pixel. The lion component was then pasted into the selection and sized to fit with* Layer: transform: scale.

To give the image an eerie quality, I applied Filter: blur: Gaussian glow *two times. And finally, I used* Color Balance *to shift the color toward the bluish end of the spectrum.*

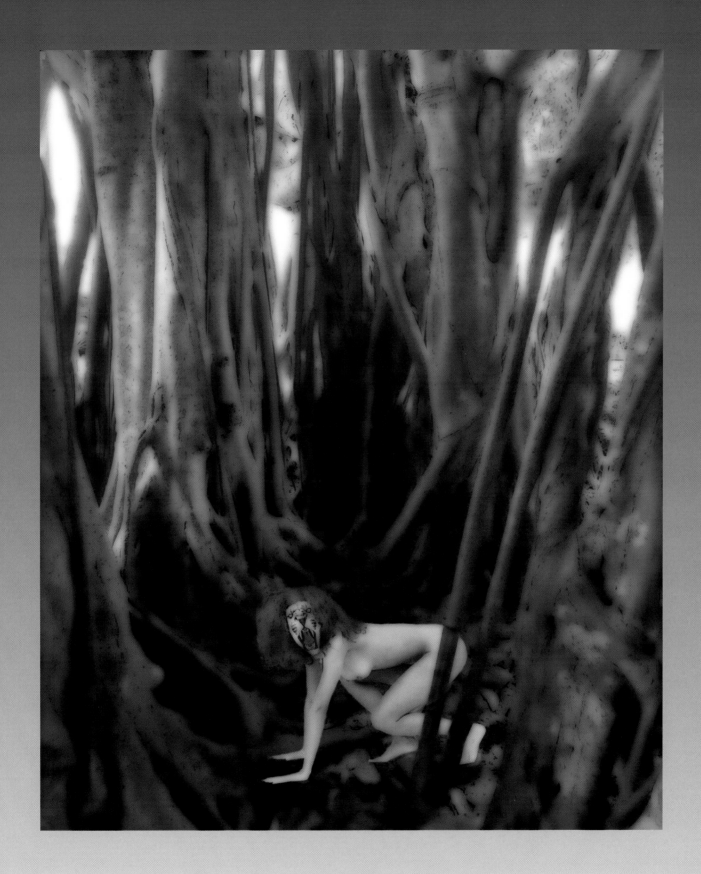

This model posed specifically to be composited with a charging bull elephant I photographed in Kenya's Amboseli Game Park. When the camera's fast shutter speed froze the animal's forward motion, both legs were equidistant to the camera, suggesting the huge pachyderm was merely standing in the grass with his trunk raised.

In Photoshop, I cut out the model and pasted her in the composition with a feathered edge of one pixel. When a subject is removed from its environment, sometimes the selection around the edge of that subject isn't perfect, and it may include a little too much. When this happens, some of the background color that was adjacent to the subject is captured in the cutout and pasted into the new photo. The Clone tool must then be used to remove the unwanted and distracting color.

A way to avoid this problem when the selection is made is to choose Select: modify: contract. This command allows you to shrink the selection around the image, thus eliminating the obtrusive color. I usually choose a two-pixel contraction.

I assumed that if a person were standing in relatively tall grass, their feet would be hidden. I used the Clone tool to do this. I cloned blades of grass and covered the model's feet.

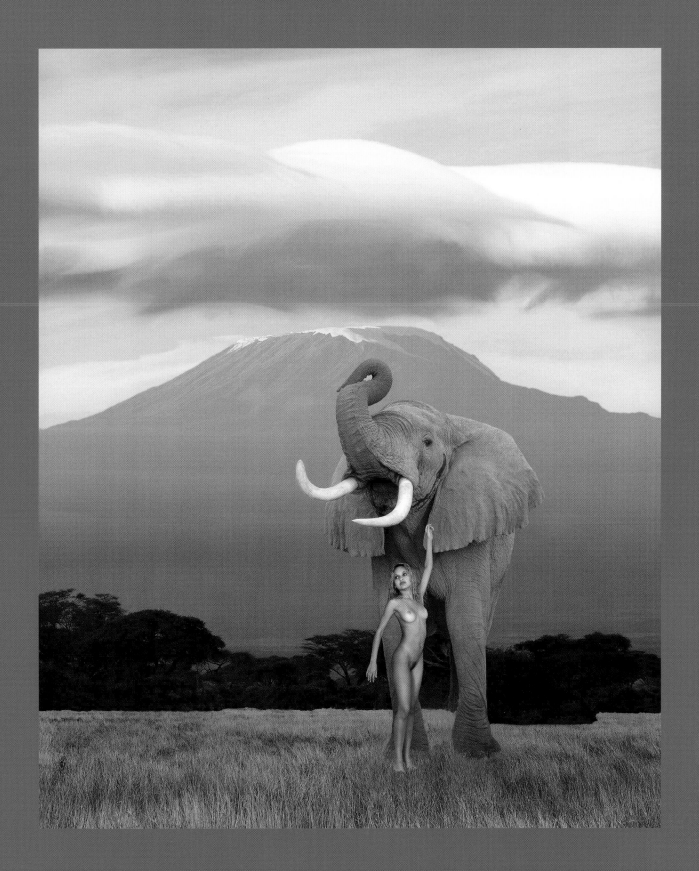

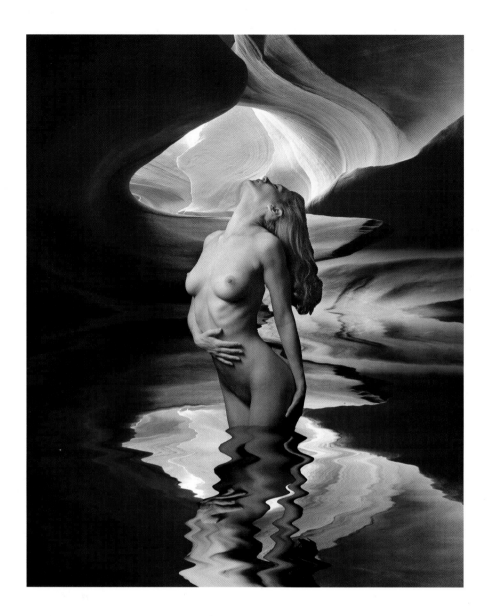

The background in this image was derived from the same original photograph of Antelope Canyon that I used in the photos on pages 55 and 94. I created the reflection of the canyon using Filter: wave in Photoshop to add realism to the virtual water. The model was cut and pasted into the scene, but the selection I used cut the legs at a place where I wanted the water level to be. The model's reflection was made once she was positioned. I used different parameters within the Filter dialog box to create dissimilar wave patterns for the two reflections. This suggests that the disturbance of the water in front of the model was unlike the rest of the pool.

 With the reflection technique, already described in the caption on page 91, a straight line is always formed between the portion of the photo being reflected and its reflection. If you look closely at this demarcation on the model's legs, the line is not perfectly straight. I used the Clone tool to accomplish this effect to suggest that the water was moving when the shutter was fired, creating a small wave.

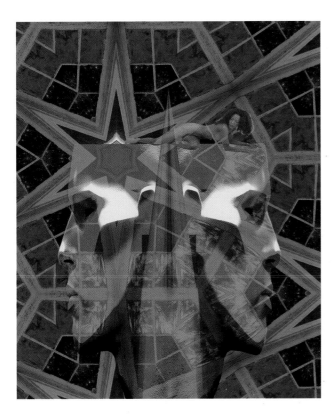

Layers

Once you have a target background photo and a selected subject that has been feathered, it is time to make the composite. You can place the selection onto the background two ways. First, you can copy it to the clipboard and paste it onto the background image. Second, with the *Move* tool in the *Tool* palette, you can simply click and drag the selection from its window and move it into the new window. This automatically makes the selection a new layer.

By making layers, each image in a composite can be moved, edited, color corrected, and otherwise manipulated separately. It is not permanently fixed to a particular location until you choose *Layer: flatten image* from the pull-down menu. In the *Layers* palette, when you

Above: Photo compositing runs the gamut from simulating reality to complete fantasy. This wild image comes from four components: a mannequin head photographed in Brugge, Belgium, architecture shot in Amsterdam, glitter sprinkled on black velvet for stars, and the model.

The mannequin head was first mirrored against a black background, and then the top of the head was eliminated with the rectangular Marquee *tool. I selected the portion to be cut off and filled it with black using* Edit: fill. *Next, I used the* Marquee *tool again and selected a central vertical section, and with* Layer: transform: distort, *I dragged it up and to a point.*

The Amsterdam apartment house was abstracted using the Terrazzo *filter.* Hue/Saturation *allowed me to have fun with the color. I selected all the black in the windows by first using the* Magic Wand *tool to select one window and then choosing* Select: similar. *Into these windows I used* Edit: paste into *to place the glitter stars, which had been copied to the clipboard.*

The double mannequin head was then copied to the clipboard. It was pasted onto the architecture with Edit: paste, *and in the* Layers *palette, I chose the* Luminosity *mode. This allowed the background to show through the heads. Using* Hue/Saturation, *I reduced the mannequin to black and white.*

Finally, the model was copied to the clipboard. She was pasted into the composite with Edit: paste *and again I chose* Luminosity. *In* Layers: transform: scale, *I reduced her in size and used the* Move *tool to position her.*

click on a *Layer* icon or name, it becomes the active or target layer. With the *Move* tool, you can then move the layer from one position to another until you like the composition.

An image can have many layers; the only limit is the amount of memory in your computer. Each layer can be altered separately from the underlying background photo. Below are some of the changes I frequently make and the commands used to do so.

Layer: transform: scale allows you to change the size of the image. The box that forms around the image can be pulled larger or made smaller. Hold the shift key to scale proportionately.

Layer: transform: flip horizontal can be used to make a mirror image of a photo.

I use *Brightness/Contrast* for contrast control and either *Color Balance* or *Hue/Saturation* to adjust color.

Layer: new: adjustment layer makes a temporary "preview" layer. The effects created in this layer can then be hidden, discarded, or merged with the image. In the dialog box, click on *Group With Previous Layer*.

To apply any filter, click on the *Layer* icon you want active and choose the filter in the normal way.

You will notice that every time you add a layer and make changes to those layers, the file size of your composite photo increases. Depending on the size of each layer, before long you may be working on an 80 MB file, or even larger. This is one reason for buying a lot of RAM for the computer. You will need the processing power to handle large files with multiple layers.

Once you are happy with the composite, you can reduce the file size by flattening all the layers together. The components can no longer be edited individually, but it also returns the file to a manageable size.

Fine-Tuning

Many times when two or more images are pasted together, the edges between the pictures aren't perfect. A selection may have traces of color from a previous background, for example. I use the *Clone* tool to eliminate this problem. With the *Magnify* tool, I enlarge the photo to at least 200 percent and closely examine the borders between the composited elements. This fine-tuning is necessary to make sure your work is perfect.

Another necessity is adding drop shadows. Even under soft, diffused lighting, an object casts subtle shadows. For instance, a model standing on a surface will have pronounced shadows at the edge of her feet and subtle shadows cast around her, falling onto the surface on which she's standing. When she is pasted into a background, no shadows exist. It is important to create these easily overlooked details to add to the illusion that she is really standing or sitting in the photo. I use the *Burn* tool in the *Tool* palette to add shadows. It's best to set the opacity of the tool to roughly 30 to 40 percent and build the shadows gradually until they look realistic.

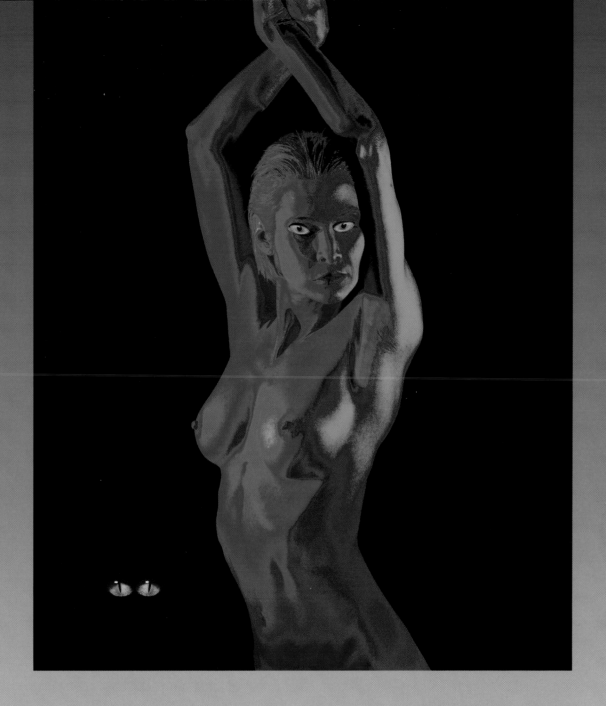

The eyes of two different cats were used in this eerie photograph. The nude, originally shot against a black background, was colorized in Photoshop using Curves. I then opened a close-up portrait of a cat, selected an eye with the Lasso tool, copied it, and pasted it onto the image of the model, automatically making a new layer. With Layer: transform: scale, I reduced the eye to fit the woman's face. With the eye layer active, clicking on its icon in the Layers palette while holding the command key made the eye a selection. By holding down the option key and using the Move tool, a copy of the cat eye was moved to cover the other eye of the model. I used Layer: transform: flip horizontal to orient it correctly. I then deselected the cat eye by choosing Select: none and flattened the image with Layer: flatten image.

A second pair of eyes from another image was copied and pasted into the lower portion of the frame in the same way.

8 Marketing Digital Nudes

The ability to transform conventional photography into virtually anything your mind can conceive opens new markets for photographers. There are still relatively few photographers working in the digital realm, which means that there is plenty of room for creative new talent to capture a share of the market in this lucrative photographic industry.

If making a full- or part-time income from your digital photography is a goal, there are three important factors that you must keep in mind to be successful. First, you must present yourself as a professional. If potential clients are to take you seriously, you should have professional letterhead and business cards, submitted work should be organized and clearly labeled, and your images must be

Model release contracts are essential in any type of commercial photography, but this is especially true when shooting nudes. Even if you think the images will not be published or sold, it is still wise to ask models to sign the form. We can't foresee the future, and there may come a time when the images are in fact offered for sale. If a model hasn't authorized the sale of her image, the pictures are worthless in the marketplace. The one exception is when a person's face is not recognizable. By using abstraction techniques in Photoshop or Painter, or otherwise hiding her features such as in this example, you won't need a release.

This image is a composite using six components. The picture of the earth was obtained free of charge from the Johnson Space Center in Houston. The stars are a photograph of glitter sprinkled on black velvet shot with a star filter to enhance the specular highlights. The mountains are the Eastern Sierras near Lone Pine, California. The model was photographed in the studio, and the mannequin head, which serves as a mask, was also shot under controlled conditions. The highway is actually a portion of a gradient design created using Kai's Power Tools within Photoshop.

The mountains were actually used twice. I pasted the shot over itself and then chose Layer: transform: flip horizontal *to make the second shot a mirror image.* Mode: adjust: invert *turned the range into a negative image, and in* Hue/Saturation, *I chose a saturated blue. The stars were then pasted above the surreal mountains, and the earth was added. I used the* Burn *tool to darken the underside of the planet to imply the sun's position and to add interest to the composite.*

I pasted in the highway component, and the model was positioned next. With the layer containing the woman's figure active, I chose 50 percent opacity in the Layers *palette to allow the background to show through her body. The final touch was to cut out the face of the mannequin head with the* Lasso *tool and paste it into a selection I made of the model's face.*

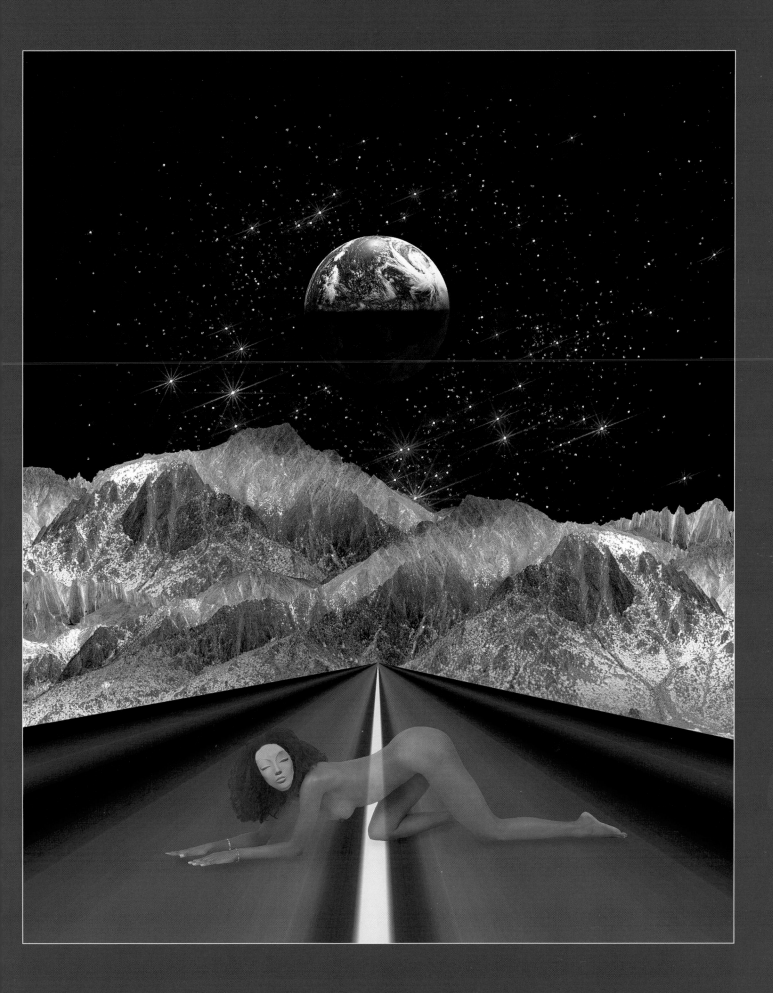

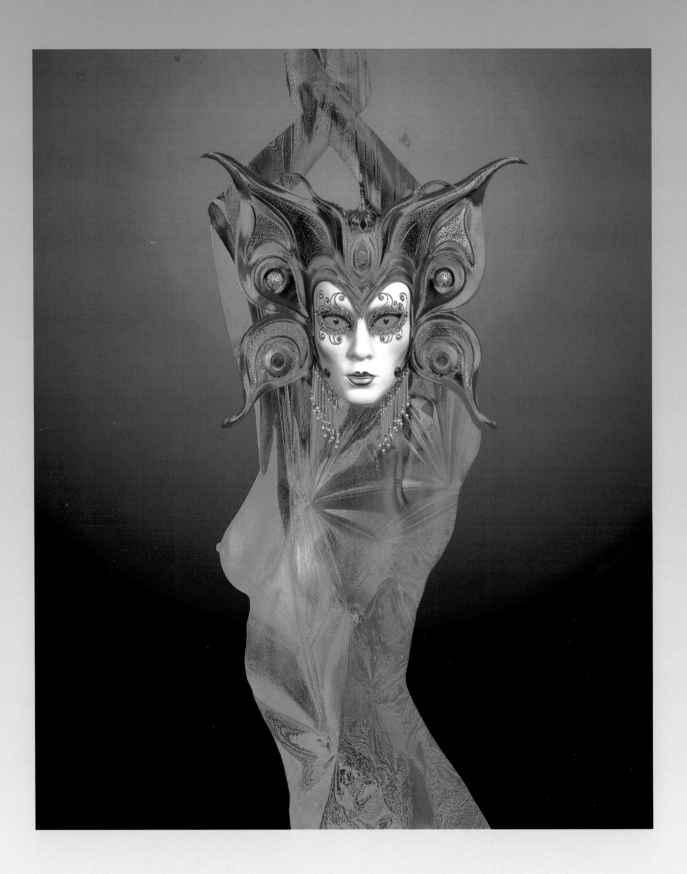

flawless. Second, all of your digital transparencies must be high resolution. If a potential client examines your work through a loupe and doesn't think it will look good enlarged to a calendar, print ad, or poster, he or she won't contact you again. Although your clients' needs may vary, 35mm digital transparencies should be output from 32 MB files, and medium-format slides should be approximately 40 MB. Enlarged prints should be 350 dpi. Third, you must always do what you say you're going to do. If you promise to deliver images by a certain date, keep your word. Be dependable. Publishing companies are constantly under inflexible deadlines, and a photographer who delivers images on time will be rewarded with future business.

Conceptual Stock

There is a large demand in the marketplace for conceptual photography. Advertisers are always searching for new and unique ways to convey their message, and the computer is a revolutionary way to satisfy this demand. Particularly with nudity, which in the mainstream marketplace is not acceptable in the United States, digital effects can soften and romanticize images such that most people won't be offended. When the original photo is abstracted with painterly effects, the essence of the nudity comes through without being shocking or vulgar.

Take, for example, a photograph of a mother nursing a child. This picture is rarely seen in print ads, but it conveys the most fundamental

One of the most powerful means of calling attention to a print ad is brilliant color. It is visually arresting, and it virtually guarantees that the message being communicated will reach a large audience. In the United States, nudity is never used in mainstream advertising, but in Europe it is acceptable. This striking image, which is not only imbued with shocking color combinations, is also compelling and even disturbing. It would not fail to make an impression.

I pasted an abstract image over the model, and in the Layers *palette, chose 50 percent opacity so her body could be seen through the pattern. I then pasted the mask over her face. The eyes of a cat were then pasted into each eye socket in the mask. I selected the background and chose* Curves *to create an unlikely range of color. Finally, in* Hue/Saturation, *I moved the saturation slider bar to the right to wildly exaggerate the color.*

loving bond. If an advertising agency could find an image that communicates this message without being blatant, they might be able to sell the concept to any number of companies who promote products that could be associated with this very human emotion. These products might include everything from diapers to flowers for Mother's Day, from health insurance to long-term investing for college tuition. If the photo looked more like a painting and less like real people, the message would most likely be unimpeded by the nudity. Techniques such as using *Cloner* brushes in Painter and filters in Photoshop would be used to create the effect.

Beautiful bodies are often used by advertisers for very different concepts. Vitamins, body lotion, contraception, and hair care products can be promoted by youthful, perfectly shaped figures. Digital effects can be used to make nudes more acceptable in these markets by abstracting them.

Fine Art

Images of nudes are accepted virtually without objection in the fine-art arena. Paintings depicting athletic men and sensual women predate the Greeks by at least a thousand years, and in recent history, Rubens, Chagall, and many other artists have carried on the tradition. Using the computer to reproduce a nude in styles that simulate charcoal sketches, pen and ink drawings, pointillism, or even surrealism is simply a modern extension of our appreciation of the human body over the millennia.

Fine-art nudity is also more acceptable (than nudity in the general marketplace) because it is meant to be enjoyed privately, in the home or office, rather than be seen publicly. If nudes were used on billboards and in magazines available in supermarkets, we would have no choice but to be exposed to it. When you walk into an art gallery, however, it is by choice, and it is by the same choice that you purchase a work of art.

Beautifully framed prints of tastefully done nudes enjoy a wide appeal among fine-art buyers. Especially today with the incredible printing technology available to photographers, we can present our work with stunning brilliance and breathtaking subtlety. I have output my digital files directly onto various art papers using an Iris printer (this is a service available at some photo labs and service bureaus), and the results are so dynamic, that for the first time in 28 years, I now hang my own work on the walls of my home. Iris printing also allows photographers to output their images directly onto artists' canvas, which makes photos look virtually like original oil paintings.

These techniques have expanded the marketability of photographs, specifically nudes. If this means of selling your work is appealing, output a modest-sized portfolio—say 16 x 20- or 20 x 24-inch prints—on art paper using an Iris printer or on photographic paper using traditional darkroom methods. Matte the prints attractively (I think black or white matte board is the most elegant), and present the collection to art galleries or art publishers.

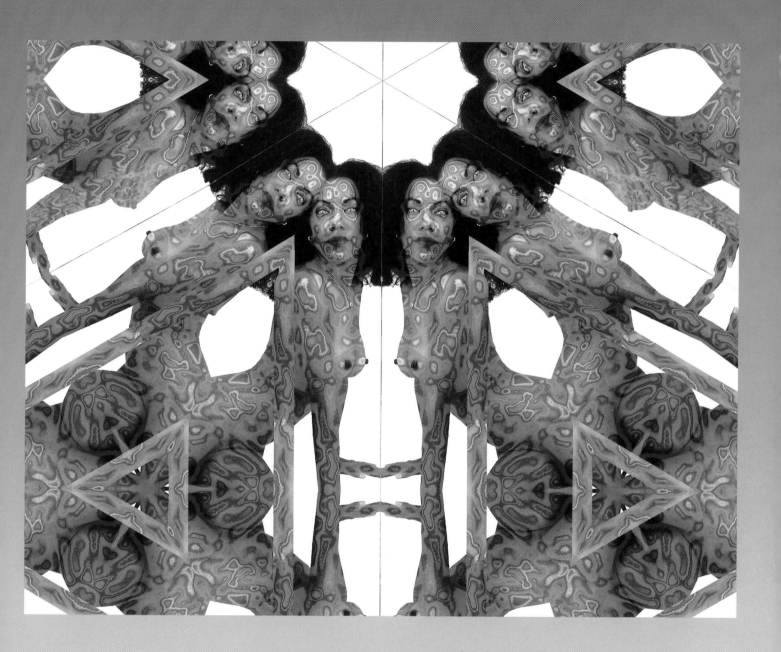

Regarding nudity, fine-art imagery runs the gamut from soft, sensual, and pastel to surreal and bizarre interpretations of the human form. Among well-known artists, compare Chagall's strange figures with the voluptuous women of Rubens.

Similarly, with digital imaging you can create anything imaginable. In the fine-art market, some galleries and print publishers specialize in traditional imagery, while others experiment with avant-garde tastes.

This surreal picture is one of my favorites in the book. I began with the photo on page 65 and applied the Terrazzo filter in Photoshop. The color alteration resulted from using Hue/ Saturation.

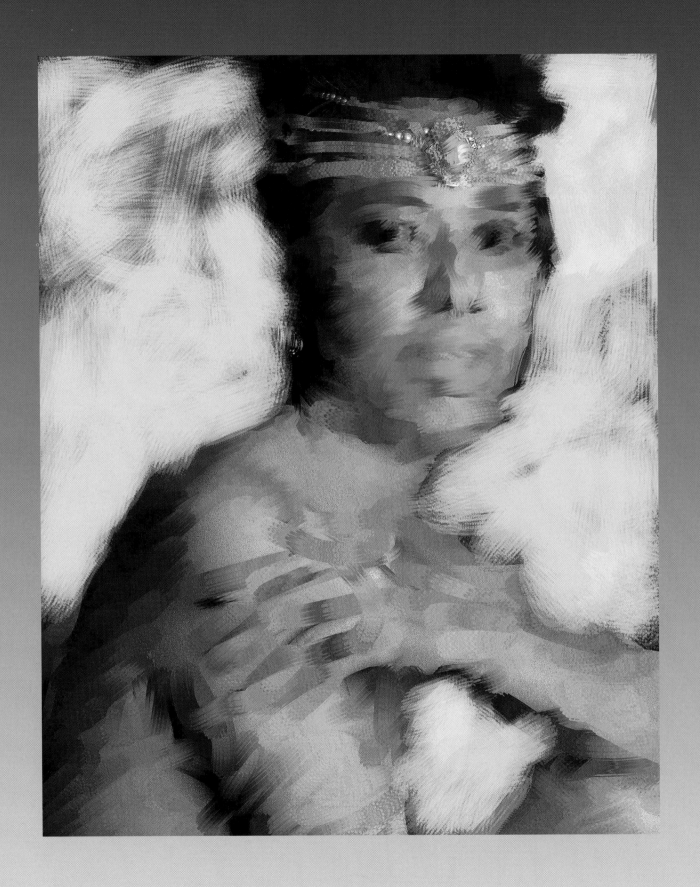

Paper Products

Calendars, posters, and greeting cards make up the market known as paper products. This is a huge industry that purchases many thousands of images every year. A tasteful series of digitally manipulated nudes could be used for a calendar, a box of note cards, or even as a set of high-end posters.

Locating the companies that use photos for these purposes is easy. Any bookstore, drugstore, gift shop, and department store sells paper products. On the back of every calendar and note card, and on the front of most posters, you can find the name of the publishing company. A more efficient method is to consult the book *Photographer's Market*, compiled by Writer's Digest Books. This annual publication has an entire section devoted to scores of paper companies in the United States and a few abroad.

Unlike the fine-art market, which is solely concerned with artful prints, paper companies may require transparencies for review and possibly for printing, although it is advantageous to provide digital files.

An alternative method of showing your work is to use CD technology. Clients can now look at dozens, or even hundreds, of images by quickly scrolling through the images you've transferred to a CD. This can be a cost-effective way to show your work, saving the expense of outputting each digital file to a transparency. A single disc is significantly less expensive than outputting many slides at a

It has been a struggle for fine-art photographers to have their work accepted in traditional art circles. Even though an increasing number of people consider photography "fine art," galleries and art wholesalers still don't speak of photographic prints and original oil paintings, or even reproductions of original oils, in the same breath. With the advent of digital imaging and the ability to produce pictures that look exactly like paintings, and with processes like Iris prints that can apply a photo to canvas or art paper, I wonder if this will change.

This photograph, like many others in this book, was created to simulate a painting. I opened the image in Painter, used File: clone to make a copy of it, and then applied the Cloner brush Big Dry Ink. In the Controls: Brush palette, I selected a large brush to abstract the photo to a greater degree. With Hue/Saturation in Photoshop, I altered the colors to my liking.

When you manipulate a photograph in Painter, sometimes the background becomes irrelevant. This can happen because unattractive elements behind the subject can be abstracted to such a degree that they are transformed into nondescript shapes and colors. This portrait was taken in my office. Behind the model was a chair, a window, and the corner of a desk. Instead of the seamless paper I usually use when I want clean backgrounds, I disregarded the busy and distracting elements in the room because I knew the large brush strokes would obliterate them.

Many photographers are now using the Internet to sell photos. It is a way to reach literally millions of potential customers from all over the world. It is also a way to circumvent conservative communities when selling nude pictures. Instead of offending local sensibilities, you can reach out to people who are interested in what you have to offer. They can review your Web site from the privacy of their homes through a computer.

One of the things that attracts "hits" on a Web site is an original and dramatic photograph. Photographers, artists, digital innovators, and Net surfers are always looking for new and inspiring sites. An image that may qualify under this premise is this futuristic nude I composited in Photoshop. I began with an abstract design in silver that was created in Kai's Power Tools Gradient Designer. I used the 3-D capability of one of Andromeda Software's plug-in filters to wrap the gradient onto a column. This is called "texture mapping." I saved the column as a component.

The abstract design was then laid out in a perspective plane using Kai's Power Tools Planar Tiling. The column was then cut and pasted into the frame, then pasted in a second time, moved into position with the Move tool, and flipped horizontally (Layer: transform: flip horizontal) to mirror the first one.

Next I pasted the stars into the top of the composition. The model was pasted behind the column by selecting the column with the Pen tool, choosing Select: inverse (which selects everything except the column), and then pasting the model (who had been copied to the clipboard previously) into the selected area by using Edit: paste into.

The mask had been photographed on my living room wall at an angle that would match the model's body position. This was pasted into the composite, sized to fit using Layer: transform: scale, and moved into place with the Move tool.

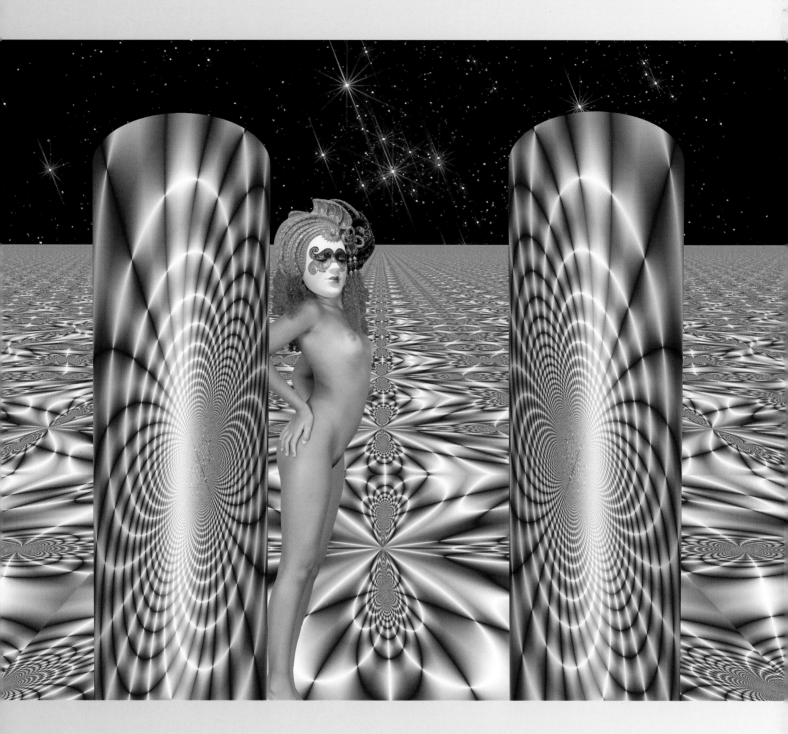

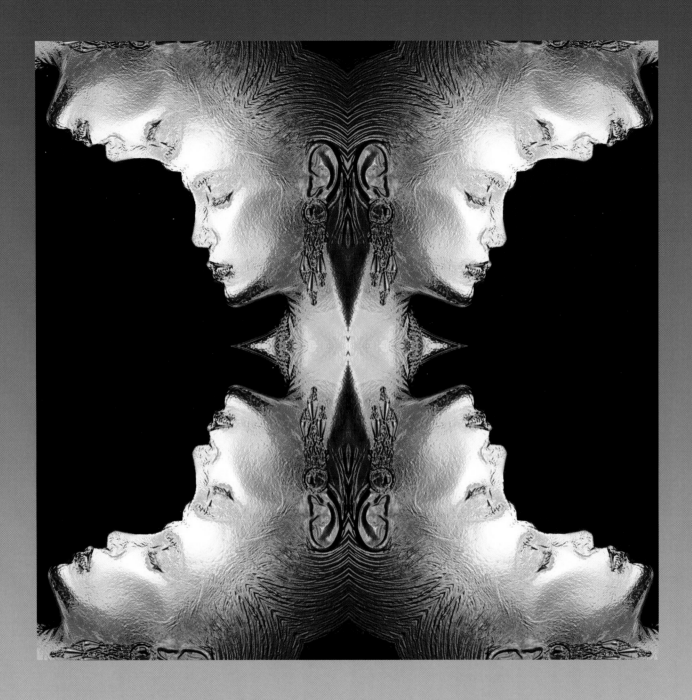

This fine-art image first began as a nude portrait, but through the abstraction process, the model's nudity disappeared. Sometimes small portions of a shot produce such stunning results that I abandon my original intention and work with the new concept.

This image comes from the same original that produced the image on page 110. In this example, I applied Effects: focus: glass distortion *in Painter, and then in Photoshop used* Hue/ Saturation *to change the color from the original skin tone. To produce this amazing design, I used the* Terrazzo filter. *Finally, I worked with the* Clone *tool to touch up a few minor imperfections along the edges of the profile caused by the glass distortion.*

service bureau. I would advise, however, to put low-resolution files on the disc. In other words, resize each picture in Photoshop to a fraction of its original size, and then fill the CD with only low-res files. This will enable you to put more images on the disc, and it will also prevent an unscrupulous client from using your work without authorization and payment. I reduce a 38.4 MB file down to approximately 1 MB. This is still large enough to appreciate all the detail on a computer monitor, but too small for a high-end, sharp reproduction.

When the publishing company decides to buy one or more of my images, I send them the transparency or, if they prefer, I give them the high-resolution digital file on another CD or Zip disc. Printing companies commonly use digital files to make their color separations. However, they will need either a transparency or an accurate print for color-matching purposes. Remember, the color you see on your monitor may be calibrated with your service bureau, but a printer in another state or overseas may see your photograph quite differently on his monitor. When it comes time to go to press, protect the integrity of your work and supply a color-corrected version of the image.

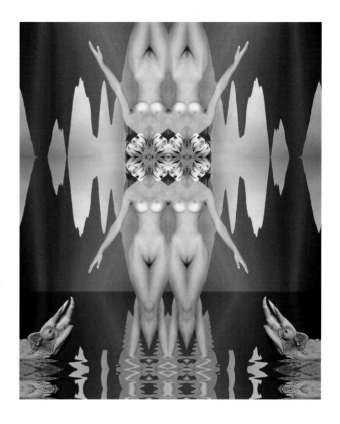

Compelling and unique visions of the nude are often well accepted in the marketplace. The female form has been celebrated through sculpture, painting, and photography since the inception of those art forms, and when an artist creates a new interpretation of a very familiar subject, people talk about it. This usually translates into sales in commercial, publishing, and fine-art arenas.

The unusual design of the model's body in this photograph is one of several versions I created using the kaleidoscope program Terrazzo *in Photoshop. The original photograph is on page 18 (another version is on page 19). Note the ultrasmall waist and the unnatural proximity of the breasts. I was able to create this form simply from working within the* Terrazzo *dialog box. I changed the color scheme with* Hue/Saturation.

Conceptual images are valuable in the advertising market because they are used to instantly communicate an idea or a feeling. Products, services, or ideas can be associated with pictures, and that association is a lasting one in the public's mind. Mermaids, for example, are positive fantasies in probably everyone's imagination.

I market conceptual photography in two ways. I create the image on speculation, submitting it to a company and hoping for a sale. Also I accept assignments whereby an art director outlines what he or she wants for an advertising campaign or for a magazine or book cover.

The model was photographed underwater in a pool with a low camera angle looking upward toward the sky. I bought half of a salmon at the store and photographed it outdoors in ambient light. The aquarium fish were photographed with a strobe in a pet store.

The tail of the salmon was simply cut and pasted to fit the model. I used the Clone tool in Photoshop on 60 percent opacity to soften the demarcation between the scales and the woman's skin at her waist. To make the fish portion of the mermaid bluish and low in contrast to match the torso, I used the Clone tool again, this time at 30 percent opacity, to clone the blue water over the shiny scales.

It took me a while to figure out how to eliminate the texture of the pool itself. The tile around the upper edge of the pool was cloned out; this was easy. But the gunite surface of the contoured pool walls made it clear where the picture was taken. Mermaids "live" in the ocean, obviously, and not in swimming pools.

I opened a new underwater picture in Photoshop. This was the same one used as a background in the image on page 70. I resized the horizontal shot into a vertical one using Image: image size. It was then pasted over the composite, and in the Layers palette, I chose 60 percent opacity. Next, I made a layer mask. I selected Layer: add layer mask: reveal all, and then clicked the Gradient tool. With the foreground and background boxes in the Tool palette filled with black and white respectively, I applied a linear gradient. This faded the upper portion of the floating layer, revealing the torso of the mermaid clearly, but the bottom of the frame retained most of the new underwater color and pattern which hid the pool's texture.

The trigger fish were then pasted into the composite and sized appropriately with Layer: transform: scale. To blend them with the underwater environment, I used the same strategy as I did for the salmon tail. I chose the Clone tool on 30 percent opacity and copied the blue water over the fish.

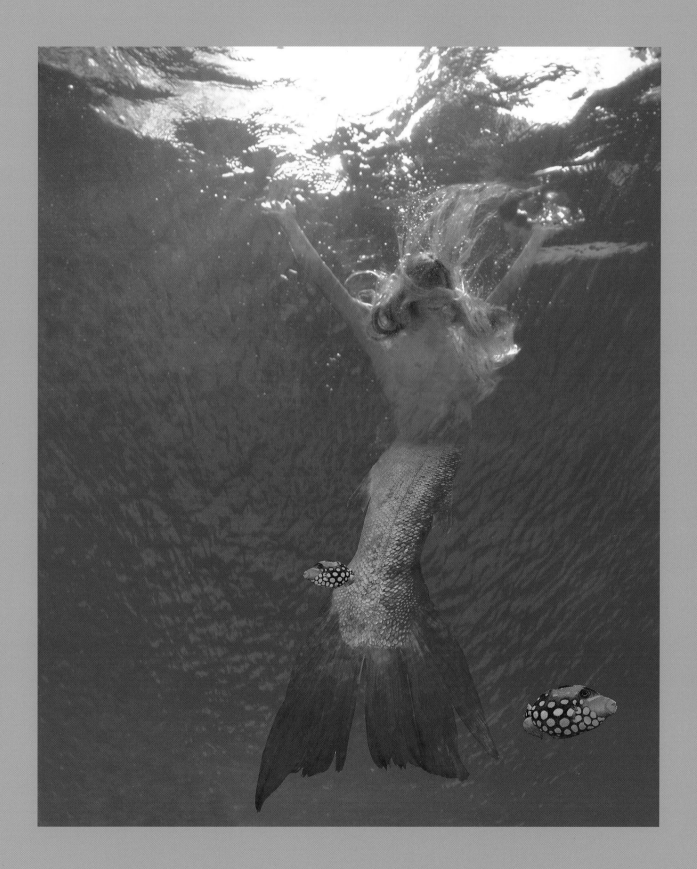

The Internet

Many photographers are now selling their photographs on the Internet. There are many advantages. It is quite inexpensive to reach millions of people worldwide, and a Web site is easily changed. There are no direct mail costs, middlemen, or commissions to pay. You have tremendous flexibility in how you present yourself, from simple and straightforward to sophisticated.

Study other photographer's Web sites and decide what appeals to you. My Web site (www.jimzuckerman.com) is simple. I wanted my photography to be the focus of attention, not spinning logos and flashing signs. Some photographers opt for slick concepts in design and interactive options in presenting their work. If you don't want to design your own site, many graphic designers now specialize in Web site design.

One of the major concerns regarding the Internet is the time required for downloading images into other people's computers. Unlike text, graphics are more memory-intensive, and it takes longer for people to view photos. It's important to have each photo used on your site in low resolution. On my site, each photo that opens larger when a viewer clicks on it is approximately 200K (one-fifth of a megabyte). The image quality is quite acceptable, but it's not ideal. Perhaps in the future the Internet will be faster and more efficient.

Model Releases

When a recognizable person is depicted in a photograph and that photo is sold for profit, it is absolutely necessary to have a model release signed and dated by the model, who must be of legal age. If you don't, you're asking for trouble. In our litigious society, where people sue for real or imagined injustices, you need the protection of a legally binding agreement which gives you permission to sell, distribute, and digitally alter the photos you take. This is particularly true of nudes. Always get the release signed before the photo session, and it is a good idea to have a witness sign the model release form as well.

The fine-art market is not concerned with shock value when it comes to color. More subtle colors are usually used in art pieces that must blend into a home or office environment. The earth tones in this photograph are easy to look at without being disturbing or distracting.

In Painter, I used Effects: surface control and chose Image Luminance to create the texture on the model's body. I then opened the photograph in Photoshop and created a pattern from the hair. This was done by using the Marquee tool (rectangular mode) to select a portion of the hair, and then Edit: define pattern established the pattern—invisible as yet—on the clipboard. I deselected the hair with Select: none and selected the background surrounding the model. I chose Edit: fill, and in the dialog box, I selected Pattern from the pull-down menu. The pattern created from the hair completely filled in the background.

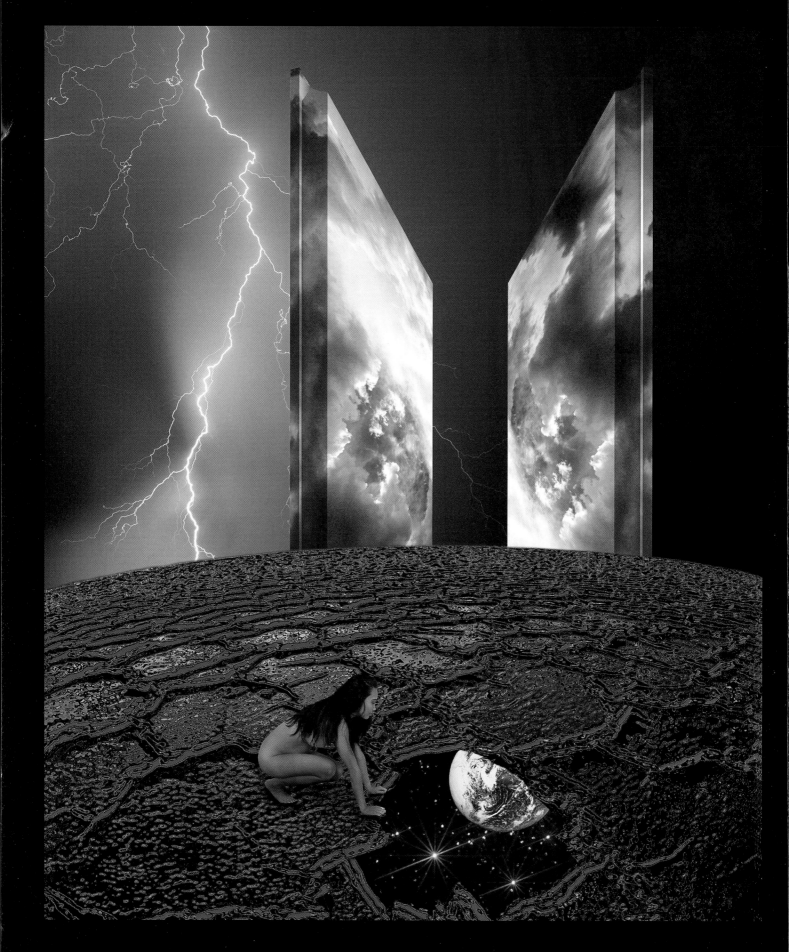

Conceptual images are created to instantly communicate a concept. Words often don't have the same power or instant association with a product, service, or idea as do photographs. This composite, for example, expresses themes like "discovery," "new horizons," "spirituality," and "the future." The modest pose makes the shot acceptable in more markets.

The landscape photograph is a shot of a salt flat in Death Valley, California. It was photographed with a fisheye lens which curved the horizon. I applied the Chrome *filter to it and in* Hue/Saturation *changed the color. With the* Pen *tool, I outlined one of the sections of the cracked earth, turned it into a selection by choosing* Make Selection *in the* Paths *palette, and then pasted into the selection the same photo of stars I've used before. Then, into the same selection, I pasted the earth. With the* Move *tool, I moved the earth such that only part of it could be seen.*

The sky consists of a lightning photograph pasted into a selection above the horizon. A monolith was created by making a geometric shape in Photoshop with the Line *tool and then pasting a photograph of clouds into it. The dimensional shading was done with* Image: adjust: brightness/contrast *where I darkened the edge of the form to imply depth. This was then pasted into the sky twice, and one of the monoliths was flipped with* Layer: transform: flip horizontal.

The model was photographed in the studio with this total concept in mind. I even asked her to bend her fingers as if she were grasping the edge of the hole in the ground. I pasted her into the scene, used Layer: transform: scale *to size her appropriately, and then used* Color Balance *to match her skin tone with the eerie environment. Finally, I used the* Burn *tool to darken the ground underneath her for a subtle drop shadow.*

Appendix

Adobe Systems, Inc.
345 Park Avenue
San Jose, CA 95110
(408) 536-6000
www.adobe.com

Andromeda Software, Inc.
699 Hampshire Road
Thousand Oaks, CA 91361
(800) 547-0055
www.andromeda.com

Apple Computer, Inc.
1 Infinite Loop
Cupertino, CA 95014
(408) 996-1010
www.apple.com

Eastman Kodak Company
343 State Street
Rochester, NY 14650
(800) 242-2424
www.kodak.com

Epson America, Inc.
20770 Madrona Avenue
Torrance, CA 90503
(310) 782-0770
www.epson.com

Fuji Photo Film, U.S.A., Inc.
555 Taxter Road
Elmsford, NY 10523-2314
(914) 789-8100
www.fujifilm.com

IBM
1 Old Orchard Road
Armonk, NY 10504
(914) 765-1900
www.ibm.com

Iomega Corp.
1821 West Iomega Way
Roy, UT 84067
(800) 697-8833
www.iomega.com

Mamiya America Corp.
8 Westchester Plaza
Elmsford, NY 10523-1605
(914) 347-3300
www.mamiya.com

MetaCreations Corp.
6303 Carpinteria Avenue
Carpinteria, CA 93013-2901
(805) 566-6200
www.metacreations.com

Photoflex
333 Encinal Street
Santa Cruz, CA 95060
(408) 454-9100
www.photoflex.com

Scitex America Corp.
8 Oak Park Drive
Bedford, MA 01730
(781) 275-5150
www.scitex.com

Sekonic
(see Mamiya America Corp.)

**Sinar Bron
Imaging Systems**
17 Progress Street
Edison, NJ 08820
(908) 754-5800
www.sinarbron.com

SyQuest
47071 Bayside Parkway
Fremont, CA 94538
(510) 226-4000
www.syquest.com

Wacom Technology Corp.
1311 SE Cardinal Court
Vancouver, WA 98683
(800) 922-9348
www.wacom.com

Xaos Tools
600 Townsend Street
Suite 270 East
San Francisco, CA 94103
(415) 558-9267
www.xaos.com

Zap Strobes
Paul C. Buff, Inc.
2725 Bransford Avenue
Nashville, TN 37204
(800) 443-5542
(615) 383-3982
www.white-lightning.com